Memoirs
of a Dada Drummer

THE DOCUMENTS OF 20TH-CENTURY ART

ROBERT MOTHERWELL, *General Editor*

BERNARD KARPEL, *Documentary Editor*

ARTHUR A. COHEN, *Managing Editor*

Memoirs of a Dada Drummer

by Richard Huelsenbeck

Edited, with an Introduction, Notes, and Bibliography by Hans J. Kleinschmidt

TRANSLATED BY JOACHIM NEUGROSCHEL

THE VIKING PRESS NEW YORK

Acknowledgment is made to the following for permission to use the materials
indicated:

The American Journal of Psychoanalysis: "Psychoanalytical Notes on
Modern Art," by Charles R. Hulbeck (Huelsenbeck), in *The American
Journal of Psychoanalysis*, vol. 20 (1960), no. 2, pp. 164–173. Reprinted by
permission of the Editor of *The American Journal of Psychoanalysis*.

LIMES VERLAG: For permission to translate "Mit Witz, Licht und Grütze"
and "New York," by Richard Huelsenbeck.

THE MUSEUM OF MODERN ART: From *Arp*, edited by James Thrall Soby.
Copyright © 1958 The Museum of Modern Art, New York. All rights
reserved. Reprinted by permission of the publisher.

NEW DIRECTIONS PUBLISHING CORPORATION: From *Poems from the Book of
Hours*, by Rainer Maria Rilke, translated by Babette Deutsch. Copyright
1941 by New Directions Publishing Corporation. Reprinted by permission
of New Directions Publishing Corporation.

RANDOM HOUSE, INC.: From "September 1, 1939," by W. H. Auden.
Copyright 1940 by W. H. Auden.

WILLY VERKAUF: "Dada and Existentialism," by Richard Huelsenbeck, from
Dada: Monograph of a Movement. Reprinted with permission of Willy
Verkauf.

The illustration on page xvii of the editor's Introduction is the front page of
the magazine *Revolution*, founded in 1913 by Hugo Ball and Hans Leybold.

The drawings in "The Dada Drummer" were made by George Grosz for the
second edition of Huelsenbeck's *Phantastische Gebete* (Fantastic Prayers),
published in Berlin, 1920. Reprinted with permission of the George Grosz
Estate.

The woodcuts in the other essays were made by Hans Arp for the first
edition of *Phantastische Gebete*, published in Zurich, 1916. Reprinted with
permission of Mme. Marguerite Arp.

We hold the hog's bladder in our hands and catch the burning oakum with our ears. We are ceremonious and melancholy, we ancient priests. In the valley, they are beating the great kettle drum, the vermilion tide is rising, the porcelain stars are falling down—eioéh eioéh—we are so ceremonious and serious in this hour. We have forgotten minor things, we tore the hyacinths from our heads, we clapped the earth out of our bellies. This means that we are very ceremonious. Have we ever had more reason to act madder, lovelier, insaner, or more ceremonious? Have we ever had more reasons for blowing red-hot smoke out of our noses or being prouder? We killed a quarter of a century, we killed several centuries for the sake of what is to come. You can call it what you like: surgery, kleptomania, calligraphy; for all we can say is: We are, we have worked some—revolution, reaction, extra! extra! we are—we are— Dada first and foremost—first and foremost a word, whose fantasticness is incomprehensible.

<div align="right">

—HUELSENBECK

</div>

Editor's Note

When Richard Huelsenbeck asked me to edit a selection from his recent writings, I accepted with delight. Not only are we both products of a German humanist education, but we were also both determined to devote our lives to careers in art and literature. My diploma from the Kaiser-Friedrich Gymnasium in Berlin unequivocally states that I was to be an art historian. Instead, like Huelsenbeck, I went into medicine and became a practicing psychiatrist. Nevertheless, an ever-deepening interest in German expressionism and the manifold evolving trends in art and literature from the turn of the century to the end of the Weimar Republic has enriched my life throughout the years.

The major portion of the text in this volume is a translation by Joachim Neugroschel of Huelsenbeck's *Mit Witz, Licht und Grütze*, published by Limes Verlag in 1957 and used here with their permission. Most of the essays have been selected from the more than óne hundred articles published by Huelsenbeck in Swiss and German newspapers and have been translated from the German by Mr. Neugroschel, who also translated the poem "Rivers" and the excerpt from Huelsenbeck's introduction to the *Dada Almanach*, which appear in my introduction. Two of the essays, "Psychoanalytical Notes on Modern Art" and "On Leaving America for Good," were written in English by Huelsenbeck; the essay "Dada and Existentialism" was translated by H. A. G. Schmuckler and Joyce Wittenborn; part of the Arp

essay originally appeared in English in a Museum of Modern Art catalogue published in 1958. The extracts from "The New Man" used in the introduction were translated by myself.

I would like to express my gratitude to Paul Raabe of the Schiller Archive in Marbach, Germany, for putting his bibliographic archive at our disposal. My thanks are also due to Peter M. Grosz for permitting us to reproduce the George Grosz drawings from the second edition of Huelsenbeck's *Phantastische Gebete* and to Marguerite Arp for permission to reproduce the Arp woodcuts from the first edition. My special thanks to Barbara Burn of The Viking Press, whose editorial assistance was invaluable.

H. J. K.

Contents

The New Man—Armed with the Weapons of Doubt and Defiance: Introduction by Hans J. Kleinschmidt

I

For a while my dream had been to make literature with a gun in my pocket.

<div align="right">—HUELSENBECK, En avant dada, 1920</div>

At the beginning of an extended lecture tour in the winter of 1970, Richard Huelsenbeck gave a talk on dada at the Goethe House in New York.[1] *
He did not beat a drum nor did he read from a prepared manuscript. For an hour and a half he spoke with wit, charm, and the disarming blend of seriousness and self-irony so characteristic of this elder statesman of dada. The audience responded with delight when he described how he had chanted his early "African" poems to the accompaniment of a tom-tom, shouting at the end of each poem: "Umba, umba." "I was very good at 'Umba, umba' in those days," he said, and his listeners roared with laughter.

But this was New York 1970, not Berlin 1918. Dada 1970 was very dignified. The man who was the courier of dada, the man who brought it to Berlin and said that "by giving the word dada to the movement, I gave it its revolutionary impetus," is today dada's chronicler.

Following the lecture, a young person loudly asked for the floor: "Dr. Huelsenbeck! Our protest, our refusal to accept the Vietnam war, our refusal to accept the hypocrisy of our leaders, isn't our protest the same as yours was?"

* Numbers refer to the Notes which start on page xlvii.

"I don't think so at all," he replied. "Because the two situations are quite different. You have to know the background story. All men are victims of—or, if you will—all men express their historical context."

There was silence. The young protester sat down in astonishment.

I had looked forward to this moment with a mixture of eager anticipation and apprehension. How, I had wondered, would a founder of dada react to the protest of 1970? In recent years he had emphasized more and more the philosophical, psychological, and moral aspects of dada, while minimizing its political side. As I expected, the issue of civil disobedience, its possible justification, had been raised at once.

Huelsenbeck fielded their probing questions calmly and wisely, no doubt disappointing most of the young people in the audience. "We were never really politicians," he explained. "Certainly not in Zurich, where ironically the police took an interest in our carrying-on while leaving completely undisturbed a politician who was preparing a great revolution. I am referring to Lenin, who was our neighbor at the Cabaret Voltaire.

"Dada was a protest without a program, without a political program. We protested the system without ever offering alternatives. Dada was a moral protest not only against the war but also against the malaise of the time; it was an awareness that something was very wrong.

"The protest arose from a deep creative doubt. One must protest what is morally wrong. To protest what is wrong is a creative act. It becomes a power in itself.

"Dada was a collective struggle," Huelsenbeck continued, "a struggle for individual rights, which included values. It was not interested in providing moral justification for political activism or, for that matter, for any particular system. The dadaist knows that moral struggle is individual; man must arrive at his own decisions, his own values."

From the audience, another voice was heard: "But in America . . ."

Huelsenbeck didn't wait. "In America," he answered, "the situation is different.

"Germans . . . we . . . were brought up with *die Kultur* to justify everything we did." Then he hesitated. "Our moral backing was *die Kultur*, the same *Kultur* that led us into World War One.

"We revolted against that system, against its justification, its *Kultur*. Dada was a revolt-plea, a plea for a new humanism. We knew," he said, "that within every civilization there is an inherent system that justifies that civilization. We protested all systems in the name of freedom, in the name of the individual."

This was the elder dada statesman speaking as philosopher and historian. He was leaving it to today's youth to start the fire the next time. The young had to arrive at a measure of spiritual awareness and achieve their own moral guidelines.

"But it is not only the young," he reminded the audience. "Everyone has this responsibility, the responsibility of existence, the creation of individual values and the acting upon them." This had been his own experience.

II

Dada is eminently civilizing. . . .

—HUELSENBECK, *Dada Almanach*, 1920

Richard Huelsenbeck was born on April 23, 1892, in Frankenau, in the province of Hesse, Germany. Frankenau at that time was very small and poor. Huelsenbeck's father was the town pharmacist and barely able to support his small family, for the peasants had little if any money to spend on medicines.

Richard was the younger of two children. (His sister died during the influenza epidemic in 1919.) Not long after Richard was born, the family left Frankenau and moved to Dortmund, in Westphalia, where his father became a chemist. His mother welcomed the move to Dortmund; she was not a particularly happy woman and had suffered a depressive episode while in Frankenau.

In 1911, Richard was graduated from the humanistic Gymnasium in Burgsteinfurt. A humanistic education in Germany in the early part of the twentieth century involved a constant emphasis on classical studies, since teaching was based on the principle of *kalokagatia*,[2] meaning that "what is beautiful must also be good." This was, of course, only a step from the rather arrogant assumption that the creation of anything "beautiful" in art, literature, music, or science justified a superior attitude to which less *kultivierte* people were not entitled.

Huelsenbeck's father had his eye on civil service and wanted him to study law, but Richard wanted to study literature and art history. The son won out. His maternal grandfather had awakened Richard's love for poetry early in his life, and he had been writing poems and short prose pieces since the age of sixteen. The boy felt that his grandfather was a frustrated poet and as a result "melancholic" most of his life.

He was permitted to go to Munich to study with two of the greatest teachers of that time: Heinrich Wölfflin, the great innovator in art-historical thinking and methodology, and Artur Kutscher, a professor of literature who belonged to Frank Wedekind's circle. Kutscher was a stimulating and provocative teacher who conducted his seminars in a fashion considered revolutionary in academic circles at the time: he encouraged his students to engage in lively exchanges of opinions and critical comments about literature, social conditions, and political events. It is not at all surprising that the young Huelsenbeck was particularly influenced by Kutscher, who, with Wedekind and the poet Max Halbe, sat at the round table of the "Eleven Executioners" in Kathi Kobus's well-known bar, the "Simple."[3] Huelsenbeck's ambitious dreams of immediate acceptance by these formidable literary luminaries into their exclusive circle remained unfulfilled.

It was in Munich that Huelsenbeck met Hugo Ball. The year was 1912, the year of the Blaue Reiter of Kandinsky and Franz Marc and Paul Klee. Hugo Ball was close to this group and was profoundly affected by Kandinsky, whose personality and teaching made a lasting impression upon him. Ball had originally planned to collaborate on the *Blaue Reiter* almanac, but his work as stage manager at the Ida Roland Theater and other commitments interfered.

Ball was an extraordinary human being. A visionary, a deeply religious man who in his youth, under the influence of Nietzsche, had rebelled against the church, a highly gifted writer and poet, he combined, in a rare fashion, a sharply critical intellect with a nobility of spirit and grace. Ball was six years older than Huelsenbeck, and he exerted a strong influence upon the young student of literature.

In 1913, Ball and Hans Leybold founded the magazine *Revolution*, to which Huelsenbeck contributed as "Paris correspondent"—even after his return from Paris, where he had been studying philosophy at the Sorbonne during the winter semester of 1912/13. *Revolution* did not survive 1913, dying after five issues. The very first number was confiscated by the police because of Ball's poem "Der Henker" (The Hangman); in fact, for a while it looked as if Ball would have to stand trial for blasphemy.

The good burghers of Munich were outraged by two lines of the poem:

O, Maria, du bist gebenedeit unter den Weibern,
Mir aber rinnt der geile Brand an den Beinen herunter

[Oh, Mary, you are blessed among women,
While the wanton firebrand runs down my legs]

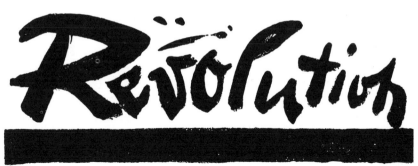

Revolution

Auflage 3000 — Zweiwochenschrift — Preis 10 Pfg.

Jahrgang 1913 — Verlag: Heinrich F. S. Bachmair

Nummer 1 — München — 15. Oktober

Richard Seewald: Revolution
(Original-Holzschnitt)

Inhalt:

Mitarbeiter:

Adam, Hugo Ball, Johannes R. Becher,
Gottfried Benn, Franz Blei, Max Brod,
Friedrich Eiſenlohr, Engert, Leonhard Frank,
John R. v. Gorsleben, emmy hennings, Kurt
Hiller, Friedrich Markus Hübner, Philipp
Keller, Klabund, Elſe Lasker=Schüler, Jwan
Lazang, Erich Mühſam, Heinrich Nowak,
Karl Otten, Sebaſtian Scharnagl, Richard
Seewald und andere.

Actually, the intent behind the poem was not so much to shock or dese-crate as to show that although man creates ideals, he lives far from them. On the road to perfection, or to ideal expression, sensuality lies as an obstacle, the symbol of man's common expression. Symbolization and idealization are always symptoms of man's imperfection, just as art derives from incompleteness. The poet may lament the human dilemma that is the source of his endless quest for ideal love, for "goodness and wholeness from that which in fantasy had been injured and rendered bad."[4]

When Ball left Munich in 1914 for Berlin, Huelsenbeck followed him. Ball left because his plans for an expressionist theater in Munich had not come to fruition; Huelsenbeck had decided to study medicine in Berlin. It was a powerful instinct for survival that motivated this move rather than an abandonment of art and literature. Gottfried Benn and Alfred Döblin, two giants among the poets and novelists of the expressionist era in Ger-many, were also *Dichter-Ärzte*, poet-physicians, who often commented on the discouraging fact that they would have been unable to survive on their meager earnings as writers.

Huelsenbeck's energy during this next decade of his life was boundless. Even with his full preclinical program of anatomy, physiology, histology, chemistry, and so on, he found the time and inspiration to write poems, essays, and book reviews for Franz Pfemfert's *Aktion*, a leading literary magazine with strong left-wing coloration, and for the A. R. Meyer publish-ing company.

Huelsenbeck and Ball, who had found work as editor of one of the many little magazines of the time, were in Berlin when World War I burst upon their lives. Their opposition to the war grew into explosive feelings against the German Reich under the vainglorious Kaiser Wilhelm II and against "the German intelligentsia," one of Ball's favorite expressions. The famous declaration of German literati and scientists supporting the Kaiser and the war impressed them as a "most terrible perversion." To give formal and public expression to their antiwar feelings, the two organized meetings and poetry readings to commemorate poets killed at the front, such as Charles Péguy, a French poet who had fallen at the beginning of the war. Soon their stance became more aggressive, culminating in 1915 in an "expressionist evening" in the Harmoniumsaal, an evening with clearly dadaist elements. German *Kultur* was condemned as an ideological power tool of the government, and Huelsenbeck recited his first "Negergedichte," in which each verse ended with a deafening "Umba, umba."

Ball left Berlin for Switzerland in the fall of 1915, and Huelsenbeck

followed him a few months later. Ball wrote in his diary (published as *Flight Out of Time*) under the date of February 11, 1916: "Huelsenbeck has arrived. He pleads for reinforcing the rhythm (the Negro rhythm). He would like best to drum literature into the ground."

A few weeks before Huelsenbeck's arrival in Zurich, Hugo Ball and Emmy Hennings founded the Cabaret Voltaire. A Swiss precursor, the Cabaret Pantagruel, occupied the same house, the Meierei, in the Spiegelgasse, for several months in 1914. Swiss poets met in the Holländerstübli (Dutch Room) of the Meierei once or twice a week to hold readings of their own works. Their magazine, *Pantagruel*, appeared twice, in March and May of 1914.[5]

Tristan Tzara and Marcel Janco, two Rumanians who had originally planned to travel to Paris, had already joined forces with Ball and Hennings before Huelsenbeck's arrival. Tzara's manner, his aggressive managerial talent and his far-flung correspondence with literary luminaries, as well as the indisputable fact that he was very much at home in French, German, and Russian literature and therefore had a tendency to take over, antagonized both the sensitive and reserved Ball and the ambitious and self-willed Huelsenbeck. Although Tzara later claimed to have found the word "dada" (and seduced Arp into writing a mock "certificate" to that effect, which was promptly taken seriously by some historians), there can be no doubt that Huelsenbeck was the one who came upon the magic word in an edition of *Larousse*. Huelsenbeck's ire at Tzara's claim knew no bounds, and even as late as 1949, in a manifesto, he continued his attack on Tzara over this very matter. But the controversy over priority can be put to rest by Hugo Ball's letter to Huelsenbeck of November 8, 1926, from Sorengo-Lugano: "Would you care to write a few lines for the *Literarische Welt* about my new book, *Flight Out of Time*, a diary of 1913–21, Duncker & Humblot? I would be very grateful, so that no Berlin wiseguy gets hold of it. I am going to have the publisher send you the book. At long last I too have described dadaism in it (cabaret and gallery). *You would then have the last word in the matter, just as you had the first.* . . ."[6]

The single element that bound these young men of different nationalities, religions, and—most important—personalities together was their impassioned quest for a new reality in the social, political, and artistic-intellectual realm. The absurdity of the mission, its truly tragicomical aspect, was the fact that all of them were artist-intellectuals but utterly naïve about politics. In Zurich, therefore, this quest for a new reality found expression almost exclusively on literary and artistic levels. In their work, Arp and Janco

rejected the overheated expressionism of the Brücke artists (Kirchner, Heckel, Schmidt-Rottluff, Nolde, and Pechstein) as fervently as they turned away from the formalism of art nouveau and the decadent neoromanticism of academic art. For Arp, especially, abstract art was far more than a protest against established formalism: it was an expression of a basic truth as an artist.

The revolutionary zeal of this group of young men pushed them to the point of doubting the validity of language and all established grammar. Ball's and Huelsenbeck's sound-poems are evidence for the excitement, courage, and creative fervor of that moment in time. What united them in their extravagant performances was the conviction that their defiance and doubt contained a moral truth.

Not surprisingly, Huelsenbeck's parents had no understanding of their son's artistic and intellectual aims. When he presented his mother with a copy of his *Phantastische Gebete* (Fantastic Prayers), she burst into tears, fearing that he had gone stark raving mad.

Hugo Ball, who found his collaboration with Tzara in running the Galerie Dada not at all to his liking, left Zurich with Emmy and settled in the Ticino in August 1916. He returned for a few brief visits to Zurich but his break with Tzara and dada was final. Huelsenbeck reacted stormily to Ball's departure—with insomnia, a "nervous stomach," continual vomiting, and obvious despondency. Although he found Zurich "unbearable" without Ball and determined to leave at once, he postponed his departure from week to week. He was still in Zurich in October when he wrote to Ball describing his suffering and noting, with characteristic self-irony, that his complaints may be "the punishment for that dadaist hubris you believe you have detected." Only the news that his father was gravely ill put an end to his own ailments, and he left at once for Germany.

In January 1917, Huelsenbeck arrived in Berlin, where he soon united with Raoul Hausmann, George Grosz, Franz Jung, Walter Mehring, and others to found Berlin dada. A period of furious literary activity ensued. He contributed to several magazines: Wieland Herzfelde's *Die Neue Jugend*, in which Huelsenbeck published his manifesto "Der neue Mensch" (The New Man), Hausmann's *Der Dada*, and Pfemfert's *Aktion*. He also found time to write the long story *Verwandlungen* (Metamorphoses), which Roland-Verlag published in Munich in 1918. This story of a marital triangle was eventually hailed as "the first symbolic surrealist novella in Germany."[7] How Huelsenbeck found time and energy to attend classes at medical school and to prepare himself for his examinations remains a complete mystery.

But he did pass his state board and became a doctor. What an unusual

doctor, though! A photograph in the second edition of his *Phantastische Gebete* shows him sporting a monocle in his right eye, which was his way of parodying the Prussian Junkers. Most of his time was spent in the Café des Westens and in interminable debates with poets, literati, journalists, and would-be politicians. There he met Else Lasker-Schüler, Gottfried Benn, Alfred Döblin, and the Herzfelde brothers, Wieland and John. At night Huelsenbeck continued to write poems and book reviews for the *Litera-rische Welt*, and somehow he found time to write his famous chronicle of dada, *En avant dada, Dada siegt!* (Dada Wins!), and *Deutschland muss untergehen!* (Germany Must Fall!), and also to edit the *Dada Almanach* —all published in 1920. The following year the prestigious Munich publish-ing house of Kurt Wolff brought out his novel *Doktor Billig am Ende* (The End of Doctor Billig), which Döblin praised as "ingenious, with striking character profiles and forcefully worked-out images."

Berlin and the Club Dada were no longer a large enough forum for Huelsenbeck's ideas. In collaboration with Hausmann he organized "dada evenings and dada conferences" in Leipzig, Prague, and other cities, always provoking the unsuspecting citizenry, whipping them into a state of uncon-trollable frenzy but always escaping personal harm at the last moment.

A falling-out with Hausmann over the direction dada was taking, and especially over Hausmann's increasing concern with artistic productivity of all sorts at the expense of a literary and social focus, led to Huelsenbeck's departure in 1922 for Danzig, where he became an assistant to Professor Wallenberg, a leading authority in the field of neuropsychiatry. It was here in Danzig that he met and married Frau Beate, a strong personality and a gifted artist, whose collages "fascinated" Huelsenbeck and impressed even Hans Arp. After a brief and unsuccessful attempt to build up a private practice as a general practitioner, Huelsenbeck returned to Berlin, but not without having first tried his hand at playwriting. Shortly before he left Danzig, his play *Das Geld unter die Leute* (Money among the People) was produced in the Stadttheater.

Back in Berlin in 1923, Huelsenbeck was a physician "only pro forma," as he puts it, although he attended many psychiatric lectures in the Charité. These were years of inflation in Germany, when the economy was in a state of total chaos. Officially, Huelsenbeck worked on a panel of physicians in a National Health Clinic, but most of his time was predictably spent in the irresistible Café des Westens. What he wanted most of all at this point was to remain a *poète engagé*, and, if this was not possible, a writer who would always be in the thick of things. Current events intrigued him, and journalism seemed to be the logical answer. He promptly became "perma-

nent correspondent" of the *Berliner Tageblatt*, the leading Berlin newspaper, and of the *Berliner Illustrirte,* the *Literarische Welt,* and the *Boersen-kurier.*

In 1925 he hired himself out as ship's surgeon on a Hapag Line freighter that was bound for China, Japan, Burma, Formosa, Sumatra, and the Philippines. On his return, six months later, he found Europe "humorless, sad, and emaciated." He was writing as always, publishing brief pieces in magazines and newspapers, all the while collecting material for a book. In its July 1926 issue, *Der Querschnitt,* one of the most widely read art and literary magazines in post–World War I Berlin, published an article of Huelsenbeck's entitled "Ostasienfahrt" (Voyage to East Asia), which is notable for its sardonic little vignettes. It also reproduced a photograph showing a youthful and handsome Dr. Huelsenbeck in a self-assured pose. In 1927, we find him again as ship's surgeon, this time on board the *Reliance,* sailing around Africa. The trip led to a new literary success for him, *Afrika in Sicht* (Africa in Sight), a combination travel book and novel, which was acclaimed by Hermann Hesse in the *Berliner Tageblatt.*

In 1928, the *Berliner Illustrirte* sent him as a correspondent to Russia, Manchuria, and China. He met Chiang Kai-shek and attended the funeral of Sun Yat-sen. A travel book, *Der Sprung nach Osten* (The Leap to the East), and a novel, *China frisst Menschen* (China Devours People), appeared in 1930. The latter, his most popular book of the thirties, is set during the Chinese civil war of the twenties. Both these books have been called early examples of automatic writing in modern German literature.

In 1931, Huelsenbeck was again working as a far-flung correspondent, for the *Münchener Illustrierte,* another leading illustrated magazine, which sent him to the United States, Cuba, and Haiti. With Hitler's rise to power, in 1933, Huelsenbeck was immediately expelled from the Writers' Union and was "forbidden to write." Repeated efforts to obtain immigration visas for the United States for himself and his family (a son and a daughter) failed because he did not know how to get affidavits, and the next three years were dominated by fear of imminent arrest. Just before the Nazi take-over in the winter of 1932–33 Huelsenbeck's comedy *Warum lacht Frau Balsam* (Why Is Mrs. Balsam Laughing), which he had written in collaboration with Günter Weisenborn, was produced, with the prominent actress Agnes Straub in the lead, at the Künstler Theater in the Ranke-strasse in Berlin. Several SS men attended the performance and created a disturbance, demanding to know where the authors were. Huelsenbeck managed to leave the theater but not without being followed by one of the

SS men. He got away, eventually, but his fear of being recognized sooner or later as the dadaist Huelsenbeck and author of anti-German literature remained strong. He devoted himself to the practice of medicine and hoped that the Gestapo would take a long time to discover that the doctor and the dadaist were one and the same person. In the meantime, letters and magazines that George Grosz kept sending from America attracted the attention of the Gestapo, and agents returned to Huelsenbeck's house more and more often, asking searching questions and convincing him that any letters he might send to America would be intercepted.

He realized that he must leave Germany and quickly. Again he found a job as ship's surgeon, this time on board the *Klaus Horn*, and took his wife with him. From the West Indies they were able to write to their friends in the States, asking for the indispensable affidavits. In the spring of 1936 Huelsenbeck was finally able to leave Germany, and a few months later Frau Beate followed him to New York with Mareile and Tom. Ironically, shortly before his flight from Germany, the big Ullstein publishing house brought out a novel of his, *Die Sonne von Black Point* (The Sun of Black Point), in one of their popular magazines.

The first two years in New York were hard, since Huelsenbeck was practically penniless. But he survived again. While waiting to be granted a New York State license to practice medicine (which he received through the personal intervention of Albert Einstein), he was able to support his family by writing a "sort of family history of a very wealthy industrialist, an incredibly boring job."

Motivated by a desire to relinquish dada completely, he changed his name to Charles R. Hulbeck. He lived a very quiet, impoverished life, having cut all contacts with his past. "All people's pasts are painful. You have to lose the past sometimes," he says, "in order to find it." And to walk away from the past meant, of course, to remain aloof from the people he had dealt with in the dada movement.

There was an unmistakable undercurrent of hope in this Americanization of Huelsenbeck's name. "Hulbeck"—the philistine American—was symbolic of his emerging new self, his new American self. Like George Grosz he wanted to give himself a chance to become a member of a new society, and—who knows—maybe a better one. His optimism undoubtedly accounts for his slip in *The Dada Drummer* when he turns the title of his friend's book around to read "A Big Yes and a Little No" (see p. 57). So the name change signified his intention to make a new beginning. He said: "Somehow it had to be possible to accept the face of the human."

He decided to practice psychiatry. He underwent a didactic analysis with Karen Horney and took part in founding the Association for the Advancement of Psychoanalysis. He later joined friends and associates in forming the Ontoanalytic Association in New York, and in 1969 he was given that society's coveted Binswanger Award for his contributions to existentialist psychiatry.

And, of course, he again found time to write. He wrote innumerable articles for German and Swiss newspapers and magazines about the "scene" around him, its social side, its psychological and philosophical and existential aspects. He wrote about the rapidly changing American art world with perception, a sharp eye, and at times, an even sharper pen. He was one of the first to recognize a dada kinship in Tinguely, whose work he furthered and about whom he wrote eloquently and with his old passion. His essays on George Grosz, Arp, and Duchamp are little gems of characterization. He also found time to write a book he whimsically entitled *Mit Witz, Licht und Grütze: Auf den Spuren des Dadaismus*, which is the central essay in this volume. This very German title with its slightly Berlinese flavor, "With Wit, Light and Brains: On the Traces of Dadaism," seemed a bit heavy for this edition, and so we have changed it to "The Dada Drummer." Reminiscing about the days in Zurich and the years of turmoil in Berlin, filled with excitement, creative courage, and innovative daring, Huelsenbeck succeeds in blending, in a casual narrative flow, philosophical flashes with illuminating anecdotal vignettes, and he tells it all with disarming self-irony.

In 1969, he retired from his psychiatric practice and moved with his wife to Switzerland, where he now lives in a place called Minusio, in the Ticino. [Richard Huelsenbeck died on April 20, 1974, as this book was about to go to press.—Ed.] He is "retired" in a typically Huelsenbeckian fashion: he lectures all over Europe and returns once a year to the United States and Canada to hold forth about dada, and of course, he continues to write. More surprising, however, this man, who is remembered by many as one who wanted to destroy art, has become a painter. A painter *à l'écart*, perhaps, but still a painter who has already had several exhibitions in New York and two in Milan. So, just as Klee and Kandinsky were poets "on the side," Huelsenbeck is today a painter apart from his first and dominant creative

Bernard Karpel put it most succinctly and beautifully in referring to "the three seminal personalities" of the dada epoch: "Arp for art, Tzara for journalism and Huelsenbeck for avant-garde literature as politics and philosophy. Without him, Dada in Europe—as well as its American reaction—is unthinkable; with him, it becomes contemporary and luminous."

III

Dada is the creative activity par excellence.

—HUELSENBECK, *Dada Almanach*, 1920

Studying the vast literature on Dada that has accumulated over the past fifty years, one is reminded of the lapidary adage that "history consists of stories we invent about the past." The temptation of an egocentric reinterpretation and re-evaluation of historical phenomena seems overwhelming. We impose structures and schemata upon the past in order to crystallize meaning and facilitate intellectual comprehension of developments that would otherwise remain obscure, bewildering, and threatening. And we also use history to understand ourselves better. We may fall into the trap of projecting our fears and prejudices, our moral, political, and aesthetic values into that past and thereby distort utterly what really happened. Kasimir Edschmid, who was a writer and intimate friend of many leading poets, playwrights, and literati of the expressionist era, and who was active in Germany during its heyday of hectic productivity and afterward, when it hit the bottom of the abyss, reveals the exasperation of a participant in events that he can no longer recognize as formulated by the historians. He wrote in 1964 that to interpret the German expressionist era from a purely philosophical point of view is as misleading as to proceed from an exclusively sociological approach. These scholars, he finds, have in common an almost uncanny method of selecting, "in all innocence, of course," only the material that fits their theories. And since they usually have only *one* theory, they are completely unable to be objective and are forced "to mix with inimitable dogmatism the qualities and contents of books and the parts individual authors played . . . their priority, their passion, their impetus, their status—they see embodiments of their own ideas of that time and not the epoch itself."[8]

The art historian has his own yardstick, the evolutionary approach. In his postscript to Richter's *Dada: Art and Anti-Art*, Werner Haftmann tries to be fair to the contribution dada has made by saying that "Dada was the effective (and thus historically right) expression of a mighty surge of freedom in which all the values of human existence . . . were brought into play. . . ." But then he goes on to reduce dada's innovations in art, typography, and literature to "derivations" stemming "almost exclusively" from "the Expressionists, Cubists, and Futurists, as well as Kandinsky, Klee and de Chirico." Both Hugo Ball (in *Flight Out of Time*) and Huelsenbeck

(in *En avant dada*) clearly indicate their indebtedness to the futurists and the cubists, but dada went far beyond anything Marinetti or Boccioni ever dreamed of or intended. Even the futurist soirees were apparently not, as Haftmann puts it, "virtually indistinguishable" from the dada evenings. Edschmid says that they were "similar in the noise they made but not in their essence. . . . The dadaist nonsense was no mere anarchy but a demonstration of how a certain anarchism might lead to something positive after pensioning off a century-old tradition."[9]

But the arbitrary attitudinizing about dada has gone far beyond anything that could be called subtle differences of emphasis, and thus research into the dada movement can be a historian's nightmare. As if the rugged and reckless individualism of the founders with their personal feuds, their malicious gossip, and their mania for priority were not enough, we find that art and literary critics have succeeded in confounding the picture further by inventing their own "histories" of dada. There are the art historians who see dada only as a precursor to surrealism and find little, if anything, to differentiate one from the other. There are literary historians who write books about the poetry of dada and surrealism, making the work an exclusively French creation, with Tzara as protagonist, and with Ball, Arp, Hausmann, Schwitters, and Huelsenbeck never even mentioned.[10] Anna Balakian in her biographical study of André Breton is thorough in her research of the surrealist movement and sensitive in her analysis of the life, background, and work of the "Magus of Surrealism." But her partisanship runs away with her when she contrasts Breton's military service during World War I (he was one of the young men "uprooted from their studies to defend their country"), with the draft dodging of Arp, Ball, and Huelsenbeck (who is described as "a physician-psychiatrist with a marginal interest in African dance"). The activities of the three dadaists are characterized as "quasi-artistic" and their "behavior was distinctly subversive both socially and politically. They practiced total unemployment for a while. Destruction and revolution were in the air; at a nearby café Lenin could be seen playing chess. The psychiatrist Jung was also in Zurich."[11]

Besides being unsympathetic to Huelsenbeck, these lines seem almost dictated by an attempt to establish political "guilt by association." Lenin was "nearby," but he was not interested in their productions; indeed he was singularly cool toward art in general and modern art in particular. Arp, Ball, and Huelsenbeck never met Lenin although Tzara later told friends in Paris that he "exchanged ideas" with him, but that impresses me as pure dada hubris. As to the implied connection with Jung, other authors

have gone even further and made Huelsenbeck a Jungian. But in fact, he never met Jung and never became an adherent of his psychoanalytic school of thought. Jung, incidentally, like Lenin, had no use for the dadaists and is known to have made some very unkind remarks about them.[12]

And as to whether the behavior of the dadaists in Zurich was "distinctly subversive both socially and politically," Michel Sanouillet for one has taken the proper stand that it is quite erroneous to stress the political side of their activities at the expense of their artistic experimentation.[13]

Even here—in their poetic innovations—many researchers have misguidedly maintained that they derived from Alfred Jarry. In fact, Jarry is frequently credited with being the father of the true dada spirit. To be sure, his outrageous *Ubu Roi* caricatured and ridiculed the bourgeoisie of the turn of the century. And he was the "inventor" of " 'Pataphysics," the ironic "science of imaginary solutions," in which Dr. Faustroll explains that the world consists of nothing but exceptions, and that the rule is precisely an exception to the exception. The philistines' blind faith in progress through technology, their pride in material gain had provoked his devastating gibes. As early as 1902, in his novel *Le Surmâle*, he satirized the influence of the machine in contemporary life.

However, I believe that the influence of Jarry and his ironic brainchild, the science of 'Pataphysics, on the dada creations at the Cabaret Voltaire has been highly exaggerated. The evidence points in another direction. The sound-poems, simultaneous poetry, and nonsense poems produced by Arp, Ball, Huelsenbeck, and Tzara, in a remarkable display of spiritual harmony and artistic collaboration, have a source much closer to them culturally than Paris and Jarry.

Hugo Ball was to claim later that he was the inventor of the sound-poem, but this is no more or less than a case of convenient forgetting in the service of narcissistic ego gratification. In Munich, Ball had been very close to Kandinsky and the Blaue Reiter group. Kandinsky exerted an immense and lasting impression upon Ball, who said later (in *Flight Out of Time*) that Kandinsky had been much more than an inspiring teacher: "He was like a priest to us."

In 1912, the *Blaue Reiter* almanac, edited by Kandinsky and Franz Marc, appeared. While it was still in the planning stage, Ball had been included among its proposed contributors, although he was later dropped. In the published volume, Kandinsky described his experiments with poems devoid of semantic meaning: "The sound of the human voice was applied in pure fashion, i.e., without being darkened by the word, by the meaning

of the word." It is totally inconceivable that Ball was ignorant of Kandinsky's theories regarding both painting and poetry. Despite Kandinsky's penchant for writing his own history (after all, wasn't he the sole inventor of abstract art, according to him?),[14] it is known that he mentioned to Ball the Russian phoneticists Kruchenykh and Khlebnikov, who had created what they called "transrational language" in their "zaum" productions. Arp, in an article on "Kandinsky the Poet," mentions that such poems from Kandinsky's collection *Resonances* were "recited for the first time in the Cabaret Voltaire." This was another of the dadaists' innovations: they were the first to recite nonsense lyrics and sound-poems publicly.[15]

As a matter of fact, "Lautgedichte" were familiar to the German public through the poetry of Paul Scheerbart and Christian Morgenstern. As early as 1897, Scheerbart wrote a sound-poem[16] that starts with

> Kikakoku!
> Ekoralaps!
> Wiao kollipanda opolasa . . .

He entitled the poem "Ich liebe dich." Morgenstern's *Galgenlieder* (Songs of the Gallows, 1905) were extremely popular, especially "Das grosse Lalulà":

> Kroklokwafzi? Sememomi!
> Seiokrontro-prafriplo:
> Bifzi, bafzi; hulalemi:
> quasti basti bo . . .
> Lalu lalu lalu lalu la!

Morgenstern's poems were also part of the repertoire at the Cabaret Voltaire, and the similarity between them and Ball's sound-poems is striking. This is from one of Ball's earliest:

> gadji beri bimba
> glandridi lauli lonni cadori
> gadjama bim beri glassala . . .

While reciting this very poem, Ball experienced something akin to religious ecstasy: "At this point, I noticed that my voice . . . had taken on the ancient cadence of priestly lamentations, that style of liturgic chant that reverberates through the Catholic churches of Orient and Occident." He had attempted to penetrate "the innermost alchemy of the word, and even give up the word entirely, thus safeguarding poetry's last and holiest realm." New words had to be found, "brand-new words invented for one's

own communication." So, what may at first sight look like total chaos—and did Novalis not say: "Chaos must glimmer through all poetry"—impresses us now as related to the utterings of medieval mystics and of Jakob Böhme, of magical incantations whose special hypnotic spell is due largely to their unintelligibility.[17] Ball became increasingly aware of this magical origin of many of the words he used in his lamentations; he felt that by abandoning conventional logical syntax, he, Arp, Tzara, and Huelsenbeck had imbued words with a new dynamism and new power. At another point, he wrote: "The source toward which we strive will prove to be the natural paradise."

But a few weeks after experiencing his religious ecstasy in the midst of reciting his sound-poems, Ball became "the renegade of dada," withdrawing from the hullabaloo of dada, both intellectually and geographically, by retreating into the Ticino mountains. On August 8, 1916, he wrote in *Flight Out of Time*:

> I am not thinking the way I did ten years ago about the inmates of mental asylums. Our new theories pursue avenues dangerously close to that sphere. The childlike concepts I am referring to border on the really infantile, the demented, on paranoia. These childlike concepts stem from a belief in a primordial memory, in an unrecognizably repressed and buried world which is liberated through the uninhibited enthusiasm of the artist or through a breakdown in a mental hospital. The revolutionaries I think of can be found there rather than in the mechanical literature and politics of our day.

The "rapture of the deep"—of the deepest "primordial layers," which are normally "out of reach"—had attacked his defenses. Ball felt on dangerous ground, too threatened to go on with his and his friends' forays into infantile regression. His ego had become threatened by disintegration. He realized that for him at least to write nonsense and sound-poetry was no joke. It had more and deeper meaning for him than for his friends, who derived pleasure from the reactions of the bewildered or enraged audience. To Arp, Huelsenbeck, and Tzara, it was a welcome means to express their revolt against convention and conformity. They were not threatened by a fear of loss of ego control. In their pronounced narcissism, they felt entitled to their anger. Their evident delight in manifestations of unreason and disorder is reminiscent of Freud's interpretation of nonsense jokes. In *Jokes and their Relation to the Unconscious*,[18] Freud emphasized that "the rebellion against the compulsion of logic and reality is deep-going and long-lasting. Even the phenomena of imaginative activity must be included in this

rebellious category." The dadaists' pleasure in, to use Freud's term, "liberated nonsense" was obviously shared by a good many of the young visitors to the Cabaret Voltaire. How else to explain the fact that it was a sensational success and literally the talk of the town?

The political specter has also been raised—inappropriately—in connection with the first Berlin dada manifesto[19] of 1918, authored by Huelsenbeck. Most critics have considered it a typically aggressive political publication of Berlin dada. Sanouillet pointed out correctly that it contained no political program but concentrated instead on an impassioned diatribe against futurism and, especially, expressionism. Bruitism, simultaneity, spontaneity, and other styles in poetry are suggested as the only "alive" approaches for art and literature. The recent formation of the Club Dada is also mentioned. The last line reads: "To be against this manifesto means to be a Dadaist!"

Huelsenbeck's initial contribution to Berlin dada, his article "Der neue Mensch," published May 23, 1917, in the magazine *Neue Jugend*, has suffered a similar fate. Even Sanouillet thinks of it as a "politico-sociological pamphlet." But it is in fact mostly poetry, written with religious fervor and in a state of almost unbearable exaltation. Hugo Ball was to say to him later that he could feel the despair that had motivated these pages and most of his early poetry. If this was meant as a "subversive" manifesto, whom was it supposed to subvert? The privileged few who were able to understand Latin and to make sense of his symbology, strange metaphors, and stream-of-consciousness prose? Or did paradox triumph again with this first dada publication in Berlin, in which dada is never mentioned and where the incitement to rebellion is lost in religious incantation and ecstasy?

Since an English version of this often mentioned prose-poem–manifesto has never been published, I have ventured to translate a major part of it:

THE NEW MAN

The dreaming Benvenuto Cellini yearns to see the disk of the sun; we, however, want to see the sun during the day, as a mightily pulsating heart, as a measure of our personality, as the goal of our spirit. We have heard too much of the dialogues of the dead, our ear has received too much that is artificial, and we run now the risk of losing our inner self. *Words, words, too many words*—silence must rise, the ear must ready itself for the orphic of most sacred nights. Days change into nights, gods fall from their thrones, that, however, remains which makes us human and grow. We are required to look deep into ourselves to understand

man, what can be made out of him; there one sees the synthesis of capabilities and all things human. We must become very humble before the power of our soul if we wish to experience the imponderable exalted moment, which gives us an answer to most complicated questions, an answer superior to the most precise calculations. There is truth in banality, truth for him who is called upon to say yes, for him who most often says yes to himself.

The new man stretches wide the wings of his soul, he orients his inner ear toward things to come, his knees find an altar before which to bend. He carries pandemonium within himself, the pandemonium *naturae ignotae*, for or against which no one can do anything. His neck is twisted and stiff, he gazes upward, staggering toward redemption like some fakir or stylite; a wretched martyr of all centuries, anointed and sainted, he begs to be crushed, one day to be consumed in the burning heart, racked and consumed—the new man, exalted, erring, ecstatic, born of ecstasy. Ahoy, ahoy, huzza, hosanna, whips, wars of the eons, and yet human, the new man rises from all ashes, cured of all toxins, and fantastic worlds, saturated, stuffed full to the point of disgust with the experience of all outcasts, the dehumanized beings of Europe, the Africans, the Polynesians, all kinds, feces smeared with devilish ingredients, the sated of all genders: *Ecce homo novus*, here is the new man.

To the heavens, in two vertical poles, his strength splashes; in this expansion upward, without violence, the mystics of growth is no more adventurous than a *buon giorno* or a *felicissima notte*. In ecstatic redemption, the new man finds himself. As Maria worships the Son, he worships himself. *Ipsum quem genuit adoravi Maria.*

Not because the times want it, the new man is new, the reorientation, groping around like a blind man, a mole man—not the subterranean spring, awaiting use from the ax of the barbarian—not because of the Hillers, the Müllers (activists dancing, libertines of the dry soul, nothing but noise before his hands) the new man is new—God of the moment, grandeur of blessed affects, phoenix of contradiction. The new man is forever new, *homo novus* of unique nobility; every minute his heart holds forth his alternative: human or inhuman. Root strength drawn from the era of Mycenae (staffs of Thyrsus, foolscaps, and bells of antique maidens dancing his afternoon conversation)—his day is like Lucian, like Aretino, like Christ—he is not yesterday, he is not today, he is nothing, yet everything.

One must talk about him as one would talk about a father who died

yesterday—an overwhelming memory since we are so much still part of him. Humility, his outstanding characteristic, great humility, forgiving nothing, understanding everything, never avenging. . . .

His voice rings over the market place—the bells of *Ave, Ave Maria.* Neither for nor against, the pains of polarity are alien to him, nationalities have lost their meaning, nationalities are no longer antagonists for him. "They are all in error," he says, "those who believe in aristocracy, an aristocratic order of life. All aristocrats are worthless, even the aristocracy of education, of wealth, of name. Only the soul exists, one soul, one *élan*, one courage, the possession of all men. . . ."

The new man changes the polyhysteria of his time into an honest knowledge, into a healthy sensuality. The new man prefers to be a good academician, instead of grasping the opportunity of becoming a bad revolutionary. The example of the antique maiden remains, the antique maiden who said: "*I've come not to hate with you, but to love with you.*" All that is problematical, every sentence, every thesis, can—nay, must—be an interpretation of this attitude. . . .

Why are you not moved to tears when reading about martyrs who were quartered for their convictions? Why do you have no idea of the beauty and courage of Jeanne d'Arc? Why do you not fall on your knees, like Raskolnikov, crying in the busy square: "Lord, oh, Lord, look down upon me, I am a sinner"? . . .

Why are you unable to think of the things that make the world great and awesome? What? Aren't you smarter than the most insignificant medical student, the student of natural science who makes the life of the Holy Mother a physiological issue? The new man knows that to fear death is to understand eternal life; for he wants a monument set to his spirituality, he has honor in his body, he thinks more nobly than you. He thinks: *Malo libertatem quam otiu¹ servitium.* He thinks: Everything shall live, but one thing must end—the burgher, the overfed philistine, the overfed pig, the pig of intellectuality, this shepherd of all miseries.

If this ecstatic prayer was meant as a political manifesto in the war-torn Berlin of 1917, I doubt that its citizens found it "subversive," and I am confident that it did not qualify Huelsenbeck to be "Commissar of Fine Arts of the Revolutionary Council," as some historians have had it.[20] Rather, he chooses Christian symbolism as the most meaningful—divorced from petty concerns and the concerns of the bourgeoisie, and expressed in

sensual terms. We may remember Hugo Ball's controversial poem of 1913, "Der Henker," where the conflict between man's sensuality and his quest for ideal expression was seen as central.

The frailty of man is no discovery of Ball and Huelsenbeck. In that coterie striving for perfection, St. Augustine succinctly stated the dilemma: "Lord, save me! Make me chaste—but not yet!"

Art is an ideal presentation of life. Certainly from an analytical point of view, it reveals the dialectic of the society, its discrepancies as well as its positive aspects. Art expresses the values of any society, its concerns, its desires. Dada warred against academic art, and, in Germany after World War I, against art frozen in a moral pose, suggesting a sanctity that was nonexistent.

The dadaists sought an art that embodied an implicit critique. Their search reflected the Hegelian and, later, the Marxist idea that all art must contain, if only in a composite form, a self-critique. As Huelsenbeck says: "At the time we acted from conviction; later, the philosophic and psychological aspects of our endeavor revealed themselves before our eyes."

The new man, the man of ecstasy, sought his own moral principles from his own experiences. He was the man turned inward as well as outward. *His life was art.* He hoped to shorten the distance between the inner experience and the exterior life. In short, *his life became art.*

"All art begins," Huelsenbeck says, "with a critique, with a critique of the self, the self always reflecting society. Our critique began, as all critique begins, with doubt. We were extremely sensitive to false situations. *Doubt became our life.* Doubt and outrage. Our doubt was so deep, finally, that we asked ourselves: Can language express a doubt so deep? Later we had read Wittgenstein, and we understood Wittgenstein, that language leads us into convention. We sought an unconventional language, an unconventional art. Our search was for the deepest language, a language expressing man's deepest concern, his doubt." And again: "Our doubt became our weapon against the smugness of the bourgeoisie."

The smug romanticism of bourgeois self-deception and hypocrisy had been replaced by the phantasmagoria of terrifying truths about the human animal.

Huelsenbeck would undoubtedly agree with Wittgenstein's statement that "an historical explanation, an explanation as an hypothesis of the development, is only *one* kind of summary of the data—of their synopsis. We can equally well see the data in their relations to one another and make a summary of them in a general picture without putting it in the form of an

hypothesis regarding the temporal development." He might even go along with Wittgenstein's belief that all theories based on empirical data, all attributions of meaning and significance to observed phenomena, are ultimately drawn "from an experience in ourselves." Dada philosophy seems to be expressed in Wittgenstein's remark: "What is true is that every view is significant for him who sees it . . . and in this sense every view is equally significant."

Huelsenbeck's views regarding the artist's role in society open up interesting psychological questions which can only be alluded to in this space. Can we really say that the artist expresses the values of his society, a thought that coincides with Ernst Kris's observation that "in the extreme case, the public tends to accept him as the embodiment of their superego or at least to delegate superego functions to him"? But Kris continues: "We meet with the opposite extreme in urbanized civilizations, where art lovers tend to form élite circles, sometimes distinct in social status, mores, and even language. We know only in barest outline about many intermediary conditions, but we are justified in assuming that art does not have, as a rule, a homogeneous public; audiences tend to be stratified in various ways and certainly in degrees of understanding."[21]

I believe that both Kris and Huelsenbeck would agree that the avant-garde artist plays a very special role, socially as well as psychologically, and that he expresses *the conflicts over values* of his society rather than the values themselves. The artist formalizes, externalizes, and expresses in emotional terms that which must by necessity be repressed by the group. All social order is based on repression, as Freud demonstrated in *Civilization and its Discontents*.[22] It cannot be disputed that connoisseurship, the experience of art, rests at least in part on the process of identification with the artist. But the nature and necessity of that identification for society warrants further exploration.

Since the artist's endowment leads to a special experiential knowledge, he endeavors to find new norms and solutions to replace the existing ones. In this sense *the artist must by necessity stand outside the social group*. This daring to stand apart, this independence to defy existing values is not without implications. The essential differences between the creative artist and the noncreative group may be explored in terms of various superego constellations: the group is interested in preserving existing values. The group promotes certain norms, and evaluates reality in terms of *what should be*. The artist, on the other hand, rejects these categorical imperatives and concerns himself with *what could be*.[23]

IV

Paradox triumphed.

—EMMY BALL-HENNINGS, *Der Dadaismus*, 1953[24]

Dada was not merely a protest against the senseless slaughter of World War I. Huelsenbeck was not even a pacifist, nor were the iconoclastic originators of dada in Zurich or Berlin self-destructive in the least. A. Alvarez in his fascinating, imaginative, and misguided book *The Savage God* devotes a chapter to "Dada: Suicide As an Art," in which he writes that "for the pure Dadaist suicide was inevitable, almost a duty, the ultimate work of art."[25] Again, here is a literary critic armed with a dangerous weapon, a theory, and he will be damned if he will permit facts to spoil his imaginative concepts. Far from being self-destructive, Arp, Janco, Tzara, Hausmann, Huelsenbeck, and Richter were all born survivors with a tremendous zest for life and living and an extraordinary capacity for enjoying and savoring what life had to offer them.

But they suffered from a malaise years before the Great War, and they were not alone in feeling this way. An atmosphere of despair had gripped artists and intellectuals all over Europe around the turn of the century and found ever more intense and even violent expression in the decade preceding World War I. Franz Marc wrote in his manifesto for the Blaue Reiter group in 1912: "Art today is moving in directions of which our forebears had no inkling; the Horsemen of the Apocalypse are heard galloping through the air; artistic excitement can be felt all over Europe—new artists are signaling to one another from all sides; a glance, a touch of the hand, is enough to convey understanding. . . ." His friend Kandinsky found solace and inspiration in Madame Blavatsky's theosophical speculations about the universe, and in his abstract paintings, he tried to communicate cosmic signals and images.[26] Others voiced their despair more openly and often even crudely.

The expressionist poet Georg Heym wrote in 1910: "If only there were a war, even an unjust one. This peace is so rotten, oily, and filthy. . . ." And the composer Alban Berg hoped that "this intolerable horror and suffering" of the war that had just begun would "show a frivolous generation their utter emptiness. . . ." In 1915, he joined the army and then wrote: "The muck heap has been growing for decades. . . . If the war ended today, we should be back in the same old sordid squalor within two weeks. . . ."

The causes of this malaise in the intellectuals and artists can be traced

to the traditional dichotomy in the German mentality, extensively docu-
mented and passionately attacked in Hugo Ball's book *Zur Kritik der
deutschen Intelligenz* (A Critique of the German Intelligentsia),[27] in which
he accuses Martin Luther of having brought about the complete subordina-
tion of the individual to secular authority. Two spheres were established—
the political sphere of power and action and the sphere of thought, ethics,
and morals—and "harmony" was achieved by a tacit acceptance of the
total power of the state, of the mighty, and of submission to its dicta, right
or wrong, for the sake of order. Since Kant, Fichte, and Hegel strongly
advocated this dualism, they too became the *bêtes noires* of Ball and Huel-
senbeck and, eventually, of all German dadaists.

But a new and hot wind was blowing in the 1890s in Central Europe,
and again, Hugo Ball's life illustrates clearly the reaction of young intel-
lectuals at that time. Friedrich Nietzsche had become the leader of a new
and truly revolutionary movement or, more accurately, the spiritual leader
of many intellectuals and artists. It was Nietzsche who proclaimed in his
works the absolute necessity of overthrowing the ossified traditional values
of a complacent, smug, self-deceived society. Ball responded with awed
admiration and excitement, an excitement that he passed on to his younger
friend, Richard Huelsenbeck. They *now* wanted their voices to be heard.
This explains, of course, the title of the magazine *Revolution*, which was
planned, discussed, and outlined in 1912 and published in 1913, *before* the
war.

By the time the war broke out, in 1914, the ground was well prepared
because the young artists and intellectuals had already been "revolutionary"
in spirit for a long time. The prevailing attitude among them was that life
could not go on as before. A radical change, socially, culturally, and
spiritually, was envisaged by them, debated endlessly, written about, but—
and this is important to keep in mind—*not* acted upon by the vast majority.
They did not organize into revolutionary cells, they did not erect barricades;
they expected that others would do that for them. The political activists
among them were few, and they came into the open only *after* the war and
after the workers and sailors had started the real uprising. Some authors
imagine Huelsenbeck and other dadaists in the thick of the bloodiest street
fighting in Berlin. Not so. Their weapon was the pen.

But the suffering of the war brought to a head the irreconcilable contrast
between their quest for a new spirituality in life and the official pronounce-
ments and actions of the reigning monarch. Kaiser Wilhelm's friendship
with the house of Krupp, the munitions manufacturers, in particular,
seemed to epitomize all that was rotten in Germany. His visits to the Krupp

family and cannon factories were duly reported in the press and much gossiped about among the common people. Nothing documents more vividly the gulf that separated the outlook of the young intellectuals from the actions and machinations of their government, the Kaiser-Reich, than these lines from a letter Herr Gustav Krupp von Bohlen und Halbach, as he called himself, wrote to the Kaiser's Chief of the Secret Cabinet (Geheimes Zivilkabinett), Rudolf von Valentini: "In order to assure the dominance of German *Kultur* in Europe," he recommends, in complete accord with numerous politicians and military leaders, moving "the German-French border farther West, the military occupation of Belgium and of the French north coast," as well as the annexation of entire "provinces in Eastern Europe," and the conquest of "a very large colonial possession in Africa." He sums up with these memorable words: "Once these goals have been reached, *the progress of mankind will be determined by German Kultur and civilization.*"[28]

The last line of this appalling document (which also contains suggestions for uprooting entire populations in the East, anticipating Hitler!) matches the most lunatic, grandiose statements the "Oberdada" Baader was to make in his parodies a few years later. Parody and persiflage were indeed made easy by a power elite gone mad.

Other forces combined to create the widespread restiveness among the educated. A general lassitude, the *fin de siècle* mentality, characterized by a pessimistic outlook and by a marked preoccupation with psychopathology, with the morbid and "decadent" in art and literature, pervaded the European intelligentsia. Von Hartmann's and Schopenhauer's works stirred up interest in the unconscious and the irrational. Some intellectuals compared the encounter with Schopenhauer's ideas to a religious experience. The young Thomas Mann, suffering profound depressions, was to say later that his discovery of Schopenhauer's work was "an emotional experience of the highest order," which saved him and showed him the way. He emphasized "the symphonic musicality of Schopenhauer's system of ideas," which caused a "metaphysical ecstasy" in him.[29]

A neoromanticism in art and poetry had become fashionable in Austria, Germany, and France. Rilke's poetry is rich in the mysticism and symbolism characteristic of the neoromantic period. Alienation from society and resignation can be found in his verses, as in these lines:

Although, as from a prison walled with hate,
each from his own self labors to be free,

the world yet holds a wonder, and how great!:
All Life Is Lived. . . .[30]

In this atmosphere of spiritual surrender to vague mysticism, eroticism, to the "morbid and decadent," and to artistic forms of the past, Jugendstil in Germany and art nouveau in France did not seem satisfactory solutions. Only the fauves in Paris, the Brücke in Dresden, and the Blaue Reiter in Munich promised to show the way.

And to Ball and Huelsenbeck, Nietzsche's voice sounded like a cry to arms: ". . . *und wer ein Schöpfer sein will im Guten und Bösen, der muss ein Vernichter erst sein und Werthe zerbrechen. Also gehört das höchste Böse zur höchsten Güte: diese aber ist die schöpferische*"[31] (". . . and he who wants to be a creator for Good or Evil, must first be an annihilator and destroy values. Thus does the most Evil belong to the highest Good: this then is creativity").

So they set out to do away with the past and to find entirely new forms for expressing the human struggle "toward the attainment of a moral attitude in life." But new forms always by necessity contain elements of whatever went before. Huelsenbeck and Ball criticized the expressionist poets and painters for "overestimating soul or spirit, just as the rationalists overestimated reason." They were impatient with them for indulging in "mere self-expression." Huelsenbeck could ridicule "the Hillers,"[32] as he did in his article "The New Man," but Kurt Hiller had already attempted to go beyond the uninhibited rendition of elementary instinctual drives and to become an "activist." Kandinsky spoke of the creative impulse as originating out of "inner necessity." Bergson's philosophy emphasized the irrational intuitive aspects of mental functioning.

We are, therefore, not surprised to find in Huelsenbeck a lifelong fascination with creative irrationality: "We are all in the hands of an irrational structure, which we can't do anything about." He shared his friend Arp's feeling that man is confronted with elements with which his reason is unable to cope. Arp, who was always interested in the problems of chance, saw the artist's ultimate goal in keeping himself in a state of creative suspense.

I heard Huelsenbeck say that "spirituality is necessary to withstand the irrationality in life" and "Dada was close to the religious solution in life." This is an important statement if one is to understand *all* the diverse elements that went into the creation of the *Phantastische Gebete*; they were an attempt at an altogether new form of expression, a stream of consciousness, a provocative and challenging stance, shouting: "Now listen to me and my

real thoughts which have nothing in common with your repressed dull lives." They were dictated by a strong desire to shock, and Huelsenbeck intended to show those bourgeois philistines that he had the courage to create "out of an inner necessity," as Kandinsky had postulated for the artist. But the religious element is also present. It informs as well his "political" manifesto "The New Man," which reminds me far more of a prayer than of a political call to arms, and I find traces of that same spirit even in his poem "The Indian Ocean and the Very Red Sun," which repeats three times the words "Oh, hear my prayer."

But they certainly are "fantastic," these prayers with their bold and wild imagery. At the Cabaret Voltaire, Huelsenbeck was very fond of reciting the one he called "Flüsse" (Rivers):

> Aus den gefleckten Tuben strömen die Flüsse in die Schatten der leben-
> digen Bäume
> Papageien und Aasgeier fallen von den Zweigen immer auf den Grund
> Bastmatten sind die Wände des Himmels und aus den Wolken kommen
> die grossen Fallschirme der Magier
> Larven von Wolkenhaut haben sich die Türme vor die blendenden
> Augen gebunden
> O ihr Flüsse Unter der ponte dei sospiri fanget ihr auf Lungen und
> Lebern und abgeschnittene Hälse
> In der Hudsonbay aber flog die Sirene oder ein Vogel Greif oder ein
> Menschenweibchen von neuestem Typus
> mit eurer Hand greift ihr in die Taschen der Regierungsräte die voll
> sind von Pensionen allerhand gutem Willen und schönen Leber-
> würsten was haben wir alles getan vor euch wie haben wir alle
> gebetet vom Skorpionstich schwillet der Hintern den heiligen
> Sängern und Ben Abka der Hohepriester wälzt sich im Mist
> eure Adern sind blau rot grün und orangefarben wie die Gesichte der
> Ahnen die im Sonntagsanzuge am Bord der Altäre hocken
> Zylinderhüte riesige o aus Zinn und Messing machen ein himmlisches
> Konzert
> die Gestalten der Engel schweben um eueren Ausgang als der Wider-
> schein giftiger Blüten
> so formet ihr euere Glieder über den Horizont hinaus in den Kaskaden
> von seinem Schlafsofa stieg das indianische Meer die Ohren voll
> Watte gesteckt
> aus ihren Hütten kriechen die heissen Gewässer und schrein

Zelte haben sie gespannet von Morgen bis Abend über eurer Brunst und
Heere von Phonographen warten vor dem Gequäck eurer Lüste
ein Unglück ist geschehen in der Welt
die Brüste der Riesendame gingen in Flammen auf und ein Schlangen-
mensch gebar einen Rattenschwanz
Umba Umba die Neger purzeln aus den Hühnerställen und der Gischt
eueres Atems streift ihre Zehen
eine grosse Schlacht ging über euch hin und über den Schlaf eurer
Lippen
ein grosses Morden füllete euch aus

[From the spotted tubes the rivers pour into the shadows of the living
trees
parrots and carrion vultures fall from the branches and always land on
the ground
the walls of the sky are hassocks and the huge parachutes of the magi
emerge from the clouds
the towers have put masks of cloudskin on their dazzling eyes
O you rivers Beneath the bridge of sighs you catch lungs and livers and
slashed throats
but in Hudson Bay the siren was flying or a griffin or the newest type of
human female
your hands reach into the pockets of the privy councilors which are full
of all kinds of pensions good will and lovely liverwursts the things
we did before you how much we all prayed due to the scorpion bite
the bottoms of the sacred singers are swelling and Ben Abka the High
Priest is rolling in the muck and mire
your veins are blue red green and orange like the visions of the ances-
tors squatting on the edge of the altars in their sunday best
high hats gigantic o made of tin and brass create a heavenly concert
the shapes of the angels hover around your exit as the reflection of
venomous blossoms
thus you form your limbs beyond the horizon in the cascades the Indian
Ocean arose from its sofa bed its ears stuffed with cotton
the hot waters are creeping from their cabins and shrieking
they have pitched tents from morning to evening across your lusts and
armies of phonographs are waiting before the quacking of your
passions
a misfortune has befallen the world

the breasts of the giant lady went up in flames and a snakeman gave
 birth to a rattail
Umba umba the Negroes are somersaulting out of the chicken coops
 and the spray of your breath is grazing their toes
a great battle passed over you and over the sleep of your lips
a great slaughter filled you out]

Perhaps Huelsenbeck is right after all when he stresses the moral, ethical, philosophical, and broadly social aspects—at the expense of the political significance—of his role in dada. He wanted to bring about change, but, not being a politician, he did not know how to go about it. And to become a blind and faithful follower of a political dogma ran counter to his intellectual and emotional make-up. The spiritual vacuum that was keenly felt by many intellectuals and artists in Europe before World War I could understandably have led to the search for such an ideology as Marxism, but a man who sees the absurdity of life everywhere and at every step cannot possibly be a faithful believer of any dogma or be expected to mouth party slogans or to follow a political party line. Huelsenbeck chose to stand alone and go his own way while Ball withdrew, both spiritually and geographically. With his wife, Emmy, Ball went into his very isolated retreat in the mountains to reflect and write about the world he had left behind. What could be more revealing than the title of his most important book, *Flight Out of Time—Fuga saeculi? Fuga saeculi*—which is only half of a line starting with *De vanitate mundi*—About the vanity of the world.

Huelsenbeck, on the other hand, wanted to change society, and as he says, "There was a moment in Berlin when I would have accepted the help of the Devil to accomplish it, so why not the Communists?" But they wanted no part of a rambunctious writer who refused to take orders from anyone and who wrote as if he had never even heard of Marx and Engels. He seemed to have distinct social aims in mind but he was almost mystical about how he was to accomplish them and about what his "new man" was really supposed to be like. He seemed to be much clearer about what that new man of the future was *not* to be. He talked like a radical with anarchist notions in the arts, but he seemed most reluctant to accept a program such as Franz Jung and the Herzfelde brothers, Wieland and John, had to offer. Little wonder that Jung became increasingly impatient and irritated with him. Together with George Grosz, Jung and the two Herzfelde brothers were the true political activists of Berlin dada, and even Grosz was far too ambivalent toward the Communist party to be "reliable."

The much-cited manifesto of the Dadaist Revolutionary Central Council, which was first published in 1919 and then reprinted in *En avant dada* in 1920 under the authorship of Hausmann and Huelsenbeck, has caused much mischief. To some historians the manifesto seemed proof positive that these men were active and loyal Communists,[33] because its "program" invokes the help of the Communists. But in the same breath, the authors demand a dadaist sexual center "for the immediate systemization of all sexual relations" and call for "the immediate carrying out of a general Dadaist propaganda *in 150 circuses* for the enlightenment of the proletariat." Hausmann said later that he considered this obviously unserious document a mockery and a huge joke but that he was not so sure about Huelsenbeck, who did not seem to think it funny, but here Hausmann was simply implying how politically naïve Huelsendada was, even as late as 1919–20. John Elderfield is right with his comment that "despite the pretensions to Communism, this is no red manifesto . . . his call for Bolshevism in art was that of a moralist-cum-mischief-maker."[34] Exactly!

Huelsenbeck's introduction to his *Dada Almanach* of 1920 reveals the same freedom from any political dogma. Instead, it is full of his usual spirit, *élan*, excitement, and his own peculiar poetic eloquence. Since it is not available in English, here is an excerpt—four of its seven pages:

I.

One must be enough of a dadaist to be able to take a dadaist attitude toward one's own dadaism. The world has mountains and seas, houses, aqueducts, and railroads. In the pampas, the gauchos twirl out their long lassos, and in the Gulf of Naples, against a backdrop that has been painted, celebrated, and stereoscoped millions of times, the romantic old tub rocks a pair of German newlyweds into ponderous dreams. Dada has grasped all this. Dada has exploited the possibilities of physical motion to the utmost. People bring you all kinds of *Weltanschauung* and club statutes, the stylites of a late civilization stand erect with the splendor of a dogmatic facial convulsion: dada. Muhammadans, Zwinglians, Kantians—yak, yak, yak. Dada has let every *Weltanschauung* run through its fingertips, dada is the balletic spirit above the morals of the earth. Dada is the great parallel to the relativist philosophies of this era; dada is not an axiom; dada is a state of mind independent of schools and theories, involving the personality without raping it. You cannot pinpoint the principles of dada. The question: "What is dada?" is undadaistic and sophomoric in the same sense as it would

be in regard to a work of art or a phenomenon of life. You cannot comprehend dada, you have to experience it. Dada is immediate and self-evident. A person is a dadaist simply by living. Dada is the neutral point between content and form, female and male, matter and mind, because it is the apex of the magic triangle above the linear polarity of human objects and notions. Dada is the American aspect of Buddhism: it rages because it can hold its tongue; it acts because it is at rest. Thus, dada is neither a politics nor a style in art. It votes neither for humanity nor for barbarity; it "holds war and peace in its toga but prefers to have a cherry brandy flip." And yet, dada has its empirical character because it is one phenomenon among many. As the most direct and most vital expression of its time, it opposes everything that it considers obsolete, mummified, and stodgy. It stands out for a radicalism; it harangues, moans and groans, scoffs, and thrashes; it crystallizes in a point and spreads out over the endless plane; it is like the dayfly, and yet its siblings are the eternal colossi in the valley of the Nile. Anyone living for this day lives forever. This means that anyone who has lived the best of his time has lived for all time. Take, and give yourself over. Live and die.

II.

Ça y est, ma femme me fait mettre tout nu,
tout nu—tout comme le petit Jésus.
—CHANSON PARISIENNE

Thus, dada is also an activity, the most dangerous and most strenuous of all. Dada has chosen for its activity a cultural area, although it could just as easily have turned transatlantic businessman, stockbroker, or manager of a chain of movie houses. Dada did not choose its cultural area out of a sentimentality that puts "spiritual and intellectual values" on the highest rung in the traditional hierarchy of values. The great majority of dadaists experience *Kulchur* in their professions as writers, journalists, and artists. The dadaist is thoroughly familiar with the way "intellectual things" are made; he knows the confining situation of intellectual producers; he has been dining for years with the voluminously printed egghead prattlers and would-be prophets among the hack writers; he has observed the profoundest mysteries and the birth pangs of civilizations and morals. Dada disseminates a kind of anticulture propaganda, its motives are honesty, disgust, and deep

nausea at the superior airs of the tried and true intellectual bourgeois. Since dada is the movement, the experience, and the naïveté that sets great store on having common sense—viewing a table as a table and a plum as a plum—since dada is a nonrelationship to all things and therefore capable of relating to all things, *it opposes any ideology whatsoever*, i.e., any kind of warfare, any inhibition, any barrier. Since dada is inner elasticity and since it cannot understand how anyone could commit himself to anything—whether money or an idea—it serves as an example of a freedom of character totally devoid of claptrap. The dadaist is the freest human being on earth. The ideologist is any man who falls for the fraud perpetrated on him by his own intellect: that an idea, i.e., the symbol of a momentarily perceived reality, can possess absolute reality; or that you can manipulate a collection of notions like a set of dominoes. The ideologist is the man who makes a "firm *Weltanschauung*" of "freedom," "relativity," all in all the insight that the contour of every object shifts and that nothing is permanent; which is why nihilists are nearly always the most incredible and most narrow-minded dogmatists. Dada is a far cry from all this. For example, it opposes cultural ideology, which it regards as one of the greatest and most infamous lies in existence—and opposes it simply for the hell of it, out of cruelty, if you will, or perhaps coquettishness. The bourgeois, the well-fed carp, the horse trader, who buys art for twenty marks on Sundays so that during the week he can continue to profit from his criminal pelt-mongering, shall be murdered by dada, reduced to silence, and made harmless for all time.

This is Huelsenbeck in 1920. If he is serious about anything, then—as a true dadaist—he is serious about opposing "any ideology whatsoever." In this respect, I believe, he was living up to the dada spirit far more than his Berlin colleagues who used dada for their political ends. No wonder that Harry Graf Kessler,[35] who supported Wieland Herzfelde in his left-wing aims, was more than a little surprised and doubtful about the political effectiveness of most of the dada publications of Herzfelde's Malik-Verlag. But Huelsenbeck did not waver, because he remained convinced that ideology can exist only at the expense of a full life.

Walter Benjamin, philosophical essayist and art and literary critic extraordinary, was more perceptive than most when he wrote in 1935:

The history of every form of art comprises critical periods in which art aspires to produce effects that can be achieved only after a drastic

modification of the technical *status quo*, that is to say by a new form of art. This is why the seeming absurdities and extravagances that emerge in times of so-called decadence, far from being mere symptoms of decay, stem from what is most vital in the art forces of the period. This explains the "preposterous" manifestations of the Dadaists less than two decades ago. We can now see what they were aiming at; they were trying to produce in terms of painting (and literature) effects the public now asks of the cinema. . . .

And further on:

Whenever a radically new departure blazes a trail into the future, it tends to go beyond its stated program. So true was this of the Dadaists that, in pursuance of intentions of which . . . they were obviously unaware, they disregarded all the commercial values which have now come to bulk so large in the art of the motion picture. For they set far less store on the financial possibilities of their works than on the fact that they could not be treated as "objects of contemplation." One of the means they used with this in view was a systematic debasement of the *matière* employed. Thus their poems are often jumbles of words sprinkled with obscenities and every sort of verbal garbage. By the same token they stuck buttons and tickets on their pictures. Thus they deprived the works on which they imposed the stigmata of reproduction of any semblance of an "aura." Looking at a picture by Arp or reading one of Stramm's poems, we are not invited to linger and muse on it, as with a picture by Derain or a Rilke poem. For a decadent bourgeoisie this withdrawal into oneself had become a sort of antisocial gesture; with Dadaism, diversion from the self became a lesson in social comportment. . . .

Walter Benjamin concludes the paragraph with the line: "One requirement was foremost: to outrage the public."[36] Can the public still be outraged by artists and writers who—in the best dada spirit—challenge society's traditional values, mock cherished symbols, and attack venerated ideals? The artist-intellectual who defied society's conventions and was denounced as an outsider, "alien" to the sensibilities of the group, mobilized powerful ego forces within himself, having found a creative outlet for his aggression. But society has "turned around": it seems to have lost the ability to be shocked. It has actually ceased to be a target for scandal and outrage. It has come to accept and absorb everything the avant-garde has to offer. At

most, the reaction might be one of mild amusement. In such an atmosphere, the question arises whether the avant-garde serves any function at all at this point. There are indeed those who are convinced that the avant-garde has outlived its purpose.[37]

I do not share this belief. I see the situation in the field of art and literature today as a startling vindication of the dadaists' intuitive awareness that any dogmatic insistence on a specific style or any formalization of artistic goals would eventually lead to their total loss of vitality and meaning. Paradox triumphed indeed. In 1920 Huelsenbeck wrote an article entitled "Die dadaistische Bewegung" (The Dada Movement).[38] There never really was such a movement, only men of talent and intelligence imbued with the aggressive dada spirit. Dada has often been identified with the development of abstraction and nonobjective self-expression in art; but Huelsenbeck found abstract art not always to his liking and has over the years moved away from it more and more. He is not surprised that mere self-expression has had its day: he criticized it as an expressionist self-indulgence a long time ago and now finds it quite acceptable that "cool 'alienation' . . . has to fulfil the function which hot self-expression once filled."[39] There is a true dada paradox in a situation that forces the young artist to detach himself from society, to take refuge in a stance of alienation, attempting to escape being swallowed up by the overacceptance of that society.

Recent events and developments in the art world show that the dada spirit is very much alive. It is alive in artists who exhibit "concepts" or produce "happenings" rather than objects for the collector. There is a special irony in a system—supported by an affluent middle class—that celebrates artists who do their utmost to frustrate attempts at using art as a status symbol. Their modalities differ from those of the original dadas, but in their new modes of expression they do again what Walter Benjamin recognized as dada's rejection of the art object as a thing of commercial value. They have "subverted" the role of art from a durable experiential statement to a fleeting gesture or a violent yet perishable action. Impermanence seems to dominate much of today's artistic endeavors. It is easy to see how tempting it might be to misinterpret these violent acts of creative turmoil as the expression of self-destructive tendencies. Alvarez has done just that in the case of dada's iconoclasm. But the aggressive impulse is directed outward in these dramatizations of inner conflict and not against the self.

The part played by dada, and by Huelsenbeck's writings in particular, in

the development of some of the most spectacular directions of today's avant-garde is documented in publications and pronouncements by prominent young artists. Wolf Vostell points directly to dada as precursor of his happenings and décollages and singles out Huelsenbeck's work as one of the "decisive influences" in the principles that motivate his décollage-ideas and "Aktionen." He forces the onlooker to become involved, to participate in an action designed to dramatize absurd and ludicrous aspects of life, and thus to invite "the public to reflect and to react."[40]

As Huelsenbeck says: "A work of art conducts a creative dialogue with the onlooker. It has, in fact, as many originators as onlookers. Tinguely's painting machine dramatizes this fact at the time that it represents a threat against the creative principle. In its expression of the creative and destructive principles in the self at one and the same time, it is the best possible example of the psychoanalytical implications of modern art. . . ."[41]

Richard Huelsenbeck—poet, playwright, novelist, essayist, journalist, physician, psychiatrist, lecturer, existentialist—has always remained his own man, bowing to no one, but imbued with a spirit once expressed by Auden:

> Beleaguered by . . . negation and despair,
> Show an affirming flame.

Notes

1 Huelsenbeck gave his talk "Dada oder der Sinn im Chaos" (Dada, or Meaning in Chaos) at the Goethe House in New York on November 18, 1970. This title was first used by him for the introduction to a book he edited in 1964, *Dada—Eine literarische Dokumentation*. An edited text of a talk given by him at the Institute of Contemporary Arts, London, on October 1, 1971, entitled "Dada, or the meaning of chaos; Richard Huelsenbeck reports on his life," has been published in the January 1972 issue of *Studio International*, no. 940, pp. 26–29.
2 From the Greek καλός καὶ ἀγαθός, "beautiful and good."
3 Kathi Kobus's famous Simplizissimus was a bar and night club, known among its many patrons affectionately as the "Simple."
4 Cf. S. Tarachow, "Remarks on the Comic Process and Beauty," *Psychoanalytic Quarterly*, vol. 18 (1949), p. 215.
5 Described by Hans Bolliger, *Dokumentation—Kunst und Literatur des 20. Jahrhunderts*. Katalog 2 (Zurich, 1971), no. 865.
6 *Hugo Ball Briefe 1911–1927*, ed. Annemarie Schütt-Hennings (Einsiedeln: 1957), Benziger Verlag, pp. 277–78. Italics added.
7 Franz Lennartz, *Deutsche Dichter und Schriftsteller unserer Zeit*. 10th ed. (Stuttgart: Kröner Verlag, 1969), pp. 336–39.

8 Kasimir Edschmid, *Lebendiger Expressionismus: Auseinandersetzungen, Gestalten, Erinnerungen* [Living Expressionism. Dialectics, Personalities, Memories], Ullstein Bücher #465 (Berlin: 1964), p. 13.

9 Ibid., p. 26.

10 Mary Ann Caws, *The Poetry of Dada and Surrealism: Aragon, Breton, Tzara, Eluard and Desnos* (Princeton: Princeton University Press, 1970).

11 Anna Balakian, *André Breton: Magus of Surrealism* (New York: Oxford University Press, 1971), p. 51.

12 Henry F. Ellenberger, *The Discovery of the Unconscious* (New York: Basic Books, 1970), p. 880, n. 345: "As to Jung, he is reported to have said of Dadaist productions, 'It's too idiotic to be schizophrenic.'" Nevertheless, Carl Gustav Jung, the pioneer in psychology, has occasionally been mistaken for Franz Jung, the aggressive Berlin dadaist, writer, and political adventurer. See: *Fantastic Art, Dada, Surrealism*, ed. Alfred H. Barr, Jr., essays by Georges Hugnet. 3d ed. (New York: The Museum of Modern Art, 1946), pp. 23 and 270.

13 Michel Sanouillet, *Dada à Paris* (Paris: Jean-Jacques Pauvert Editeur, 1965), pp. 17–45. Also in a handsomely illustrated Italian edition, in *L'Arte Moderna* (Milan: Fratelli Fabbri Editori, 1967): vol. 19, *Le Origini del Dada: Zurigo, New York*, pp. 81–120; and vol. 20, *Il Dada in Germania e a Parigi: Diffusione del Dadaismo*, pp. 121–60.

14 In a letter dated August 4, 1935, Kandinsky describes "my first ["allererstes"] abstract painting made in 1911, which happens to be the very first abstract painting made in our time." And again, on December 28, 1935: "It is indeed the very first abstract painting *in the world*, since no artist painted nonobjective paintings at that time. It is therefore 'a historic picture.'" Quoted in Hans J. Kleinschmidt, "The Angry Act: The Role of Aggression in Creativity," *American Imago*, vol. 24, no. 1 and 2 (1967), pp. 105–106.

15 Raoul Hausmann, *Am Anfang war Dada* (Steinbach/Giessen: Anabas-Verlag Günter Kämpf, 1972), pp. 39–42.

16 Richard Huelsenbeck, "Dada als Literatur," in *Dada* (exhibition catalogue; Amsterdam: Stedelijk Museum, 1958).

17 In this connection, see Leonard Forster, "Poetry of Significant Nonsense," *Revue de l'Association pour l'Etude du Mouvement Dada*, no. 1 (October 1965), pp. 26–27.

18 Sigmund Freud, *Jokes and their Relation to the Unconscious* (1905). The Standard Edition, vol. 8 (London: The Hogarth Press, 1960), p. 126.

19 The 1918 dada manifesto was authored by Huelsenbeck and co-signed by Tzara, Franz Jung, George Grosz, Marcel Janco, Gerhard Preisz, and Raoul Hausmann. Furthermore, it was endorsed by Hugo Ball, Prampolini, Hans Arp, and others.

20 Among them Hugnet and—most recently—Lucy R. Lippard in *Dadas on Art* (Englewood Cliffs, N.J.: Prentice-Hall, 1971), p. 45. See *Memoirs of a Dada Drummer*, p. 52 and corresponding note. Actually, Huelsenbeck himself, in characteristic dada spirit, had started the "rumor" that he had been appointed "Commissar of Fine Arts of the Revolutionary Council."

21 Ernst Kris, *Psychoanalytic Explorations in Art* (New York: International Universities Press, 1952), pp. 57 and 62.

22 Sigmund Freud, *Civilization and its Discontents* (1930). The Standard Edition, vol. 21 (London: The Hogarth Press, 1961), pp. 64–145. See, for example, p. 112: "civilized society is perpetually threatened with disintegration. . . . Civilization has to use its utmost efforts in order to set limits to man's aggres-

sive instincts and to hold the manifestations of them in check by physical reaction-formations. Hence, therefore, the use of methods intended to incite people into identifications and aim-inhibited relationships of love . . ."

23 In this concern with new possibilities and revolutionary innovations, the avant-garde artist-intellectual may, of course, become as doctrinaire and prescriptive as the academic world and bourgeois institutions against which he rebels. Thus he exchanges his very own new dogma for the established one. The dadaists were aware of this trap and tried to steer clear of it. Huelsenbeck attacks and rejects expressionism as infatuated with mere self-expression, and makes an impassioned plea for the dada spirit in art, for social and aesthetic critique. But the last line in the 1918 manifesto (see n. 19) sounds a cautionary note: "To be against this manifesto means to be a Dadaist!"

24 Emmy Ball-Hennings died in 1948. The date 1953 refers to the year her article "Der Dadaismus" was published in *Ruf und Echo. Mein Leben mit Hugo Ball*, ed. Annemarie Schütt-Hennings (Einsiedeln, Köln: Benziger Verlag, 1953).

25 A. Alvarez, *The Savage God. A Study of Suicide.* (London: Weidenfeld and Nicolson, 1971), p. 189; (New York: Random House, 1972), p. 228.

26 See the fascinating work by Sixten Ringbom, *The Sounding Cosmos: A Study in the Spiritualism of Kandinsky and the Genesis of Abstract Painting* (Abo: Abo Akademi, 1970). Also Rose-Carol Washton Long's article, "Kandinsky and Abstraction: The Role of the Hidden Image," *Artform*, June 1972, pp. 42–49. In addition to Kandinsky's own account in *Concerning the Spiritual in Art* (English version, New York: Wittenborn, Schultz, 1947), Johannes Eichner's book *Kandinsky und Gabriele Münter: Von Ursprüngen moderner Kunst* (Munich: Bruckmann, 1957), sheds a great deal of light on Kandinsky's state of mind.

27 Hugo Ball, *Zur Kritik der deutschen Intelligenz* (Bern: Der Freie Verlag, 1919). Ball intended in the somewhat ambiguous title a reference to the German mentality as well as to the German intelligentsia. The book is dedicated to "the leaders of the moral revolution," thus bearing out Huelsenbeck's claim that a moral revolution and not political subversion had been their aim all along.

28 See Willi A. Boelcke, ed., *Krupp und die Hohenzollern in Dokumenten* (Frankfurt: Akademische Verlagsgesellschaft Athenaion, 1971). Italics added.

29 Thomas Mann, *A Sketch of My Life* (New York: Alfred A. Knopf, 1960).

30 "Und doch, obwohl ein jeder von sich strebt
wie aus dem Kerker, der ihn hasst und hält,—
es ist ein grosses Wunder in der Welt:
ich fühle: ALLES LEBEN WIRD GELEBT. . . ."
From Rainer Maria Rilke, *Das Stundenbuch* (*The Book of Hours*), trans. Babette Deutsch (Norfolk, Conn.: New Directions, 1941), p. 39.

31 From *Ecce Homo* (Leipzig: Insel Verlag, 1908), p. 117.

32 Kurt Hiller (1885–1972)—Berlin writer and political activist. Particularly prominent in expressionist literary circles in Berlin before and immediately after World War I. See his piece "Begegnungen mit 'Expressionisten,'" in Paul Raabe, ed., *Expressionismus: Aufzeichnungen und Erinnerungen der Zeitgenossen* (Olten and Freiburg: Walter Verlag, 1965), pp. 24–35.

33 So, for instance, William S. Rubin in his otherwise informative and lavishly illustrated book *Dada and Surrealist Art* (New York: Harry N. Abrams, [1969]), p. 10. This factual error is all the more surprising since Huelsenbeck, still living in New York at the time of Rubin's writing, was not consulted about this rather relevant personal question. Rubin's misinterpretation of the Haus-

mann-Huelsenbeck manifestoes as Communist propaganda rather than as typically antiauthoritarian exercises of youthful intellectual anarchists is equally astonishing. Less surprising should be Paul Vogt's remark about the "draft dodgers who had detached themselves from the greatness of heroic times" in his book *Geschichte der deutschen Malerei im 20. Jahrhundert* (Cologne: Verlag M. DuMont Schauberg, 1972), p. 202. The nonconformist dada spirit must remain anathema to the nationalist!

34 John Elderfield, "Dissenting ideologies and the German Revolution," *Studio International*, no. 927 (November 1970), pp. 180–87.

35 Harry Graf Kessler, *Tagebücher 1918–1937* (Frankfurt: Insel Verlag, 1961). Politics, art, and society in the twenties. Translation: *In the Twenties: The Diaries of Harry Kessler*, introd. by Otto Friedrich, trans. Charles Kessler (New York, Chicago, San Francisco: Holt, Rinehart, & Winston; London: Weidenfeld and Nicolson, 1971).

36 In *Dimensions of the 20th Century: 1900–1945*, by Robert L. Delevoy, trans. Stuart Gilbert (Geneva: Skira, 1965), p. 148. The lines by Walter Benjamin, Marxist philosopher, essayist, and literary critic, are from his essay "The Work of Art in the Age of Mechanical Reproduction," which appeared in a collection of his "essays and reflections" under the title *Illuminations*, ed. Hannah Arendt (New York: Schocken Books, 1969). But Harry Zohn's translation appeals to me less than Stuart Gilbert's. A comparison of the two English renditions of the same passage (pp. 237 and 238 in the Schocken book) illustrates the difficulties of "The Task of the Translator," another famous piece by Walter Benjamin to be found in the same edition and beautifully translated by the same Harry Zohn.

37 Hilton Kramer, "The Rise and Fall of the Avant-Garde," *Commentary*, vol. 54, no. 4 (October 1972), pp. 37–44.

38 Richard Huelsenbeck, "Die dadaistische Bewegung. Selbst-biographie," *Die Neue Rundschau*, 8, August 1920, pp. 972–79.

39 Anton Ehrenzweig, *The Hidden Order of Art* (London: Weidenfeld and Nicolson; Berkeley and Los Angeles: University of California Press, 1967), p. 143.

40 Jürgen Claus, *Kunst heute. Personen, Analysen, Dokumente* (Reinbek bei Hamburg: Rowohlt Taschenbuch, 1965), pp. 112 and 210; and *Happenings-Fluxus, Pop Art, Nouveau Réalisme*, ed. Jürgen Becker and Wolf Vostell (Reinbek bei Hamburg: Rowohlt Taschenbuch, 1968), p. 403.

41 Charles R. Hulbeck, "Psychoanalytical Notes on Modern Art," *The American Journal of Psychoanalysis*, vol. 20, no. 2 (1960), p. 173. For text, see pp. 149–61.

Memoirs
of a Dada Drummer

The Dada Drummer

I

During 1914, I lived in Berlin, in the rear wing of a building in the Uhland-strasse, and day in and day out, my nostrils were filled with a horsy smell from a Tattersall's.* Later, I moved to the Berliner Strasse, where a fine widow and her daughter took care of me, both of them marveling at my carryings-on. I was supposed to be studying, but I never studied. I stayed up all night and slept all day. I behaved like a vagabond without really wanting to be one. Sometimes I would read twelve hours straight or jot down some poems, which I brought to my girl friend R. L., a *diseuse*. Her boy friend Stadler[1] ** had just been killed in action. She had been involved with Rudolf Leonhard[2] and was about to break off with Alfred Richard Meyer,[3] by whom she had had a son.

She frequently traveled out to active combat areas, on both the western and the eastern fronts, to entertain the troops with recitals of Morgenstern and Busch.[4] She provided them with a recreation period in between their butchering and being butchered, a serious business that easily tires people. The highest echelon thought that Morgenstern might improve matters, and indeed he did. R. L. told me how grateful the soldiers were for her recitals and for Trude Hesterberg's and Claire Waldoff's.[5]

* A riding academy in Berlin.—ED.
** Numbers refer to the Notes which start on p. 90.

I had been seeing a good deal of Hugo Ball, but one day he vanished. Although a civilian, he had hopped on an army train, and the soldiers had cheerfully let him ride along. In Liège, he was taken out and arrested, but when they realized that he was an idealist and not a spy, they sent him back home. He returned to Berlin and worked for various magazines. He also wrote plays and novels, primarily the former. R. L. knew him, too, and was very fond of him, in fact at one point she didn't know whom she liked more, Hugo or me.

The dilemma was solved when Hugo left us one day. I didn't know where he was, but then I received a postcard from Zurich.

When people like Ball and me get together, it doesn't matter where they come from, what their fathers do, or whether their mothers dye their hair brown or blond. For years on end, I lived, worked, wrote, and recited with Ball, and I didn't know where he had been born or how old he was. I didn't even know his nationality. Naturally he was German, we took that for granted; but we were totally unconcerned about race, nationality, or religion.

It was only gradually and almost reluctantly that I learned more about Ball. I heard that he came from the Palatine, and later on I read in Emmy Hennings's memoirs that his father was a leather merchant, and that Ball had been a gifted student. We never spoke about our backgrounds, we never spoke about our gifts. We would spend our evenings in small taverns, drinking beer and talking about literary goals. Ball was an indefatigable smoker and coffee drinker, but he rarely touched alcohol. I never saw him plastered. He spoke in a quiet, clear voice, and he often had an ironic smile on his face. He was tall, his hair was black, and his complexion bad. He was obviously poor; he could never spend much money, and he lived in very modest rooms. He was quite unconcerned about his wardrobe; and since I wasn't very clothes conscious either, I can't say whether he owned one or two or three suits.

He always leaned slightly as he walked, his head bent as if he were listening to something and as if it seemed important not to miss the least word spoken by whomever he was with.

At the time, Ball was very interested in the theater, and when I met him in Munich, he had the position of stage manager at Ida Roland's Kammerspiele. We talked a lot about theater, and he always dwelt on his enormous interest in it. The stage was his world, at least in those days in Munich and subsequently in Berlin. He was friendly with a number of actresses, but I can recall the name of only one of them, Lola Sernau. We were intro-

duced; later she married the Swiss writer Dr. Humm, and now she lives in Ascona in an old-fashioned house.

When I met Ball, he was anything but religious and never spoke about Catholicism, which subsequently played such a great part in his life that he left all his unpublished writings in trust with a monk. A huge portion of the valuable manuscripts (which contradicted the principles of the church) were thus destroyed. I was unaware of all this; but when Ball died, I wrote an article about him in Rovereto, in the Ticino, for the *Berliner Tageblatt*, only to receive an irate letter from Emmy Hennings. She claimed that I had no right to call attention to Hugo's posthumous works; they were solely the church's concern.

About a year ago, a young man from San Francisco came to see me in New York. He was doing a doctoral dissertation on Hugo Ball. Proudly, he placed a heavy typewritten manuscript on the table. He wanted to hear further details of Ball's life during the dada period, hoping to make use of them in a second volume.

The young man told me he was going to Switzerland to hunt for a copious journal that had to be somewhere in the estate. He claimed it was a major work and that *Flucht aus der Zeit* (Ball's famous portrayal of his own life) was merely an excerpt.[6]

I never heard from the young man again. Presumably, the situation is exactly as my friend Bondy[7] in Zurich described it. Emmy Hennings made sure that Ball's will stipulated that any material containing even the slightest utterance against the church was to be destroyed in due time.

After Hugo left Berlin, an increasing tension developed between myself and R. L. Berlin and the German world were unbearable for me. My relationship to Ball was much more important than I had been willing to admit to myself. In him, I had met an unusual person, who encouraged everything of value in my personality. He had a reckless imagination that subsequently expressed itself in dada, the free, fantastic roaming you find in his sound-poems, his novel "Hotel Metaphysik," and in my *Phantastische Gebete* [Fantastic Prayers]. He coupled a whole world of critical reflection with a superior education. Ball's attitude toward Germany, his attitude toward the social order, his hatred for the "bourgeois" around us and within us, were all nascent within me and waiting to see the daylight.

I felt that I would never be able to exist without Ball. Or rather, that my literary and personal development would be disastrously interrupted without Ball's help. So I made up my mind to leave both Berlin and R. L., although she gave me everything that a woman can give a man—love, warmth, and

charity. She embodied the feminine blend that I have always looked for but seldom found, mother and mistress, beloved and madonna.

Ball wrote me detailed letters about Switzerland and his activities. It was 1916, the year that Swiss soldiers were guarding the border to prevent any "incidents" and to make sure, with the help of arms, that none of the belligerent powers would work up an appetite for Switzerland. The Swiss are a valiant nation, and even Hitler, who never shrank from any violence, was forced to realize that the conquest of Switzerland was not worth the risk.

Thus I heard about the Cabaret Voltaire for the first time. Ball and Hennings had opened a cabaret in the old part of town. The exact address was Spiegelgasse 1. The century-old building belonged to a Dutch sailor who had now berthed in Zurich.

The idea of starting a cabaret seemed logical since Emmy was a *diseuse* and Ball an excellent pianist. He accompanied Emmy's songs but he also performed as an improvisator, half-classical, half-modern, to the joy of the naïve audience.

Ball characteristically dubbed his cabaret "Voltaire." Voltaire, who, as we know, was one of the most violent opponents of the Catholic church, had already fascinated Ball in Berlin. Ball, like all of us, was an "enlightener," a liberal, who expected the salvation of mankind to come from the mind and the intelligence rather than from metaphysics. This attitude, which was also expressed in his interest in Landauer,[8] Bakunin, and Kropotkin, subsequently changed under the influence of Emmy Hennings. He then "returned to God," as she triumphantly puts it in her book *Hugo Balls Weg zu Gott* [Hugo Ball's Road to God].

The Balls came to Zurich without a cent and left their fate to chance. They had nothing to eat and sat on the shores of Lake Zurich, envying the well-fed swans for their feed. Since Ball did not have a valid passport, he was arrested by the police but released after a short time. All his efforts at finding a job and earning money were to no avail.

Ball had taken it into his head to be a waiter since he owned a black suit and a white shirt. But one day, while sitting with Emmy on a bench at the lake, he suddenly became hysterical, and just as he was about to throw the package containing the suit into the water, it burst open. The suit and the shirt fell into the clay and the sand. This accident spelled the end of his dream of being a waiter, and Emmy thought it might be better to sell the piece of clothing that had never proved lucky for them.

Chance, which played such an amazing part in the founding of dada, now began to guide the existence of these two unusual people. Emmy went

to Niederdorf, the oldest part of town, and entered one of the many seedy music halls to talk to the owner about selling the suit to a waiter or a performer. Instead, she was asked whether she sang. The interview ended with her being hired. Ball was to be her pianist, and so the period of famine was over.

The idea of the Cabaret Voltaire grew out of literary thoughts as well as the slum atmosphere of the music-hall performers, the singers, the magicians, fire-eaters, and others portrayed by Ball in his novel *Fiametti*.

Meanwhile, Ball continued his studies, spending the tiny sums he earned on books and more books. It was during this period that he developed a passion for Léon Bloy, whom he told me about when I arrived in Zurich. We discussed this religious writer at length. Poverty interested Ball as a sociological and political problem, although he never concealed his opposition to Marxism. Ball must have done his preliminary studies for his book *Zur Kritik der deutschen Intelligenz* [A Critique of the German Intelligentsia] in those days when, spurred on by the war, he was shaken by his love-hate for Germany.

Now my destiny, too, took shape, and I resolved to go to Ball and join the Cabaret Voltaire. I didn't dare tell R. L. about my plans; I ran away a few times, she came running after me, and I finally told her I was going to my parents in Dortmund. This decision was all the more difficult because of another woman in my life, I. V., a Hungarian, who had a tremendous power over me. She was very attractive, very willful, and so temperamental that I often avoided her on the street because I dreaded her anger. I was very young, and my personality was still so weak that I could never develop any resistance against this older woman. I was so sophomorically in love with her that I often couldn't sleep at night; and I howled like a dog at her door, waiting to be let in.

But Ball's personality was stronger. One day, I boarded a train and traveled home to tell my parents about my projects. My father had been very sick, and a doctor had explained that he was suffering from cirrhosis of the liver, a disease that would slowly but surely lead to his death. My father, however, reached the ripe old age of ninety-two, and the doctor died long before he did.

I told my parents I wanted to leave Germany and study medicine in Zurich. They knew nothing about Ball and the Cabaret Voltaire. And how could I have explained it to them? After everything else that had happened, I couldn't talk to them about a regular course of studies; my parents were comforted, however, by the thought of my being outside Germany,

which was then at war. I could be drafted almost any day. Now and then, we would hear about friends who had died in action, and a stoic resignation had taken hold of Germany's parents. They now saw through the official web of lies that depicted Germany as the invincible stronghold of Siegfried. The triumphal melody in newspapers had given way to the monotony of bleak promises. If Germany would only hold out . . . , if we only didn't lose heart . . . , if we only put up with turnips and artificial honey for just a little longer . . . everything would turn out for the best.

"If you feel you have to go to Zurich," said my father, "then go. Do whatever you like, but do it well."

His main quality was tenacity, German tenacity, physically, spiritually, and morally. Whoever strives for goodness, he thought, will attain it.

My mother was more skeptical. My sister's fiancé was stationed near Verdun, and his postcards from up front hinted at what was going on there.

By day, the German soldiers lay in their trenches playing cards; at night, munitions were conveyed along roads that lay under steady fire. Verdun was besieged for months on end; the French knew every nook and cranny of every road leading to the stronghold, and they knew exactly where to aim their shots. At the very last minute, shortly before the armistice, my brother-in-law to be was nearly torn to bits by a grenade while he was posted in a tree as a lookout.

"It was like a great wind," he said, "a howling that turned into a screaming. The howling came from the projectile, and the screams, I realized next, came from the wounded. They were lying around all over the place, with arms and legs ripped off and stomachs split open, and the chaplains sniffing around them with their crucifixes so that they wouldn't go to heaven without the blessings of the church. . . ."

My mother was like all other mothers and all other women; but she was also intellectual. Her father had taught her never to take all words and all deeds at face value. She understood the deeper meaning. She forgave easily, she pardoned even more easily, and so she was easy prey to intrigues and malice. She nearly died at my birth; my father at that time was a druggist in the small town of Frankenau. She often told me about the God-forsaken desolation of the place, the poverty of the farmers, who paid with eggs and chickens instead of money, and the ignorance of the midwife and the doctor.

She was glad to let me go to Zurich since she valued my life more highly than my profession. She had full confidence in my capabilities, and she sometimes would say: "Something will come of it." But when she received

my *Phantastische Gebete* later on, she burst out crying. The book was way beyond her.

Armed with a certificate from my friend Dr. Klapper, I screwed up my courage to go to the draft board. Berlin 1916. Day after day, we could see the draftees, accompanied by their wives, children, or sweethearts, carrying cardboard boxes through the streets. The men who hadn't been drafted glanced about shy and abashed. So did the old people, who said they no longer understood the world.

On General-Pape-Strasse (then known as "General-Pappkarton-Strasse," *Pappkarton* being German for "cardboard box"), I finally found the military official whose permission I needed to march off to Switzerland. He gazed at me with vacant eyes while sucking on a cigar butt. Why did I want to go to Switzerland? To rest and also to study . . . ? Who can rest, and who can study . . . ? His myopic eyes glanced at the piece of paper on which powerful words described my mental exhaustion. He was obviously used to seeing quite a number of certificates, and this one didn't seem to impress him especially.

And then it happened—one of the many miracles of chance that have so often determined the course of my life. I have frequently said that my joining dada was a crucial, perhaps the most crucial, event that influenced the course of my life. If I hadn't succeeded in getting out of Germany then, I wouldn't have helped to found dada along with Ball, Tzara, and Arp— and my life would have been completely different, perhaps quite unremarkable.

And then it happened. The man was called away. He stood up, buttoned his jacket, put the cigar on a chipped porcelain plate, and left without saying a word. A quarter of an hour elapsed, half an hour, a whole hour. No one came. Then a man emerged from another door and asked me what I wanted. I explained the whole business again and held up the certificate right in front of him.

"How long do you want to stay?" he asked, adding that permission was granted only in rare cases. I whittled the time down to three months, although a semester lasted six months. But I had already made up my mind never to return. Three months or six or twenty meant nothing to me. I had to get out forever, come what might. The red-tape atmosphere, from which the murderous disaster rises innocently, then huger and huger like a storm wind, collapsed upon me, my heart began to hurt as if I had sat up all night drinking coffee and smoking. I could barely pronounce the words as I said: "Not more than three months . . ."

I could see that the man was good-natured, and I felt that he wanted to help me. I have often run across a good-natured official. It is a matter of psychological intelligence to give him the chance to be nice.

In the end, I received permission for a six-month stay. The man had a brother-in-law in Switzerland, he gave me the address and told me to look him up and tell him a "little about Germany." I could see that he was in no way satisfied with the "situation." We shook hands, and as I was leaving, he made one more comment that I have often thought about. He said something like "Don't overshoot the mark. . . ." Did he realize what was going on inside of me? Did he sense it?

Was Zurich a city in which one might overshoot the mark? I loved Zurich from the very first moment and have loved it ever since. It seemed bright, clear, and cheerful, although I did spend a number of gloomy days there. Later on, I heard many complaints about the weather and the temperature. People wailed about the *Föhn*, that warm, dry Alpine wind that supposedly causes suicide, migraine, and swellings. A woman I know even claimed that the *Föhn* will increase your size by 17 percent. But in those days, changes in the weather had no effect on me. It was only in America that I learned otherwise.

At the time, Zurich was still an unhurried city; there was no traffic problem, there were no cafeterias or Mövenpicks.* I found the people down to earth, easygoing, but not inflexible. Their patriotism (which included a strong rejection of Germany) was always keen and often assumed grotesque forms. The city is constructed within a medieval framework against the lake, although the Bahnhofstrasse, the avenue along the railroad terminal, leaves nothing to be desired in the way of modernity. Zwingli's cathedral and the maze of little streets in Niederdorf always reminded me of a good, pious past.

I arrived toward evening and asked how to get to the Spiegelgasse. Recently, when I came to Zurich once again, I followed the very same route. Most of the houses are still there, a few have been improved and modernized, although keeping the medieval touch that eludes the years and breathes history.

I still have a clear memory of the evening on which I entered the Cabaret Voltaire for the first time. I stepped into the premises, which Ball had rented from an old Dutch seaman, Jan Ephraim, and which he and Emmy

* A restaurant chain.—Ed.

had transformed into a combination artists' club, exhibition hall, pub, and cabaret. Mynheer Ephraim, who looked sunburned at the time and subsequently died of jaundice, told me about his seafaring days that evening, but when I recited some Negro poems that I had made up myself, he motioned for me to join him outside.

"They sound very good," he said, "but unfortunately they're not Negro poems. I spent a good part of my life among Negroes, and the songs they sing are very different from the ones you just recited." He was one of those people who take things literally, and retain them verbatim. My Negro poems all ended with the refrain "Umba, umba," which I roared and spouted over and over again into the audience.

But when we sat down together on one of the wooden benches that lined the walls of the main room, I was impressed by the seaman's well-meaning ways. I asked him about his experiences, and he narrated a long yarn, which I have since forgotten. I told Ball about our conversation. He knew my Negro poems from the Berlin "expressionist evening," where I had caused a great sensation.

"Perhaps," he said, "it might be interesting to recite something authentic."

So I asked the Dutchman for advice, and a few days later he came to me with a sheet of paper on which he had scribbled the following:

Trabadya La Modjere
Magamore Magagere
Trabadja Bono

I read the lines through slowly while Ephraim sat there smiling, and I ended up liking them. I went to the cabaret to see Hugo. Whenever someone opened the door, thick clouds of smoke would come pouring out like the smoke that hovers over fields during the burning of the harvest leavings. A caustic, cindery smell wafted through the corridor. The Zurich students would bring their long pipes with them from the restaurant. This was their way of irritating the bourgeois. They would sit at round tables with their feet up on the boards.

I recited my new "authentic" Negro poems, and the audience thought they were wonderful. Naturally, no force on earth could have gotten me to leave out the "Umba" at the end of every verse, although my Dutchman shook his head disapprovingly. He wanted everything to be "authentic," literal, factual, just as he had heard it in Africa and the South Seas.

That first evening, as I entered the cabaret after my fateful trip from Germany, Hugo was sitting at the piano, playing classical music, Brahms

and Bach. Then he switched over to dance music. The drunken students pushed their chairs aside and began spinning around. There were almost no women in the cabaret. It was too wild, too smoky, too way out.

Hugo had written a poem against war and murderous insanity. Emmy recited it, Hugo accompanied her on the piano, and the audience chimed in, with a growl, murdering the poem. During this period, I saw Tzara for the first time (a little man with a monocle), as well as his friend Janco[9] and Janco's brothers. Plus René Schickele,[10] Werfel,[11] and J. C. Heer, a Swiss poet celebrating his native soil (the mountains weighed down his heart).

The furnishings of the cabaret were inconceivably primitive. Emmy, on whose success or failure as a singer the existence of the cabaret hinged, had no dressing room. She would change behind a trestle over which a canvas was stretched with holes as big as your fist. There was little of the prima donna about Emmy, but she delighted in showing me the different costumes that belonged to the different numbers. These songs, known only in Central Europe, poke fun at politics, literature, human behavior, or anything else that people will understand. The songs are impudent but never insulting. There is no intention of hurting anyone, only the desire to express an opinion. Sometimes they are erotic, treating old farce themes such as the cuckold or the ignorance of the bride on her wedding night. The intellectual level is low but not unpleasantly so. Usually, they subsist on refrains and popular music, but Ball made up the melody for every song he wrote.

The songs created the "intimate" atmosphere of the cabaret. The audience liked listening to them, the distance between us and the enemy grew smaller, and finally everyone joined in. The students rocked on their chairs, and the Dutchman, our landlord, stood in the doorway, swaying to and fro. As we stepped out into the Spiegelgasse at one A.M., Ball asked me where I was living. Nowhere. I had to admit that I hadn't given room or board a second thought. The necessity of letting the old Adam function played no part whatsoever in my philosophy. I would have slept on park benches. I would have lived on dry bread. I felt strong, young, and healthy.

A certain blindness is necessary if you want to accomplish something unusual. You have to "make your way through the world," you cannot stop for details. What you need is the closeness of like-minded friends. And that's what we had in Zurich, and there was no other way for dada to develop. There were no conflicts among us; we had all left our native lands, we all hated war, we all wanted to accomplish something in the arts. I really feel that dada grew out of friendship, congenial love and congenial hate. From the very beginning, dada was different from the philosophy being

spread by Brecht, Becher,[12] and other poet-politicians. The times had shown that the idea that only the prosperous live comfortably was working well for its authors but not so well for those to whom prosperity had only been promised. We never promised anybody anything; we looked for something indefinable, the essence, the meaning, the structure of a new life. And so we became dadaists.

"I can put you up in my old room," said Ball, and he took me through a maze of angular streets, opened an old wooden door, and climbed up an ancient groaning stairway. I found myself alone in a garret. Below me, Zurich lay asleep, not a puff of air was stirring, and the red sickle of the moon hung over me.

The next day I ambled through Zurich. I paused at Bellevue-Ecke, which hadn't yet become a traffic center. Then I walked along the lake, watching the swans whose feed Ball had envied; I walked, last but not least, down the Bahnhofstrasse, which was more of an international promenade in those days. Here, one might see refugees from all over the world; you could tell them by their clothes, which were so different from the respectable Swiss coats.

I sat in the Café des Banques, which no longer exists and where we subsequently saw Mary Wigman dance. She put on a special performance for us dadaists and "danced Nietzsche." I can still see her in the center of a circle, waving *Zarathustra* about. Left, right, left, right—"and conceived deeper than day."

At the time, there was a "Laban" group in Zurich.[13] Maestro Laban had revolutionary ideas, dance ideas. He would gather the most beautiful girls from near and far for his group. I really can't say whether I was drawn more to the beauty of the girls or the newness of the dancing. But since I've never particularly cared for, or understood much about, the dance, I tend to think that I was drawn more to the beauty of the girls. I must say that we behaved quite aggressively toward them. We ran after them, asking for dates (although we didn't have the money to take them anywhere), and making every effort to draw them into our erotic fantasies. The only one of us who had any success was Marcel Janco, a ladies' man, handsome and tall, with broad shoulders, winsome ways, and other qualities that no girl could resist for long. Eventually, he married one of the Laban dancers.

Many years later, I ran into Janco's daughter on Fifty-seventh Street in Manhattan. She is married to a man who coordinates financial campaigns for the State of Israel. I met the two of them in 1954 at the dada exhibition

at the Janis Gallery in New York. The exhibition was put together by Marcel Duchamp, Hans Richter, and myself, and we wanted to have paintings by all the former members of dada. Thus, we met again, and I had a chance to see Janco's latest work.

He is now a prominent man in Tel Aviv, but a number of people have told me that he isn't happy there. Israel, now in the process of developing, doesn't have much time for the fine arts, and painters of Janco's talent tend to feel isolated and neglected.

Janco, Hans Richter, Duchamp, and I often discussed the possibility of starting a kind of neodada, but America, the only possible soil, is at the same time the land least suited for such a project. And so we sit together in New York and recall the good old days. We've grown old and we can't evoke our youthful ardor or the miracle of working together spontaneously. The explosive energy of dada, such as we experienced in Zurich, could happen only once.

II

I didn't meet Hans Arp the first evening that I dropped into the cabaret straight from Germany. Arp lived in seclusion and saw people only on occasion. He had an apartment on the outskirts of Zurich and was living with Sophie Taeuber, who taught drawing at the Institute of Technology.

Arp appeared to be shy and somewhat anxious. His delicate complexion, the balletic slenderness of his bones, his elastic gait were all indicative of enormous sensitivity. I knew he was a "painter," but I had never seen any of his work. In contrast to him, I was noisy, energetic, and strong-willed. I took one look at the cabaret and instantly wanted it to be a success; I saw the people involved and wanted them to work together productively. I saw the city and wanted to understand its beauty. I enjoyed the foreign milieu, the lack of German substance in my life. Here in Zurich, I was a foreigner, and I wanted to remain one.

Ball, in his *Flight Out of Time*, has a highly accurate description of me on the podium, holding my cane and reciting my *Phantastische Gebete*. Arp was the very opposite, he never performed, he never needed any hullabaloo, yet his personality had such a strong effect that, from the very first, dada would have been impossible without him. Now that Arp is a major sculptor of our time, we can have a better understanding of the

Phantastische Gebete

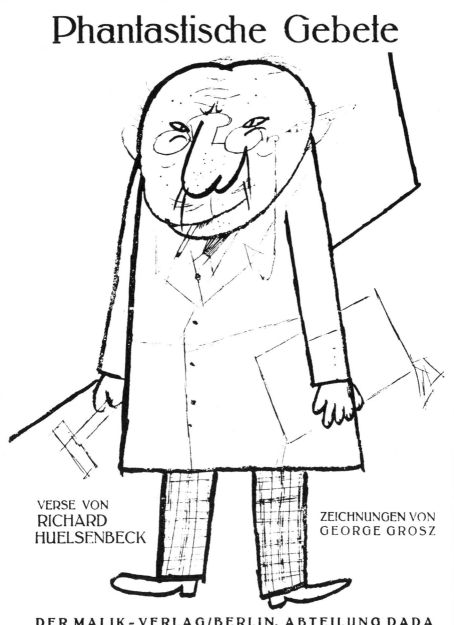

VERSE VON
RICHARD
HUELSENBECK

ZEICHNUNGEN VON
GEORGE GROSZ

DER MALIK-VERLAG/BERLIN, ABTEILUNG DADA

scope of his personality. He was the spirit in the wind and formative power in the burning bush.

I saw a good deal of Arp and was strongly attracted by his manner. "Arp," writes Ball in his *Flight Out of Time*, "is an obstinate advocate of abstract art." Ball betrays a certain skepticism, leaving the reader with the impression that the author does not fully share Arp's view.

Dada, for me, was a point of breaking off and starting out. In the liberal atmosphere of Zurich, where the newspapers could print whatever they pleased, where magazines were founded and antiwar poems recited, where there were no ration stamps and no "ersatz" food, we could scream out everything that we were bursting with. It was here that my *Phantastische Gebete* were written. They are typically dada, but I could have written them even without the cabaret. They are human, they are a liberation from impossible conditions—what Marinetti termed "parole in libertà." And yet different and more profound, more psychological or rather *seelisch*,* as the Germans put it—anything made in Germany is *seelisch*. Marinetti, who sent his *Parole in libertà* to Ball, intended a more technical meaning. He was a revolutionary of grammar, whereas from the very outset we wanted to be revolutionaries of humanity.

In the early days of the cabaret, Arp and I often strolled along the Bahnhofstrasse, talking about art, just as Ball had so often discussed art with me. In my conversations with Ball, art was a destiny; our constant themes were the personality and the destiny of the artist. We discussed Rimbaud, Baudelaire, and a few others, but primarily Rimbaud. The latter had abandoned art, which promised him a golden crown, only to become a gunrunner in Harrar. What did it mean to leave art behind? Such an act contained the possibility of a re-evaluation of art as such. And so our theme expanded to include the question: Could one be an artist in our time? Could a man live and create as an artist in the industrial revolution?

These reflections developed into the "anti-art" sentiments anticipated by Duchamp and Man Ray in America. But dada contained a great deal more: for one thing, a desire for further developments toward a new form and a new life. If art was no longer possible, one might become an adventurer of the body or the mind, change one's creed, turn monk, murderer, Casanova, or religious fanatic. Existence was uppermost in our thoughts, not art. Thus we were phenomenologists and existentialists; and Sartre once said of himself: "Moi, je suis le nouveau Dada."

Arp's greatness lay in his ability to limit himself to art. Everything he

* "Psychic"; from *Seele*, "soul," "psyche."—TRANS.

thought and desired, the feelings that moved him, the dreams that shook him, had only one meaning and purpose: art. Arp was and remained an artist par excellence. Consequently, he became the greatest artist in the dada group. Precisely because he glanced neither to the left nor to the right, he wanted to change art more than anything; and he believed that it was only through art that one could change human life. More than any other dadaist, he was an artistic genius.

Arp loved sunshine, elegant women, fine food. His alert eye took in everything that happened around him. His gift for observation was unique, and his irony helped him retain the necessary sobriety.

My ideas on art were obscured by what I described a few pages back. Above all, I wanted to change life, my life and that of other people, which is why I was indifferent to the way one paints, writes, or composes. My opinion on art was the opinion of those who abandon her like an unfaithful sweetheart.

I remember one day when Hans Arp and I were crossing the Bahnhof-strasse, talking about art and discussing—believe it or not—the art of the Renaissance. I was praising it for all possible reasons, but Arp would have none of it. There was no greater antithesis for him than Renaissance art and abstract art.

I was terribly idealistic, and it took me a long time to realize that every art is a product of its time. I lived in an age in which catastrophes, wars, disasters were mixed with optimistic sauce—I felt this age from which Hugo Ball wanted to flee, but I didn't know what position to take on it. Should I say yes or no?

The question never existed for Arp, since he regarded himself as a special instrument of the age. He was an artist, and as such he had to express himself in an art that was influenced and produced by the age. He felt himself to be a product of the *Zeitgeist* yet simultaneously he was above the age. Thus he created the maternal symbols of his sculptures and developed his faculty for simplicity, something both archaic and modern.

Hans was somewhat perplexed at my stubborn defense of Renaissance art and invited me over to his apartment to show me some of his work. We finally went up, and as I stood in his studio, I caught sight of a painting that depicted potatoes. But what potatoes! They were the most unreal, the most anemic, the most cerebral potatoes in the world. This was the metaphysical formula for the existence of all potatoes in the world.

We gazed at the potatoes for a while, and suddenly I had a greater understanding of modern art than ever before. Modern art aimed at the essence, it desired a reality to be found behind objects, *la réalité nouvelle*,

the new plasticity. It was tired of the pretty objects that the Victorians had put on their mantelpieces. No more genre paintings.

And I suddenly understood the double problem of simplicity and details. I had always felt uncomfortable when looking at detailed paintings, such as George Grosz's. Form, space, and structure were the important things.

A few weeks ago I returned from a trip to Europe. It is now 1955; almost forty years have elapsed since we founded dada in the Cabaret Voltaire in Zurich. In Paris, at the Louvre, I saw a huge Picasso exhibition in honor of the artist's move from Spain to France fifty years earlier. In 1909, a few years before dada, Picasso, along with Braque and Juan Gris, had given birth to cubism. He had mangled the old reality and introduced a new honesty, a new thoroughness, a new essentiality into art. We knew about it in Zurich; we knew about his collages, his use of new material, his love of Negro art. We admired it all, the urge toward essential simplicity, toward the structural, the formally certain, toward depth and the answer of depth—we admired it all and knew that we had to follow along this road.

In 1916, I lived on the Wolfbachgasse in Zurich, near the square, where the Kunsthalle stands today. The Komödienhaus has replaced the Pfauen-Theater. There were no newspaper stands in those days. There were no taxis on the square, and at nine o'clock it was as lonely as the Sahara. The Swiss didn't care for any night life—early to bed and early to rise. They are a nation of hard workers, similar to the Germans, and in my time there was no entertainment to be had after work. Radio was unknown, movie houses were few, concerts were given only on high holidays. Recreation consisted in reading good books.

Today, with cars and motorbikes transforming the Rämisstrasse into pandemonium, and girls hopping about in American Levis and with polished fingernails and toenails, we are living in a different Switzerland. I wonder whether anyone would pay any attention now to the great efforts we made in those days. The present generation is very demanding, and the entertainment we offered in the cabaret was not very professional.

Except for Emmy Hennings, we had no professional cabaret performers. Her little voice was so meager and boyish that we sometimes had the feeling it might break at any moment. She sang Hugo Ball's aggressive songs with an anger we had to credit her with although we scarcely thought her capable of it. Was this a child disseminating antiwar propaganda? Hugo's playing was untrained but persevering, and he played anything the drunken audience demanded. And the Dutch landlord just shook his head.

Then came the famous crisis: the man told us we must either offer better entertainment and draw a larger crowd or else shut down the cabaret.

Hugo Ball was ready to close shop. I talked to him; he was fed up, he wanted to move to southern Switzerland and write a book on Bakunin. (He *did* write it, but it was never published.) He surrounded himself with all kinds of books, his interests were unlimited, psychoanalysis was as important to him as Luther and Calvin. Luther subsequently moved closer and closer to the center of his research. Ball hated him for embodying a whole collection of German traits including crudeness, positive factualness, social realism, mental heaviness, against which Nietzsche had tried to revolt. Ball's earlier enmity toward religion was now directed against one person. Luther became the anti-Christ, and Emmy and Catholicism continued to sustain him.

It is impossible to measure the influence this frail girl had on Hugo Ball. She helped him toward qualities that fascinated him. Emmy was one of the few women who do not take the world literally. Under their influence, everything is transmuted into relationship, expectation, spirituality. She was a true angel, although she didn't have the least hint of wings. Yet she seemed lost in this world. She was unearthly in the best sense. There is no question that she transferred these qualities to Hugo, she conjured up a kind of paradise for him. Hugo and Emmy lived in a world in which the necessities of everyday life were reduced to a minimum. I cannot say to what extent this had a positive effect on Ball and his work. But one thing is certain: Hugo was so strongly influenced by Emmy that one cannot love his writings unless one fully and deeply understands this influence.

My relations with women were meager enough, although Zurich in 1916 was full of interesting female creatures. The sexual revolution, also known as the liberation of woman, had not yet started or at least it was still invisible. Nor did we really feel it in our heads. I, for one, didn't. My attitude toward women was as primitive as could be. I wanted a mistress, and I wanted sexual pleasure. I took it for granted that any woman would have to adjust to my way of living. I knew nothing of a woman's desires or a woman's interests. Both Switzerland and Germany had a patriarchal system, and a male lived mainly in the illusion of his superiority.

One day on Bellevue-Ecke, I tried to pick up a girl after watching her for some time from my bench. She was waiting for someone who never showed up. Tall, black-haired, and attractive, she wore the average clothing of female clerks with a strong touch of Swiss respectability. When I tried

to strike up a conversation, she gave me a withering glare but didn't send me packing. Thus began my friendship with L.

For a while, we would meet every evening, take walks along the lake, and end up in a small tavern somewhere in the maze of Niederdorf. We would sit here, drinking beer and listening to the miserable music.

The crisis of our cabaret was upon us. It seemed, mysteriously, to accompany the crisis of world politics. Emmy had set up a large altar covered with white linen in Ball's barren room; she would kneel down before it in prayer, and her murmuring would blend with the hammering in the courtyard, where a coffinmaker was constructing his chests. Ball, as I have said, was more and more taken with Emmy. She was his mistress, his mother, his angel, and his high priest. I often saw the admiration in his eyes when he turned from his piano to Emmy. Emmy had cut her hair short, she knew how to shake her head and her hair as if she were standing in a summer wind. The light of our dim cabaret lamps shone through her thin dress, revealing her boyish figure. She wasn't merely a child, she knew how to play the child, and Ball had a mystic love for all naïveté, genuine or not.

Ball read a great deal of Léon Bloy; but he also began studying the history of the martyrs. He plunged with masochistic delight into the self-punishment of medieval men and women who slept on thorns and thistles and sought in their own way to conquer God in caves and rocky cellars. Before our very eyes, Ball was turning into a mystic.

The Dutchman, who saw the world with the eyes of a normal human being, declared that the cabaret was driving him to bankruptcy; something had to happen to make it profitable.

Tzara concentrated on his correspondence with Rome and Paris, remaining the international intellectual playing with the ideas of the world. He told us about Picasso and cubism, he knew about the futurists, not only Marinetti, but also Carrà, Boccioni, and Severini.

He introduced us to Picabia, Delaunay, Braque, and others who had made names for themselves in modern art. He was the aesthete who collects antiques, African sculptures, and primitive art. He was also the politician of our group and considered himself—like all politicians—destined to lead the group. He was the *littérateur*, the writer who wanted to record everything on paper instantly, and he emphasized the documentation of everything we did, thus keeping an eye out for posterity and fame. Once the word dada had been uttered and become all the rage, Tzara founded the magazine *Dada* with us, and now it is sought after as a collector's item.

Arp always maintained a certain distance. His program was clear. He wanted to revolutionize art and do away with objective painting and

sculpture. From behind the spiritualized potatoes in his studio, he expectantly observed the developments in the cabaret in order to help us out whenever necessary.

The German writer Serner,[14] author of *Letzte Lockerung* [The Last Laxity] and a series of fantastic detective novels, made equally rare appearances. The Viennese painter Max Oppenheimer (Mopp)[15] remained on the fringes of our activities; he was greatly impeded by his sexual problems. I ran into him much later in New York, where he died of heart disease several years ago. He had sunk down from his earlier fame to a miserable existence, and no one would have believed that he had once competed with Liebermann and Corinth under the aegis of the Cassirers in Berlin.[16] He had a flaccid, sallow complexion, and his handshake felt like a cat's paw. Like Marcel Duchamp he loved chess, and every evening he would leave the Hotel des Artistes on Sixty-seventh Street to play chess in a branch of the YMCA.

I won't repeat the way our attempts to set the cabaret afloat led to the use of the word dada. It took place in Ball's room near Emmy's altar in the presence of the Blessed Virgin at a time when Ball's desire for a strict mother was becoming more and more obvious. The strict mother who would adopt him, the church, was ready and willing, and we could already smell the clouds of incense, a wind that hung over the prairies of the centuries.

I don't want to neglect the Russian painter Slodki,[17] who drew posters for our cabaret. He was a small, black-haired man of few words and a good heart. During World War II, while trying to return to his country, he was killed by either the Nazis or the Communists (who are one and the same, in the last analysis). Someone told me about that terrible event.

Ball, in *Flight Out of Time,* explains that the Cabaret Voltaire was started by him and Emmy Hennings in Zurich in 1916 as an "artists' co-op." They meant it to be a gathering place for all artistic trends, not just modern ones. But we had in mind mainly living artists, not only those who took part in our cabaret, but others as well all over Europe. Here in Zurich, on neutral soil, there was no censorship, and we were able to get hold of any books we needed. Poetry played as great a part as painting and music. The verses of Kandinsky were read. And Else Lasker-Schüler,[18] Jakob van Hoddis,[19] Georg Heym[20]—to name but a few German poets— were our daily bread.

At the point when our cabaret was practically on its last legs, I went through a great crisis that grew out of my friendship with L.

L., as I have mentioned, was a Swiss girl of average background. She

was a bit taller than I—which doesn't take much—dressed conservatively, and spoke "literary German" (as the Swiss put it) with a distinct local accent. Although she wasn't pretty, there was something attractive about her, and she had a good figure.

I soon realized, however, that L. had something that I have always sought and admired in women, a kind of confidence, justified in instinct but seemingly illogical in the experience of reality. In contrast to me, she lived securely in her milieu, she knew only Switzerland and, at that, only the lovely city on the Limmat. The people around her, her family and friends (some of whom I met), all lived in the same milieu, had the same customs and habits, and spoke the same "literary German," but in a starchy way and with old-fashioned gutturals.

The confidence that I felt in L. became part of our relationship in the sense that I made myself totally dependent on her; my complete lack of roots, my constantly shifting opinions, plans that I rejected before I even articulated them were all affected by this attachment.

A product of the bourgeois middle class myself, I have always been drawn to a conventional mode of living although hating it with all my might. L. became my rock, my "rocher de bronze," which I clung to in my lost state. I soon imagined that I couldn't survive without this anchor hold. In the early days of our friendship we met almost every day to stroll along the lake and to feed and watch the swans.

Every evening, I would take L. back to the Drahtzugstrasse in a Zurich suburb, to the house she lived in with her parents. I never found out what her father did; but once, when I visited them, I saw that everything was even more petty bourgeois than I had dreamed.

It took weeks for L. to allow me to kiss her; but I had no hard feelings, the qualities of her character more than made up for it.

I have a very clear recollection of the first kiss. It was in front of L.'s house on that famous Drahtzugstrasse shortly before our usual good night. She had half turned around and was looking for her key in her handbag. L. had prudish lips and put up a strong resistance. Then she said: "That's all," turned around, and stepped into the house.

My double activity as a student of medicine and a cabaret performer and dadaist was a heavy burden. My despair was sometimes so great that I longed for an end to the cabaret. When L. heard that I had cut classes, she scolded me like a mother. She was shocked that I was neglecting my obligations. She herself was a salesgirl in Jelmoli's, a department store, although she always made it clear that she didn't have to work. How could

I dare stay home simply because I felt like it? When I told L. it was because of her, she made fun of me. But even though I hated her during this fight, I didn't have the nerve to really argue. I was still fascinated and paralyzed by her deliberate manner. Later, when I was alone, I rebuked myself for my weakness, but I comforted myself with the thought that I was weak only with women. Wasn't I, in real life, the energetic, ruthless "Dada Drummer," as Ball had dubbed me? Wasn't I always the first to plunge into any justifiable fight, mentally and physically? Hadn't I exchanged blows with the drunken students? Hadn't I knocked about the world more than anyone else? And now . . . A woman? A girl? And an average one at that . . .

I made up my mind to tell her everything and ask her to end our affair; but when I saw her coming toward me, I lost heart. "Let's take a walk," she said, and I followed her without even trying to talk back.

L. hated the cabaret but was greatly interested in my studies. She said the cabaret was spawned by insanity. She called the men and women of the cabaret "immoral" and added: "They're good-for-nothings, they're worthless. . . ."

My dependence was so pathological that once I even agreed with her, and I have to admit, to my great shame, that I denied my friends, like Judas Iscariot.

Once, I succeeded in getting L. to visit the cabaret; I introduced her to Ball and Emmy Hennings. They simply couldn't get over the fact that I had chosen someone so totally unintellectual and middle class.

I had L. sit at one of the small tables along with a few other customers. The entertainment had already begun. Ball then reminded me that it was time to recite the *Phantastische Gebete*. In *Flight Out of Time*, he described my performances in the cabaret. I would roar my lungs out, more like a sideshow barker than a reciter of verse, and wave my cane about in the air. The spectators saw me as an arrogant and utterly belligerent young man.

I would often recite the poem "Rivers" because it contains extremely daring images and always brings out the audience's antagonism. I got on the podium with a blasé expression on my face and doing my best to hide my stage fright. As I spoke, I saw L. get up and head for the door. I stopped in the middle of the poem and leaped off the podium. The audience protested. Ball, who had been sitting at the piano without playing, stood up in amazement.

L. was hurrying out of the cabaret. I dashed after her, impeded only

by the crowded chairs and tables at which a relatively large number of people were sitting. The whole place was darkened by cigar smoke. Talk, singing, shrieks, and cries of protest became audible.

"We want our money back!" shouted a drunken student.

"What a crappy—"

"Highwaymen!"

I caught up with L. in the vestibule; Ephraim, the Dutchman, happened to be passing through. He looked worried, since as usual his mind was on the impossible financial situation of the cabaret.

"Why are you leaving?" I caught hold of L.'s arm.

"It's crazy," said L., her tone of voice expressing utmost scorn. "I don't want to hear a lot of crazy nonsense and I don't want to sit with a bunch of drunks."

I was at the end of my rope, I tried to calm her but couldn't. As usual, she wouldn't give in and kept saying she wanted to go home. Now Ball came over and said the audience was demanding that I finish the poem. When the Dutchman realized what was going on, he took Ball's side and added reproachful remarks about the situation the cabaret was in.

I was like a mule that doesn't know whether to turn left or right to get his bundle of hay. L. solved the problem by simply vanishing, and she was so quick that I couldn't go after her. I was desperate. I followed Ball and the Dutchman like a broken man; but Emmy, becoming my protectress, got me to gather all my strength. I picked up my cane and got back on the podium.

I waited for L. at Jelmoli's the next day, but she refused to talk to me, and she held her head higher than I'd ever seen her hold it before.

Our activity had increased daily. Janco and Slodki had made posters, which were duly gazed at. Janco had also made a series of extremely beautiful blood-red masks that now adorned the walls of the cabaret. The Dutchman, watching our great efforts, seemed more satisfied and less yellow than usual.

We discussed the possibility of having an open reading some evening (we subsequently staged one in the Meise*). Ball told us quite a bit about his writings, his sound-poems; we spoke about Klee, Kandinsky, and abstract art. Ball was skeptical about modern art, but I was moving closer and closer to Arp's side.

* A restaurant in Zurich.—ED.

In the evening, we would go drinking in the Bazerba, a Spanish wine cellar, or else sit around with friends in the Café Odeon or in the Bellevue. We would visit a man named Brupbacher, who called himself an anarchist. We would meet Leonhard Frank[21] and other German and French writers. All around us, the world was in flames; we watched French and German officers, now prisoners of war, ceremoniously saluting one another.

Tzara, Janco, and I recited a "simultaneous poem." We came out on stage, bowed like a yodeling band about to celebrate lakes and forests in song, pulled out our "scores," and, throwing all restraint to the wind, each of us shouted his text at the bewildered spectators. This was the first simultaneous poem ever publicly performed on a European stage.

I grew more and more nervous and was at a total loss as to what to do first. My relationship with L. had not gone back to normal. We still went out but were quite distrustful of one another.

I found out what L.'s problem was. She had a completely ready-made opinion about men and women, expressed in a conventional formula that is handed down from generation to generation and repeated from mouth to mouth. Men belong to a wild tribe that will do anything to retain its freedom. Men have little sense of stability or responsibility, and it is a woman's business to train and strengthen them. In L.'s eyes, my activities in the cabaret were an expression of this wildness. On the other hand, my medical studies were a stable activity that she had to support because they provided a possible foundation for marriage.

Now, I tormented L. day and night to sleep with me and I acted more and more dissatisfied.

We had long discussions about it, and finally the whole matter was summed up in my promise: "If you sleep with me I'll leave the cabaret." Since the possibility of the cabaret's being shut down was imminent and since both Ball and I were tired of the rumpus, my vow was hardly an act of great generosity.

L. was deeply impressed by my words. She said she had to think it over. I saw her two days later, but even then she couldn't manage to make up her mind. She seemed more reserved than ever. She wouldn't disclose her feelings, unlike the Latins or southern types, who wear their hearts on their sleeves.

The reason that she finally did decide to give in was the marriage of a close girl friend. L. was obviously jealous. This was someone who had grown up with her, had had the same experiences, and came from a similar middle-class family.

Her friend had been engaged to an engineer, but the relationship had gone through many crises. You didn't have to be a detective to see L.'s satisfaction at the crises and her malicious joy, her glee at the possibility of a total rupture. But then, however, when things worked out contrary to L.'s expectations, and her girl friend married the engineer, L. fell into a state of depression. It was now more important than ever for her to keep hold of me. Here I was, a doctor-to-be, a not unattractive man, and perhaps not uninteresting (although I'm not sure that the latter quality made any real impression on L.).

And so, in a hesitant tone of voice, she told me she was ready. I was beside myself with joy and ready to give up everything for her, including dada and the Cabaret Voltaire. I discussed the matter with Ball, but it was mainly Emmy who talked to me about it. She told me about her own life, her childhood in Flensburg (her mother was still alive then), the family's poverty, her career as a *diseuse*, her literary past. For a while she had been so rootless and lost that she had even landed in prison. In fact, she had written a book entitled *Gefängnis* [Prison]. (It was subsequently published, and Ball, in *Flight Out of Time*, calls it a reaction against the evils of our civilization.) Emmy was an extremely perceptive woman; but her intelligence had nothing "intellectual" about it, she was more of a visionary type.

We once again recited our simultaneous poems, but the simultaneity of our action was on the decline. In the middle of our dada period, Ball took a trip to the Ticino and wrote about it in his book. "The Ticino, now I know where one can go. . . ."

Needless to say, my "nuptial night" with L. was extremely disappointing. Her friend who had married an engineer was sympathetic and let us use a room that she had given up after her wedding (she had also worked at Jelmoli's).

The outcome was total chaos. I behaved as well as I might, but I couldn't reconcile my dadaist "wildness" with L.'s reserve. Although, as I have said, I greatly sympathized with the conventional, I was still a very poor comforter and savior. There is nothing more sensitive on earth than a man's potency. Every kind of love-making involves freedom, real or imaginary. Here, however, we found ourselves in a hopeless bramble of violently contradictory feelings. So we had no choice but to leave the apartment that had been so generously offered to us. We walked wordlessly through nighttime Zurich, which in those days did not as yet illuminate its venerable buildings with neon lights.

It was really dark, very dark. I wanted to take hold of L.'s arm but

she pushed me away, and in the Drahtzugstrasse—I'll never forget the name of that street—L. became icy cold and bitter. I felt that our relationship had come to an end.

Nevertheless, I went out with L. from time to time; the real end was so peculiar that I have to mention it. I lost L. in a movie house in which a panic had broken out. It's hard to believe, but in a small room—cinemas weren't very large in those days—a man in the back row uttered such a grotesque moan that several people in the audience screamed. Next, others stood up, and eventually the entire audience began rioting. They shoved their way to the exits, stamped about, called for help; but no one could find out what had happened. Fire? Murder? Revolution? Nobody knew, and nobody cared. All they wanted to do was get out, get away, run off. It was what the Australian farmers and cattlemen called a stampede, an effective English word because it expresses the stamping of the cattle onomatopoetically. The herd starts moving suddenly and for no reason. It flees, it stamps, a sinister sight, and woe to anyone landing under the hoofs. Thus, I lost L. in a stampede in a Zurich movie theater many years ago and never saw her again. I hope that since then she found what she deserved. Despite her great limitations, she was a fine woman.

After this last experience, I had a nervous breakdown. I couldn't eat or sleep. I had always slept badly and still do (for many years I haven't been able to sleep without sedatives), but in those days I would sit on my bed night after night, listening to the Wolfbach flowing past my window. Early in the morning, when my weary eyes wanted to close, I was startled awake by the barrelmaker's hammering below. Ball had a coffinmaker, I had a barrelmaker; the two of us lived in a constant din.

I couldn't eat, I would vomit, I lost weight; at my wits' end, I scurried about the city. I walked up and down the Bahnhofstrasse, an animal in a cage. I wondered whether I should go back to Germany and wrote to my parents; but my antipathy to Germany was great. This was the period in which I also had a funny antipathy toward Switzerland because, as I put it, the country was one big sanatorium. And I preferred death on the battlefield to life in a sanatorium.

I saw little of my friends. Hardekopf[22] came on the scene. In Germany, he had been an intimate friend of Emmy Hennings. Later, he married Sitta Staub, the wife of an attorney who died in New York. Hardekopf, a delicate, highly sensitive, and neurotic man, who would wear a heavy woolen scarf in the heat of summer, succumbed—if I may put it that way—in

poverty. In his own way, he had rejected the world. Afraid of sinking from the height of his expectations, he isolated himself from the world to the point of total solitude. He would sit in his rooms in Zurich, starving, with his scarf wound tightly around his neck, and he would work on translations. He had written little of his own except for a few marvelous poems and a short scene that—as far as I can remember—Kurt Wolff had published in *Der Jüngste Tag*. I read the scene during my student days in Paris and was greatly impressed. It began (I am reciting from memory): "The carpets are deep and red . . ."

Klabund[23] came over from Arosa and vanished. I became friendly with Oppenheimer and Leonhard Frank, but Frank was a willful man who arrived in Zurich with one desire that he loudly reiterated: "All I need is a table, paper, and an inkwell."

Once, when I came back to Berlin after a trip around the world and ran into him in the Romanisches Café (which had replaced the Alte Café des Westens), I told him enthusiastic tales about Japan. He said: "I'd go there, too, but only if I had a first-class cabin." Through Frank, I met the Strasser family; both he and she were doctors, and they took care of *émigrés* from all over the world. The two of them were Adlerian psychoanalysts. In those days, I knew little about psychoanalysis, and the name Adler had cropped up only in my zoology book.

Dr. Strasser associated with poets and writers, and he also wrote himself. A novel of his ran in a Zurich newspaper. He had the reserve of a man who wants to create the impression that there is more to him than one might normally divine. Whatever it was, nobody knew, possibly not even he himself, since no one took the doctor's works seriously.

His wife was also a doctor and added her maiden name to her married name, the result being Dr. Nadja Strasser-Äppelbaum. From the very first moment she struck me as the more sympathetic of the two. At any rate, I made up my mind to undergo therapy with Frau Doktor Nadja Strasser-Äppelbaum.

Ball was in the Ticino, and I wrote him a desperate letter. He comments in his journal:

"Huelsenbeck has sent me his *Phantastische Gebete*. 'For weeks now,' he writes, 'I have been resolved to return to Germany, but at the moment I can't go because I've been suffering from a nervous gastric disease. It's horrible, a triple inferno, I can't sleep, I'm always puking, a punishment perhaps for that dadaist hubris that you think you've discovered. My opposition to this art has always been great. I've found an extraordinary French-

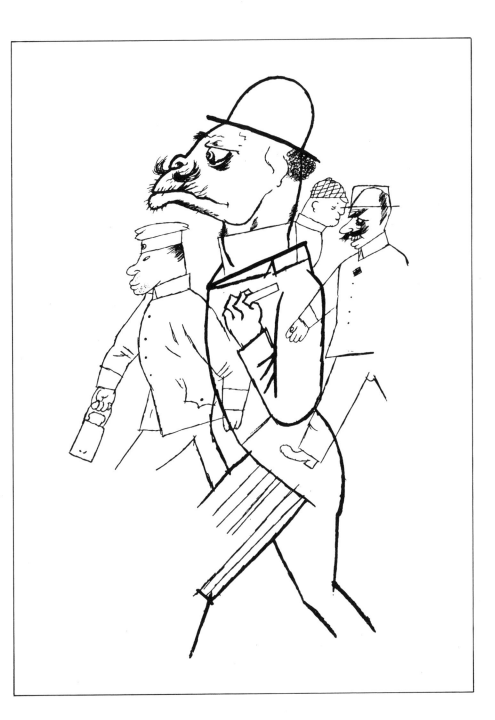

man: Léon Bloy. You can tell from my book that I have no less desire to become a Jesuit. . . .' "

Ball wrote the above in his journal, apparently because he felt he had discovered something in me akin to his growing mystical religiosity. But this was not the case. My antipathy to mysticism had always been as great as my antipathy to doctors; but that didn't prevent my consulting Nadja Strasser-Äppelbaum.

Death, however, has leveled everything now. Dr. Strasser-Äppelbaum died early on. I doubt very much whether her husband is still alive. The two of them played a great part in the period of emigration, but I myself was not socially involved. I was too young and too unimportant. The leaders were Frank, Schickele, and Werfel.

I said that death levels everything. Schickele died of a kidney inflammation in the thirties.* Werfel died in America. I once saw him at the St. Moritz Hotel in New York, where he and his wife, Alma Mahler, were holding court.

When I first entered Nadja Strasser-Äppelbaum's consulting room, she clapped her hands and called out to her husband on the other side of the door:

"Just look, a boyish man. . . ." I was somewhat embarrassed and nearly bowed the way youngsters do in a dance class.

Frau Nadja was one of those people who love to break out in sudden enthusiasm. "Oh, how lovely! Oh, how interesting!" she would constantly exclaim. She appeared to be telling you that psychoanalysis had loosened enough of her unconscious. Thus, every "Oh, how lovely!" camouflaged a "Don't you see how well I've managed to develop and improve my personality? I am the best example of a psychoanalytic success. . . ."

Our psychoanalytic work consisted of a conversation, which Nadja recorded earnestly and accurately on a sheet of paper.

"We won't be getting to sexual things so soon," she said.

I shrugged my shoulders. Sexual, shmexual—who cared? Frau Doktor overestimated my sensitivity. Naturally, we soon got down to it, and she extracted interesting material from the darkness of my dadaist soul.

She clapped her hands and said enthusiastically, as if she had come upon a rare flower: "Oh! Isn't that interesting. . . ."

I couldn't tell where the whole thing would lead, but every week I would come faithfully, sit down next to Nadja, and watch her rapid fingers write

* Schickele actually died in 1940.—ED.

down my confessions. Gradually, however, the therapy became boring, although I enjoyed the attention I had sought and I actually felt better.

Then, one day, something happened that left a deep impression on Nadja and elicited a remark from her that put an end to our conversations. There was a loud bang, a kind of cannon boom followed by shell splintering, a shrapnel explosion in the Strasser home, a suburban disaster. Everyone came running to look for the cause. No one seemed hurt. I could hear talking, murmuring, discussions. Something was going on in the next room. The voice of Dr. Strasser hovered over the waves. Someone emitted a final shrill scream. Then in walked Nadja, who saw me sitting in the same place I had been sitting before, clapped her hands together with her usual enthusiasm and said: "Oh, the chandelier dropped from the ceiling, and you haven't budged from your seat. Nothing could startle you enough to make you move. How interesting. . . ."

The chandelier *had* dropped from the ceiling, and I *had* remained in my chair. Chandeliers simply don't interest me.

I soon noticed that Dr. Strasser-Äppelbaum had drawn certain conclusions from the chandelier incident. I'm not quite certain what sort of conclusions they were, or rather, I wasn't sure then. Today I realize that she regarded my reaction—or lack thereof—as symptomatic of some mental disease. Now we dadaists may have been in a—shall we say—unusual mental state. But we certainly weren't as mentally ill as Nadja thought we were.

I couldn't have cared less whether Nadja considered me mentally ill or not, but the kind of attention she bestowed on me changed, and now I sensed the observing diagnostician in her. This bothered me greatly, and eventually I stopped coming.

However, the Strassers did give me a certificate for the consulate; their diagnosis of my mental state must have seemed correct to them in the light of the chandelier incident.

Arp, an Alsatian—then still a German, he later opted for France—Ball, and others were often summoned to the consulate in regard to their draft status. I was totally resigned, and since I realized I would have to return to Germany someday, I accepted the inevitable induction into the armed forces. I had constantly heard about the horrors of war, but no one can imagine war without having crouched in trenches and listened to the whistling of bullets and the moans of the wounded. I was extremely naïve, and if it hadn't been for Dr. Strasser, the "Prussians" would easily have gotten me.

To this very day I don't know what the letter said, but I'm sure it didn't contain any encomium on my mental health. The army doctor at the consulate took one look at the certificate, glanced at me, cleared his throat, and left the room. Then he returned, pausing for a while beneath the mustachioed portrait of Hindenburg.

"Are you one of those people who call themselves dadaists . . . ?"

"Yessir," I said, stiffly clicking my heels on Zurich's neutral soil.

"Well," he said in a paternal and almost melancholy tone of voice, "you'll be hearing from us."

"Yessir," I replied in an even stiffer tone (if that was possible).

The army doctor looked back at me as he was about to step through the doorway: "Be careful and avoid excitement."

III

Dada is an experience of our age, a protest as well as an act of submission. Through its projection into art, dada is a dissolution and synthesis of the idea of the New Man.

Ball, in *Flight Out of Time*, writes: "The dadaist trusts the sincerity of events more than the brilliance of people. He feels that people are dirt cheap, including himself. He no longer believes in comprehending things from one single vantage point, and yet he is so convinced of the over-all connection between all entities and beings, so convinced of totality, that he suffers from the dissonances to the point of self-disintegration. . . ."

Then, further on: "The dadaist wages war against the agony of our age and its intoxication with death. Averse to any sage inhibition, he cultivates the curiosity that revels in even the most dubious form of a rebellion. He knows that the world of systems has gone to rack and ruin and that time, a dunning creditor, has started a rummage sale of godless philosophies. The point at which a booth owner is assailed by fear and a bad conscience is the point at which a horse laugh and a mild solace begin for the dadaist. . . ."

Anyone, especially a writer, who can say these things about dada, expressing everything in a few words, aggressiveness and laughter, as well as degradation bred by despair—such a man could not possibly turn his back completely on this experience. His "renunciation" of his friends was only half-serious. It was serious only to the extent that Emmy had found a dif-

ferent way of life for him. She took charge, childlike, calculating, innocent, and yet fully aware of the inescapable.

Heuberger, our charming Swiss printer (who uncomplainingly dealt with prose and poetry that were totally incomprehensible to him), put out my *Phantastische Gebete* as well as my poem *Schalaben Schalamai Schalamez-omai* with drawings by Hans Arp. These drawings were semirepresentational as opposed to the completely abstract and austere woodcuts that he had given me for my *Phantastische Gebete*.

Ball discusses Arp in *Flight Out of Time* and says (I am quoting only some of the many remarks): "Arp is against the pretentiousness of the gods of painting (the expressionists). He finds Marc's bulls too fat; Baumann's[24] and Meidner's[25] cosmogonies and insane fixed stars remind him of Bölsche's[26] and Carus's[27] stars. He would like to see things arranged more rigorously, less arbitrarily, and not bursting with color and poetry. He recommends plane geometry instead of paintings of the creation of the world and apocalypses. When he advocates primitiveness, he means the first abstract draft, showing awareness of complications but refusing to get involved with them. Sentiment should vanish, as well as any dialectical process reserved only for the canvas. A passion for circles and cubes, for sharp lines. He favors the use of unequivocal (preferably printed) colors (colored paper and fabric), and generally the application of machinelike accuracy. . . ." Ball then adds, interestingly enough: "Any Americanism that art can include among its principles should not be scorned. Otherwise art will remain sentimentally romantic. Arp sees form as a barrier against the indefinite and the nebulous. He wants to purify the imagination and concentrate not so much on disclosing its hoard of images as on whatever constitutes those images. . . ."

And so on. Ball wrote these lines in April 1916, in Zurich. Arp simply expressed what all of us were thinking. In going to extremes and beyond all discipline, we were looking for a new rigor. Although seemingly not following any law, we were producing an inner set of laws characteristic of the times. We anticipated psychoanalysis.[28] In trusting our instincts but rejecting normal logic, we became aware of the existence of a structure within ourselves.

I would now like to offer the poem *Schalaben Schalamai Schalamezomai,* to give my readers an idea of what I was doing in those days.

Die Köpfe der Pferde schwimmen auf der blauen Ebene
wie große dunkle Purpurblumen

des Mondes helle Scheibe ist umgeben von den Schreien
der Kometen Sterne und Gletscherpuppen
schalaben schalamai schalamezomai
Kananiter und Janitscharen kämpfen einen großen
Kampf am Ufer des roten Meeres
die Himmel ziehen die Fahne ein die Himmel
verschieben die Glasdächer über dem Kampf der hellen Rüstungen
o ihr feierlichen Schatten Therebinten und Pfeifenkraut
o ihr feierlichen Beter des großen Gottes
hinter den Schleiern singen die Pferde das Loblied des
großen Gottes
schalaben schalamai schalamezomai
das Ohr des großen Gottes hängt über den Streitern
als eine Schale aus Glas
die Schreie der Kometen wandern in der Schale aus
Glas über den Ländern über dem Kampf über dem
endlosen Streite
die Hand Gottes ist schön wie die Hand meiner Geliebten
schalaben schalamai schalamezomai
es trocknet das Gras im Leibe des Generals
auf hohen Stühlen sitzen die Schatten der Mitter—
nachtssonne
und die Weiße des nahen Meers und den harten Klang der Stürme die
 der Vulkan ausbrach
so Gott seinen Mund auftut fallen die Schabracken und
kostbaren Zäume von den Rücken des Reittiers
so Gott seinen Mund auftut brechen die Brunnen der
Tiefe auf die Gehängten spielen am Waldrand die
Köpfe der Pferde aber hängen am Wogenkamm
schalaben schalamai schalamezomai
ai ai ai ich sah einen Thron ich sah zehn Thronsessel
ich sah zehnmal zehn Thronsessel und Königssitze
ich sah die Tiere des Erdkreises und die Metallvögel
des Himmels singen das unendliche Loblied des Herrn
der Phosphor leuchtet im Kopf der Besessenen schalamezomai
und die Säue stürzen in den See der Lamana heißt
schlage an deine Brust die aus Gummi ist laß flattern
deine Zunge über die Horizonte hin
wedele mit deinen Ohren so die Eisgrotte zerbricht

ich sehe die Leiber der Toten über die Teppiche zerstreut
die Toten fallen von den Kirchtürmen und das Volk
schreiet zur Stunde des Gerichts
ich sehe die Toten reiten auf den Baßtrompeten am Tage des Monds
rot rot sind die Köpfe der Pferde die in der Ebene schwimmen.

[The heads of the horses float on the blue prairie
like huge dark purple flowers
the bright disk of the moon is surrounded by the shrieks
of the comets stars and glacier dolls
schalaben schalamai schalamezomai
Canaanites and janizaries are fighting a great
battle on the shores of the Red Sea
the heavens draw in their flags the heavens
slide the glass roofs over the battle of the bright armors
oh you ceremonious shadows terebinth and hogweed
oh you ceremonious worshipers of the great God
behind the veils the horses are singing praises to the great God
schalaben schalamai schalamezomai
the ear of the great God hangs over the fighters
like a glass bowl
the shrieks of the comets wander in the glass
bowl over the lands over the battle over the endless fight
God's hand is beautiful as the hand of my beloved
schalaben schalamai schalamezomai
the grass dries in the general's abdomen
the shadows of the midnight sun sit on high
chairs
and the white of the nearby sea and the harsh clanging of storms that
 the volcano threw up
as God opens his mouth the caparisons and costly bridles fall off the
 backs of the mount
as God opens his mouth the wells of the
deep burst out the hanged men play at the edge of the woods the
heads of the horses hang on the crest of the billow
schalaben schalamai schalamezomai
ai ai ai I saw a throne I saw ten chairs of state
I saw ten times ten chairs of state and royal thrones
I saw the animals of the earthiac and the metal birds

of heaven singing the endless praises of the Lord
the phosphorus glows in the heads of the possessed schalamezomai
and the sows plunge into the lake called Leman
beat your breast of rubber let your tongue
flutter over the horizons wag your ears so that the ice grotto smashes
I see the bodies of the dead strewn over the carpets
the dead drop from church towers and the people
are crying at the hour of judgment
I see the dead riding on bass trumpets on the day of the moon
red red are the heads of the horses that swim in the prairie.]

This was in August 1916, at the height of the dadaist rage. There are symbols in this poem that are characteristic of what we were thinking in those days. The universal element, the totality, or the attempt to transcend the subjective and grasp the totality of the world, the universe, and experience. Then, the apocalyptic element, the fear of life as psychiatrists call it. A religious feeling exists between the two, it appears in all my poetry even though I do not belong to any religion personally. Lastly, the grotesque element, expressed in lines like "wag your ears so that the ice grotto smashes. . . ."

Arp wrote *Die Wolkenpumpe* [The Cloud Pump], a volume of poems that he handed to me personally upon arriving in Berlin in the early twenties. These poems are well formed and full of an ardent joy of colors; they reveal a sense of humor that, never turns monstrous although bordering on the grotesque. Arp aims at totality, depth, essence. After *Die Wolkenpumpe*, Arp published many more volumes of poetry. I can recall *Muscheln und Schirme* [Shells and Umbrellas], which came out in Meudon in 1930, and *Le Siège de l'air*, which as far as I know was written only in French.[29] A native of Alsace, Arp knows both languages perfectly, but his mother tongue is German, so he probably knows it slightly better. After World War I, Arp had to decide whether he wanted to be a German or a Frenchman. He tried to become a Swiss citizen, but the Swiss wouldn't let him. I'm not certain whether it was the Swiss critic Korrodi who, when asked about Arp's significance, replied that Arp wasn't normal (and quoted a few lines from *Die Wolkenpumpe*). There's no proof of it, or rather I don't have any, but in those days, Korrodi and his newspaper, the *Neue Zürcher Zeitung* (he was literary editor), were rather hostile toward us.[30]

In 1955, I met Herr Arnet, the editor of the *Neue Zürcher Zeitung* and a very pleasant man. I wrote an article for him, "A Knight in Con-

necticut" (see p. 108), describing my troubles as an actor in Hans Richter's new film *8 x 8*. The article came out promptly, and when Arp heard about it, he reminded me of the old feud; but he also felt that I had succeeded in breaking the ice. One should never give up with newspaper editors. They're like generals, and they often reveal the dubious qualities of politicians who, when doing something bad, claim they are working for the general welfare. Many people who work for the good of all often forget about the rights of the individual.

Arp and Sophie Taeuber reduced forms to the utmost simplicity. Sophie Taeuber's talent and energy were amazing. I saw very little of her, she sometimes showed up in the cabaret but never took part in our wild doings. She taught school and lived with Arp, who now lovingly attends to his deceased wife's fame. Thus she is the only woman who really made a name for herself in the development of the new art.

The simplicity I mentioned and that Arp writes about in his book *On My Way*[31] was in part mathematical and in part organic. We were fairly unaware of Piet Mondrian, one of the founders of the Dutch Stijl movement, whose rectangular forms deeply influenced the architecture of Le Corbusier, Mies van der Rohe, and Gropius. Therefore it is all the more astounding that Sophie Taeuber's works contained the seed of everything that the future would realize.

Collages, paste-ups of paper as well as other—theoretically any—material, appear early in Picasso's work. When I visited the great Picasso exhibition in the Louvre in 1955, I found a collage dated 1911; but there are probably still earlier ones. As in his *Still Life with Chair Caning*, Picasso and also Braque incorporated "foreign material" into several other pictures. Alfred Barr talks about it in his standard book *Picasso: Fifty Years of his Art*.[32] Arp and Taeuber, subsequently Schwitters, and indeed all the dadaists and surrealists made collages.

I sincerely believe that the finest collages are done by my wife, who together with my son and me had a show in 1951 at the Galerie des Deux Îles in Paris.

The interest in collages has never waned during the decades in which the new art developed from modest beginnings to what it is today. In Paris, Seuphor[33] and an intelligent woman, Herta Wescher,[34] are promoting and keeping critical track of the collage.

My wife, Beate, began to paint and sculpt when Arp came to New York in 1949 and stayed at our place. She turned out to have a lot of talent. Now she is a member of the American Abstract Artists, which was founded

by George L. K. Morris[35] some twenty years ago and to which Mondrian and Gallatin[36] belonged.

When I went to Europe shortly after World War II, I lived at the Plaza Athénée. In those days, an American in Paris could live the life of Riley on very little. Later, I had to stay in more modest hotels; but it always felt wonderful to be in Paris, even in the Hôtel Louvois, which faces the Bibliothèque Nationale and is separated from the Rue Richelieu by a small park right in the middle of the huge city. Here in the center, old and new Paris are uniquely combined. On the Avenue de l'Opéra, there is one de luxe shop after another—only a few steps away from a maze of charming little streets untouched by tourism and exhaling medieval openness. You can walk by butchers' and greengrocers' shops, studying *gourmandise* and the "French way of life"—naturalness linked with a special sophistication such as no other nation in Europe possesses. It is this form of charming sophistication that leaves room for the instincts of love-making and eating.

Until 1949, I never heard from or saw Arp after he left Berlin, in the early twenties. All I knew was that he was living in Meudon, near Paris. In 1936, I moved to America, and in my struggle for existence, my connections with dada were no longer as fresh as they had been. I had moved into life itself, I preferred it to art, and with my medical work I began a new existence. Now, after the war, I went to Europe to visit my father, who had grown very old, and I spent a short time in Paris. I walked along the Champs-Elysées, sat down in one of the big cafés, ordered a marvelous meal, and drank a bottle of Beaujolais to my health. The shock of returning to where my existence had begun was enormous. I never intended to look up old friends, and certainly not those who would remind me of my interrupted literary career. For some reason that I find hard to explain, I just couldn't visit Arp.

Tzara and Arp had finally settled down in Paris in the early twenties. Ball and Hennings spent part of the year in Agnuzzo, in the Ticino, and part in Rome. Overnight Tzara had got in with influential literary cliques, the underworld and overlords of the intellect, which had their headquarters at the Deux Magots and the Café de Flore. It was in these cafés that Aragon, Eluard, Soupault, Ribemont-Dessaignes, Picabia, Gabrielle Buffet, Hans Richter, Edgar Varèse, Igor Stravinsky, Huidobro, and others drank and lived. They sat behind their Pernods, discussing the great men of our time, the deceased, such as Lautréamont and Rimbaud, and the living, such as Picasso, Braque, and Mondrian. Sartre was not yet "le nouveau Dada,"

but his forebear, the Marquis de Sade, played an important part in the minds of intellectuals. Sade is the man who said that a human being is whatever he becomes through his vices; and in that pre-existentialist world, people were willing to accept that kind of dictum.

Breton, who had studied medicine for a while, was an extremely intelligent and talented man; he had read a good deal of Freud, thereby coming across the "unconscious." The UNCONSCIOUS, the automatic, the effect of chance. Here, a liberation from the increasing constriction of our world seemed to be rampant. War, brutality, a growing conventionalism, dictatorships, the middle classes and their reign of terror—what could be the remedy . . . ? Dada, brought to Paris by Tzara and Arp, had the same effect as in Zurich: that of an explosive antidote.

Dada had managed to stir up Zurich for a while. A few publications came out. Marcel Duchamp and Picabia's magazine *en voyage, 391*, showed the public that dada was more than just a local matter. The Galerie Dada and its public discussions on music and writing became a success far beyond the expectations of everyone involved.

In the Salle Kaufleuten, Tzara, Richter, and Serner had attacked an audience nervously fidgeting in its seats. What was the world coming to if literature, which parents used to teach obedience to their children, was involved in such carryings-on? Cocteau, Augusto Giacometti, Richter, Huelsenbeck, Eggeling,[37] Hausmann,[38] and others took part in the *Anthologie Dada*.[39] My old friend Ehrenstein[40] was peripherally active, and so were Mary Wigman and Laban.

Tzara's entry into Paris was a triumphal procession, and the manifestations in the Salle Wagram mortally offended all the people who regarded French art as a timelessly beautiful and immutable export product.

Surrealism, which has been described so often and whose history fills books on modern art and literature, grew out of dada through the teamwork of Tzara, Arp, Breton, Aragon, and Eluard. It soon became apparent, however, that there were two essentially different types among the intellectuals—artists and politicians. Tzara, Eluard, and Aragon opted for politics, and Breton opted for art.

Surrealism, which I didn't help to establish personally, interests me here only in terms of its effect on my mood in those days. Surrealism had its good and its bad points. In its introduction of the "automatic," it consistently followed through on Arp's discoveries in regard to the law of chance. On the other hand, it was essentially distinct from dada: it returned to a romanticism of the sinister, the void, nothingness. In dada, nothingness

means something different from what it does in surrealism; it has no touch of sweetness to it. Dada is rigor, relentlessness, an insight into the destiny of man and an understanding of the trap in which man finds himself; it is a philosophy from which Sartre drew a good deal of material, as he himself admits ("Moi, je suis le nouveau Dada").

Herbert Read, who, as I see it, misunderstands the significance of romanticism, is nevertheless perfectly right in calling surrealism a child of romanticism. Surrealism turns tragedy into a miracle, it expresses amazement at the beacon of total decline and finds it "oh, so interesting." By absorbing Freudian theories, it is not far removed from neurosis, arrogance, despair. Dada, however, in Arp, in Ball, and in myself, wanted to return to the mothers, not the sentimental ones but the strict ones.

I was sitting in the Café Sélect on the Champs-Elysées in 1947 and didn't know what to do with myself. I visited my old friend Marx, who, after useless efforts in New York, had finally landed an excellent job with the health plan in Paris. He lived in the Hôtel des Bernardins, one of those antediluvian little French *hôtels garnis*, smelling of unborn *rôtis*, with stairways like prison corridors, and toilets like . . . Oh, the toilets, I don't think I can come up with an apt expression. As a student, I lived in a Latin Quarter hotel that bore the pompous name of Au Grand Condé, but even the great condé would have never used those toilets. There was one located between two landings; the paper (*Matin, Figaro,* and *Humanité*) squeezed through the opening beneath the door, rolling and flying down the steps. And the inside, my God! One wonders whether this institution has anything to do with human needs. This is a theme for a doctoral dissertation at some future time when we can speak more freely than now about essential matters.

I will never forget the sensation of sitting on the Champs-Elysées. The wideness of the street, the spaciousness, the murmuring of men and women, the waiters busily piling up saucers, the typical French beverages, the dreadful coffee, the most elegant women in the world—all this adds up to an afternoon in a café on the Champs-Elysées.

Everything is different from what it was in my youth, when there were few cars, the Garde Civile rode through the streets—the hoofbeats still echo in my ears—and the milliners delivered hats and dresses in huge boxes. There was no commercial traffic, no rushing about, no mechanization pressuring stomachs and brains.

After finishing my meal at the Sélect, I wanted to smoke a cigarette, but

I didn't have any matches. Unexpectedly, a woman offered me a light. She opened her handbag, from which the fragrance of perfume wafted and a white handkerchief foamed out. She hunted around in her bag, half-consciously, as women do, apparently as secure in darkness as they are in light.

We began speaking, first neutrally, then with growing interest, and soon listening for deeper tones and searching for something hidden below the surface. A sensible and witty solution, the voice of instinct, an invitation to the theater or to a discothèque.

She said she was a teacher. Teachers aren't my ideal, but there are other kinds beside the British governess type with panther's teeth, bony fingers, and straight hair. There is such a thing as a young teacher. As a matter of fact, there are a lot of young teachers, and there have to be in a time when young ladies are forced by circumstances to work in order to help out their families.

Everything's clear, I thought. A beautiful girl forced to work by lack of money. What might have become of her otherwise? Someone would have discovered her, she would have become a movie actress, her hips, bust, and legs would have been projected on the screen to be admired by everybody, but really everybody.

She was a beauty, a small beauty, not a great radiant goddess, whom one looks at with a bow. She was well-proportioned in every way, demure and pleasant, reserved in every respect.

What I really enjoyed at the time was the sense of being lost in Paris and the feeling of not really belonging. I was glad to be an American, coming from a land that Europeans think of as a land of milk and honey. I knew of other things and realities in America, but I let everything seem to be the way Europeans thought it was. I strolled through the Jardin des Tuileries, stood awhile at the fountain, where in accordance with tradition French children (and adults) were sailing toy boats. I went to the Orangerie, which was having an exhibition of impressionists, and I thought about my new friendship.

I felt I didn't belong in the Plaza Athénée, where fat Aga Khan and the American actor Edward G. Robinson were staying, the latter with his family. In the evening, when I sat in the restaurant and tasted the different kinds of filet de sole and Beaujolais, I felt out of place. I found the elegance of the women and the exaggerated politesse of the men grotesque. I longed for simplicity, fresh air, and a trip to the country. I thought it might be a good idea to go to Fontainebleau or Versailles. Versailles was being reconstructed with Rockefeller's money, and so I thought it belonged a bit to us

Americans and that it was excusable for me to go there again, even though it was nothing but a tourist trap.

I thought of my little beauty and met her again in the Café Sélect. My efforts to turn her into a Colette character failed. I'm not the type of man to fit into a novel like *Chéri*. After all my experiences, the Hitler period, dada, the war, emigrating, the fight for survival, all charm had vanished, as well as faith and delight in beauty. Distrust, frivolity, and sometimes nothing but cynicism are the qualities that have remained in us.

Her name was Suzanne, of course. What other name can a Parisienne have? The name is so ordinary but as Parisian as a stone in the gutter. Suzanne . . .

She was a serious variety of the many Suzannes that inhabit Paris. Coming to grips with life seemed to fill out her day. Her eyes had something searching, something anxious about them. She was not part of the leisure class, to which so many women would like to belong. Work is a means to an end for them, but for Suzanne it was a condition. She was a teacher.

"Paris certainly has changed," I said.

Suzanne felt that Paris was as it always had been. The city had not been destroyed. A German general whom Hitler had ordered to destroy the city preferred to listen to his good instincts at the last moment rather than to the dull fury of the Austrian adventurer.

Suzanne told me that the Germans had acted decently at first, but then as the underground became more active, the Germans had made a daily practice of arresting and shooting people. In Vincennes, they had shot twenty hostages, men and women who had nothing to do with the whole thing.

I noticed that Suzanne's face was growing more earnest; but it wasn't memories that were changing it. It was a general earnestness derived from a *Weltanschauung* that I didn't know.

I suggested that we go to Versailles. She had a few days off, and so we took a taxi to the Gare des Invalides.

The Gare des Invalides is located underneath a railroad station for air passengers from all over the world. Upstairs, splendor; downstairs, everyday French life. You walk through the darkness of an immensely sober hall screened by cement ceilings. Silence mingles with the smell of machine parts, the breath of oil and rags. You can see Paris through rough-hewn windows—even the Eiffel Tower, that weird structure built in an age in which technological pride could still become part of a landscape. The Seine

Bastmatten sind die Wände des Himmels und aus den Wolken kommen
die großen Fallschirme der Magier
Larven von Wolkenhaut haben sich die Türme vor die blendenden
Augen gebunden
O ihr Flüsse Unter der ponte dei sospiri fanget ihr auf Lungen und
Lebern und abgeschnittene Hälse

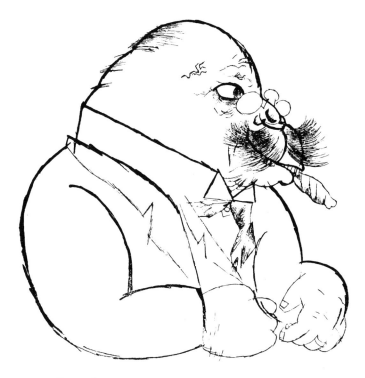

In der Hudson Bay aber flog die Sirene oder ein Vogel Greif oder ein
Menschenweibchen von neuestem Typus
mit eurer Hand greift ihr in die Taschen der Regierungsräte die voll
sind von Pensionen allerhand gutem Willen und schönen Leberwürsten

10

and, of course, apartment houses, big ones and little ones, thousands of them, stone blocks and more stone blocks. I learned that Paris is no different from other big cities. If you go beyond the city limits, you see the ugliness that modern manufacturing brings into human life. When nations like France and Italy do "technological" construction, they totally ignore beauty.

Suzanne's resistance to Versailles grew the closer we came. How stupid it was of me to take her where every tourist has to go. I could have had any number of better ideas; but not the "public monument," as Suzanne put it, where the kings and their mistresses had drunk chocolate in gilded beds until one day the shouts of the *pétroleuses* awoke them. *Dies irae, dies illa . . .* It may have been the apocalyptical part of this adventure that always attracted me. The idea that a man has everything and then nothing, the infernal paradox of life, which the ancient Israelites were thinking about when they said that the first would be the last.

The gardens of Versailles are beautiful, the Trianons, the yew hedges, which in their pruned straightness so effectively symbolized that bygone age.

As a guide took us along with a horde of tourists through the palace, Suzanne spoke to me about these things. We enjoyed walking along the well-tended paths through the park and the woods to the Trianons, where Marie Antoinette once lived and where she may have spoken the words that became famous as the most arrogant remark in history: "If they have no bread, let them eat cake. . . ."

But we know how the words of historical figures get distorted. Perhaps she was simply a queen raised with the royal idea that there is only one kind of human being: her kind. . . . It was a tragic mistake.

We were talking, and Suzanne's ironical hostility toward anybody trying to be better than "the common people" became clearer. I realized that she had been politically indoctrinated and had settled firmly on her opinions. This made her no different from kings or royal mistresses. She had simply draped the royal mantle around the proletariat. "The common people" were the absolute, they were God in Suzanne's ideology. No one was permitted to interfere. She was, as she admitted to me, a Communist, a member of the French Communist party.

She had witnessed the liberation of Paris and cheered the Americans; now she hated them. It was a quiet, fanatic hatred, but it was not directed at me. She said it wasn't directed at me or any individual. Good Communists are moderate about everything, they love and they hate moderately. That was how Suzanne was.

Through her father, Suzanne had gotten to know the Münzenberg group.

Münzenberg,[41] a Swabian, had an almost unique organizational talent, aggressive and pro-Communist, but disguised by his bonhomie. He put out newspapers and magazines that he circulated all over the world under the guise of liberalism.

Münzenberg was one of those men responsible for making so many innocent fellow travelers believe that Communism was working for the greater freedom of the individual. He and his co-workers Otto Katz and Arthur Koestler belonged to the Comintern, that great secret organization piloted by Moscow but possessing its own moral, or rather immoral, laws. Theirs was a fanatical troop, whose members belonged to it body and soul, as Koestler points out in his book *The Invisible Writing*. Disobedience spelled banishment and death. Münzenberg was killed, Otto Katz was killed, and Koestler escaped death only by a miracle. He may have been a true liberal unable to identify totally with his goals.

I must admit that today I find it incredible that these groups, which were stronger in Germany than anywhere else, never succeeded in drawing me in. I met Otto Katz through Piscator.[42] He was working with Piscator for the "theater," but his theater wasn't the stage, it was world politics. He regarded himself as a grand politician, until his comrades strung him up in Prague. He changed his name to André Simon, a lovely name, but beauty has no effect on murderers. If he had died promptly with Egon Erwin Kisch,[43] whom I also knew, he would have gotten a ceremonious state funeral, schoolbooks would be praising him, and a street would be named after him.

Once in the early twenties, I had a date with Otto Katz in Berlin. We sat in the Café Kranzler. Then we went for a walk along the Unter den Linden, as if it were Sunday. I can't remember the details exactly, but it was obvious that this professional revolutionary's goals were different from what he said. He knew that I was politically inexperienced. But nothing happened, and nothing came of it. Koestler was still completely unknown; I once ran into him at the Ullstein publishing house, where he was working. He was the type of man that people like Katz were looking for, namely a liberal in love with, but not really loving, Marxist philosophy. Under such circumstances, exploitation becomes sacrifice, discipline becomes manly self-control, and murder an act of sublimated brotherly love.

Otto Katz, alias André Simon, may have considered using me for his purposes. We talked a bit about a book by Anna Louise Strong that had just been put out by the Malik publishing house; then we said good-by. After a slight whiff of Communism, I became its absolute enemy.

Suzanne and I walked through the garden of the palace of Versailles,

and although I sympathized with the background of her world, I couldn't help revealing my aversion. Our conversation struck a hostile chord, we tried to get away from it, but we couldn't manage. And so my friendship with Suzanne, a true little beauty, came to an end.

In 1950, I returned to Paris for the second time after the war. Arp had already been in New York and we had renewed our friendship. This was a time when the French were still suffering greatly from the consequences of the war. The sincere efforts of the Marshall Plan were pilloried by the newspapers as a diabolical plot; the universal aversion to America was revealed in all sorts of vexations and sometimes in open hostility. Friends of mine had their tires slashed; others got into verbal and physical fights.

I visited Arp at his home in Meudon. Meudon lies on the route to Versailles, the same road that I had traveled many times as a student and subsequently with Suzanne. Meudon-Val-Fleury does not have an impressive railroad station. It has little or nothing of the cachet that France is so proud of. You climb up a long narrow street, choking in summer dust, outdistanced by awful motorcycles whose chief goal is to disintegrate the world with noise.

There is a public square named after a dead resistance fighter. Halfway along the square, you can see Van Doesburg's house, shaped like a cube, where Nelly van Doesburg is now living. Rodin lived and died somewhere around here. The homeliness of the entire surroundings is overwhelming. Small grocery stores and dairy shops fit in with Meudon's monotony. There are taverns here and everywhere, with signs saying that you can bring your own food. *La douce France* is not ubiquitously sweet and tender.

Arp's home was on a hill, at the end of an ascending street. The woods begin right behind it. Ancient trees, their high crowns swaying against Arp's roof. Even if you weren't sure of where you were, you couldn't mistake the house, for suddenly, behind a normal fence, you caught sight of abstract sculptures, world eggs, universe breasts, space thighs. This was Arp, here's where the master lived. He settled here in 1926 with Sophie Taeuber, who died in 1943. In 1950, he still kept her clothes in his closets, and her paintings covered the walls.

Arp gave a reception for me in the Café Sélect on the Champs-Elysées. Picabia was there; his wife, Gabrielle Buffet; and many others, including Michel Seuphor, an extraordinary young art critic who has also made a name for himself as painter and graphic artist. You sit and talk. You look and you're looked at: that's the whole point of the French coffeehouse. Socializing plus intellectuality and projects. You talk about new paintings,

new magazines. So-and-so has started a new magazine. Is it good . . . is it bad? Only fifty copies . . . ? They've stopped publishing it . . . ? They'll try again. Oh, this public, infected by movies, radio, and cars. "Waiter, another Pernod, please, and *s'il vous plaît, un sandwich jambon*."

In those days, you couldn't buy hot dogs in Paris. Now, there are cafeterias, self-service restaurants, that smell of linoleum and detergents instead of food. The business ideal of our age has won again. Food isn't as important as hygiene, glass, cement and brass rails, and vitamins. But let's not waste any words on those subjects.

I met the German painter Baumeister,[44] who died in 1955 in Stuttgart at the age of sixty-six. The Nazis wouldn't let him paint because they felt they had to keep his "degenerate" art away from the healthy minds of the Hitler youth. Yet he was one of the pioneers of abstract art in Germany, whereas Beckmann,[45] whom I met at Valentin's, is actually an expressionist.

Baumeister was one of the few artists in Germany with a feeling for the primitive. He found inspiration in prehistoric drawings and transferred the dynamics of the murals in Altamira and Lascaux to his drawings. He was a mild, pleasant man, thoughtful, kind, and talented, a friend of Arp's and Seuphor's, one of the "decent" generation.

I visited André Breton.

He lived in one of those narrow streets that converge like a web of arteries on the heart of Place Pigalle; one of the many petty-bourgeois streets of Paris that have lost their old charm without acquiring a new one. I looked for the house entrance among dusty shops and taverns that emitted the wine- and Pernod-oiled voices of lower middle-class Frenchmen. Here, an old movie house, no longer in use. There, a wall with drawn blinds. Aha, at last! You walk through the usual courtyard, and the concierge raises her breasts from her sewing. The cat inevitably near her stiffens and curls its tail.

I walk up a spiral staircase, come upon a number of doors with calling cards on them, and end up at the door with the name Breton on it. A great name written on a small area in simple surroundings. Breton was certainly a great man who will go down in the history of French literature.

I received a warm welcome, his girl friend served the meal from behind the curtain. The walls were covered with modern paintings. I looked at a huge library. This was the home of a great French intellectual.

It was a get-together that I remember fondly. Friends came by, we spoke

about everything exciting in art and literature. The evening was less cere-
monious than a visit with Gide, but equally rewarding. You came home
with the feeling of having been with important men.

One day, Seuphor and I went to one of the typical little cabarets near
Saint-Sulpice. The sentimental songs, the irony that was limited to two
themes, sex and politics, reminded me of my student days. Le Chat Qui
Fume, Le Chien Qui Pêche, or vice versa. Le Boeuf sur le Toit. And it
sounded as it had in the days when I lived in the Hôtel de la Sorbonne,
loved a Russian girl, and comforted the Yugoslav student who could only
sleep with corpulent women.

> Quand les papillons fermeront leurs ailes,
> les fleurs naîtront pour durer toujours,
> les chansons d'amour seront éternelles.

> [When the butterflies close their wings,
> the flowers will be born to last forever,
> the love songs will be everlasting.]

The newsdealers had vanished from the streets of Paris. *L'Intransigeant,
Liberté, La Presse*. Rochefort, the strong man, had been buried long ago,
probably in Père Lachaise, like all French celebrities. Bergson was dead,
Lichtenberger, everybody.

I showed my son the Hôtel de la Sorbonne. From outside, I looked into
the former dining room and discovered the window seat where I had
spoken with the very anti-German grandmother. And here were the stairs
down which my valise had tumbled, spilling my belongings all over the
place. "Ah, ah, monsieur," the proprietress had said, but her husband simply
stood aloof and gave me a dirty look. They couldn't realize that the worst
was still to come. After 1914, France fell to its knees twice, and on its
stomach once; the "empire" was breathing its last, like all empires. And
then America came on the scene. Jukeboxes, TV furniture replacing Louis
XV commodes, the battle of the grape growers against Coca-Cola, Mon-
sieur Mendès-France who tried to introduce milk drinking, the bicycle
tour as the major national event, the decline of literature, the movie house
as the temple of the restless, the advent of the motor scooter, Monsieur
Sartre with his morality of complete "laisser aller" (anybody can do what-
ever he likes, as long as he develops into a personality), the more and
more powerful desire for dictatorship and the increasing opposition to
democracy and parliament, American anti-intellectualism, earnings as the
sole test of capability, and so on.

My son said: "You can still find sawdust on the floor of French restaurants."

"Certainly," I said, "and the women are still fashionably dressed, beautiful and elegant."

We were sitting with Marguerite Hagenbach, Arp's girl friend, at the Doucet (in the Rue Marbeuf), a place devoid of any *chichi*, and where you get your money's worth. And what you get *is* worth your money. In my student days, Paris had a chain of Duval restaurants. The Doucet is similar. There's a manageress in a raised cage, looking down at you like a New York police sergeant.

Arp had had two heart attacks. Then one day, while climbing his little mountain in Meudon, he broke a leg. We feared for his life. When I visited him in the hospital, he was calm and friendly.

"I'll talk to the doctor," I said. "After all, I'm a doctor myself."

Meanwhile Seuphor arrived, along with his wife, Suzanne, and my wife.

We stood around Arp s bed and discussed a dada anthology that a Zurich publisher wanted to put out.

"You've got to write the introduction," said Arp. "I don't think I'll have enough time. . . ."

"All right," I said, "I'll write the introduction."

I came to realize what the dadaists had accomplished as poets, Arp, yours truly, Tzara, Schwitters, Ball, Hennings, and the others.

"Everything's clear," I said, "I'll write it with whatever material there is. . . ."

Then we embraced and said good-by. Two days later I flew back to New York.

IV

The direct reason for my return to Germany in 1917 was the closing of the cabaret. Ball and Emmy Hennings had moved to Agnuzzo, in the Ticino, where he intended to live a solitary life in accordance with his religious inclinations. I next saw him in 1926 shortly before his death of esophageal cancer; the doctors had already given him up for lost.

It is no longer up to me to say anything about Ball's great importance. Besides *Flight Out of Time*, which, I believe, formulates all the essential ideas of our age, he also wrote *Byzantinisches Christentum* [Byzantine Christianity] and *Zur Kritik der deutschen Intelligenz*. Both works derive

from the same intellectual source, although treating completely different themes. Ball's passion concentrated on God and religion, his hatred of stupidity, and a special form of stupidity characteristic of our time as it developed from the industrial revolution. I think that despite his identification with Catholicism, Ball remained a Protestant. He had protested by means of dada. When his protest grew too loud for him, he retired, but he continued to protest against everything that had evoked our wild outbursts in the cabaret.

Ball was not a visual artist, but his comments on modern art reveal a profound understanding of all its problems. He was an avowed enemy of Communism, even in those days when Communism was hardly known in the United States. Ball was a major poet, although formally he remained within conventional limits. In his novels (chiefly in the unpublished "Hotel Metaphysik"), the fantastic, surrealist element plays a great part. Ball felt the diabolical, the sinister, and the irrational in the world and in people, and he tried to integrate these elements in his concept of the personality.

Ball's departure made Zurich unbearable for me. When we returned to Europe after World War II, I had powerful memories of Hugo Ball and what had happened to him.

I recalled mountain climbing in the Maggia Valley, when Hugo and Emmy were living in dire poverty after the death of Emmy's mother. Emmy's daughter, Annemarie, was nine years old. She showed a great facility in drawing and painting. Hugo really loved her, and when the family lived in Sant' Abbondio he helped her get a commission through his friend the planter Baumann[46] (author of *Tropenspiegel* [Mirror of the Tropics], an interesting book). Frau Baumann commissioned Annemarie to paint up her house with murals. On my desk, I still have a Don Quixote executed in terra cotta from a drawing of Annemarie's. But all this is less important than the goat that Hugo brought on a short rope to the Brussada, a thirteen-thousand-foot mountain on whose peak stood the stone house in which the Balls had settled down to write. In the course of two months, they were visited only by a chamois hunter, the solitude, and the stillness of the nighttime moon. The beauty of the Alpine meadows beyond the windows, which weren't windows so much as holes that the "mason had left in the wall."

Here, the holy family lived with a child, a goat, a typewriter, and a strong desire for solitude and poverty. This philosophy was the opposite of everything that makes the world go round: the striving for success, riches, and comfort.

I don't know how justified one is in praising or censuring an event of this sort. Going out and up the mountain sometimes seems to me like a metaphor for poverty that wants to go far. Then I agree with Shaw, who says in *Major Barbara* that poverty is a crime. "I often think of Hugo's death," said my wife. "I really think he could have prolonged his life by living more sensibly. . . ."

In her womanly way, she accuses Emmy of never having taken proper care of Hugo. But Hugo wasn't looking for a housewife in Emmy; he was seeking childlike innocence, childhood, the unconscious, the fairy-tale world, and the metaphysical.

The tobacco planter Baumann had allowed the Balls to use the house in Sant' Abbondio. A former cloister with huge rooms painted blue and red, with flowers and hovering birds. There was also a chapel, which Emmy immediately decorated and adorned with flowers.

The church was only a few steps away, and the bells rang into the rooms. Hermann Hesse, who was painting, was also nearby. Everything within easy reach.

Hugo thought of doing a book about exorcism and psychoanalysis. He knew Dr. Lange, a psychoanalyst who told him about Freud and with whom he discussed Freud's books. Hugo believed that the devil had been rediscovered and was becoming a center of universal interest because of Freud's writings.

Hugo's constant endeavor was a definition of the devil, immorality, evil in the world. He believed that if he could succeed in his definition, then the spiritual could be grasped and experienced. The diabolical had to be checked. The discovery of the devil would let magic come into its own and enable it to turn human life into a paradise.

"What happened with the water from Lourdes?" my wife asked. Emmy had procured some. Hugo had complained about pains in his throat and received different kinds of advice from various doctors in Lugano. Precious weeks were lost; then, in Zurich, his ailment was diagnosed as esophageal cancer.

Hugo lasted only a few months more. The water from Lourdes?

I heard about it from my friends in Zurich. The Balls sent away for some of the holy water and received a catalogue: so much for large bottles and so much for small bottles. I assume they ordered a large bottle.

"Did they really believe in it?"

"The diagnosis had already been made. . . ."

We held our peace and had our own thoughts on the subject. Was it

naïveté? Was it madness? A confusion of realities, a distortion of facts? Can you kill a tiger with soda water or stop a train with a yodeler? That would be a real miracle. . . .

Miracles hinge on reasons that may be hidden but that do exist. They are the final product of a long series of consequences that we never hear, see, or understand. A miracle is like a telephone call from God; we can be certain that the Old Man hardly ever picks up the receiver and that in most cases man is left to his own devices. This is something our age has learned.

Hugo Ball wanted to join the angels in heaven. He was a man who hated our time, calling it a work of the devil; he wanted to flee into the Middle Ages, to Byzantium, to Paradise. Emmy, the blue flower, the angel, the child (suffer the little children to come unto me), the fairy, the woman representing the Unconscious, the Divine, the Miraculous, she was I and thou together. She knew she was desired in a special way, and so she created Hugo's world while neglecting certain things that might have been necessary to someone else. Her comb lay next to the butter. She bought a huge bottle of water from Lourdes. She writes about it in her book *Hugo Balls Weg zu Gott*:

> . . . I had ordered holy water from Lourdes, and when he had trouble breathing he only had to cross himself and put a bit of the water on his heart to feel instant relief . . . thus this powerful, intellectual man, who studied the deepest and most serious problems of life, needed the most poignant and pious remedies until the very last moment. . . .

Ball died in September 1927. I had visited him repeatedly, as Emmy writes in her book. We carried him to his grave on a day on which heaven poured its entire wrath on mankind. Karla Fassbind, who usually lived in Paris with a Polish musician but owned a number of hotels in Switzerland from which she drew a good income, invited us to dinner afterward. There was no one there besides her, Emmy, my wife, and myself. We were soaked through and immersed in the mood of depression that follows funerals. Bewildered yet not unglad to be alive.

We didn't know what Emmy was thinking. They had to take off her wet clothes. She lived in another world, although her head, her hands, and her legs were there at the table. A tragic figure such as I have never seen before. Her life was over. The man who had made her a madonna, who had made her philosophy his own, whom she had influenced so deeply that he lived her life as his own, had just been lowered into humid earth. The fairy tale was over.

My friendship with Arp did not develop until much later, after the Second World War. Tzara, whom I visited several times, remained alien to me. I was extremely fond of Janco.

I would like to depict objectively the part that Tzara played in dada, even though I admit that it is difficult for me to do so. Tzara's claim to having discovered dada is one of the eagerly recorded ironies of world history. Since Tzara had a wide open field in Paris for many years, he managed to satisfy his ambition to find important followers. His court chronicler, Hugnet, described everything in accordance with the master's wishes.

A dictionary of modern art, published by Knaur in Munich in 1955,[47] lauds Tzara as the inventor of abstract art. He claims to have coined the term "abstract art," although even laymen know that the term was used as early as 1909 by Wilhelm Worringer in his book *Abstraction and Empathy*. It's not wise to put on airs.

Tzara's conception of dada, as revealed in his manifestoes, concentrates on its completely negativistic, crazy, irrational aspects. The concept of paradox, of negation and canceling out, which Sartre later formulated, becomes clear when we hear over and over again that "being a dadaist means coming out against dada."

Tzara's poetry, however, is markedly rationalist and rarely achieves the genuine poetic tone that occurs so powerfully in Ball and Hennings. Arp, in his book *Our Daily Dream*,[48] states that Tzara wrote important poems; but I personally feel that Tzara never attained anything extraordinary. No one expects screaming and noise to be convincing, but once peace and quiet settle in, one wishes to see a poetic personality.

Tzara tried to give his personality an aura of esteem and luster with Communism. Together with Eluard and Aragon, he exerted a great—some say tyrannical—influence in the twenties.

The question of political radicalness was, as I have indicated, discussed and resolved in Ball's *Flight Out of Time*. I personally never had any inclination toward political activity. So it was odd that all the people involved in dada became political—not by joining the party (as far as I know, only John Heartfield was a member of the Communist party). Nor was it the content of Communism that attracted us. What made us, shall we say, sympathizers, was the revolutionary impetus, which in those days could be found only in that party.

An added factor was the reaction of the German government, which, during the reign of the kaiser, tried to preserve the illusion of a feudal

system until the very last and, under the Social Democrats, readily inch by inch lost the ground that had been won by the efforts of the workers and soldiers. After the collapse, we were repelled by the pseudo-bourgeois or rather petty-bourgeois mentality of the Ebert-Scheidemann people.

Naturally, we soon realized that the political radicalness of the Communists was accompanied by a mentality that was not only petty-bourgeois but also tyrannical and—most important of all, as far as we were concerned —hostile to culture. While the Social Democrats with their principle of "live and let live" never managed to set up a politically viable structure, the Communists were prevented by their total ignorance of cultural and human problems from achieving anything constructive. After observing them for a short while, I began hating them. In my eyes, they were worse than the German aristocrats, who had ruled the land brutally but with a certain intelligence. One could live with them, even if one couldn't breathe freely.

Hugnet and others have claimed that Berlin's dadaists were nothing but revolutionary politicians. It has even been claimed that during the short-lived Communist regime I accepted a position as art commissar. All these claims are either malicious or ignorant.[49] The fact that Tzara later developed into a Communist and that I became an out-and-out enemy of Communism tells the true story.

Dada, as I see it now after so many years, was a revolt of the personality that was threatened on so many sides. It was a revolt against imminent leveling, stupidity, destruction. It was the distress cry of creative people against banality, such as Ortega y Gasset subsequently described in his famous book *The Revolt of the Masses.*

This revolt was turned by Tzara and his followers into a new form of suppression—political Communism. As grotesque as it may sound, in Berlin we projected our resentment into politics, but we were never really political. We remained eternal revolutionaries. We projected into art as well, but since there was more politics than art in Berlin, art got the worse end of the bargain. There is a difference between sitting quietly in Switzerland and bedding down on a volcano, as we did in Berlin.

Our artistic interest in Berlin was no less keen than that of the dadaists in Zurich—as our books and manifestoes plainly show. What I personally brought to this atmosphere was a pre-existential note. According to my mind, my tendencies, and my emotional state, I was the first existentialist.

Because of our ultramodern system of communication, every notion loses its meaning, and thus the concept of existentialism has nearly lost its meaning. Sartre, Jaspers, Gabriel Marcel, are names for snobs, to be used as

bait at cocktail parties; but for the average brain, existentialism is identical with "doing one's own thing totally"—rape and murder, homosexuality, and the like.

I see existentialism as a philosophy primarily concerned with human beings and their affairs. We were existentialists in Zurich when we came out against war with our poems and songs.

In all my writings, man and his needs play a major part, although I have always been far from any sentimental humanism. For me, existence and the right of the personality were identical, and for this reason alone, I could never have become a Communist. The notion of the common people, much as I supported it, often took on the menacing physiognomy of the masses. In a word: I regarded existence as the survival of the creative individual in an age of bleak leveling. The expectation of leveling and its obvious inevitability often manifested themselves in grief, negativism, and aggressive irrationalism.

I was by no means in favor of any traditional aristocratic hierarchy. It was much more a state of exhausting conflict, in the course of which one often had one foot in a friendly camp and one foot in an enemy camp. The universal existential resentment could theoretically have been projected into all opinions and activities of life. But we succeeded in formulating it only in art.

Heidegger's idea that man is lost in this world became clear to me in 1917, when I came back to Berlin. The situation, which hadn't been very good when I had left the city in 1916, had turned tragic. The war had done its work, many of my friends had been killed in action, the desperate problem of food occupied everyone, theoretically and practically. What would become of Germany? And I asked myself: What's to become of man?

The negativist feeling, the resentment toward our civilization was surprisingly confirmed when I arrived in Berlin. It was as if somebody had said: "Here is the proof of everything you people have said."

The disappearance of German humanism was symbolized in the unlimited rule of the military, whose catechism was made up of two principles: Kill and Hold Out.

However, it wasn't that we weren't willing to make sacrifices or that we weren't interested in Germany's fate. Anyone claiming this is a victim of chauvinist blindness. There wasn't and isn't anything I would rather see than a free, great, and happy Germany. The fact that we couldn't "hold out" was due not so much to a lack of patriotic conviction as to our insight into the furious, self-destructive tendency that we blamed on a cer-

tain group of people. The war, we felt, was not any kind of political, economic, or other necessity, but a product of the sick megalomania of a certain clique who couldn't see the needs of their age and were unwilling to give up their privileges.

Thus, dada was of its time and painfully realistic. Its demonstration of nothingness, madness, and destruction was quite constructive. We weren't political, we were literati and artists and thus could express ourselves only symbolically. Now that dada has been examined and understood, people realize that initially symbols are hard to comprehend, but ultimately they exert a lasting and deep effect. I myself was in the midst of developing and I can't say that I had clear notions about any problem. I wasn't a sculptor and painter like Arp, I wasn't a mystic like Ball, I wasn't trying to reach heaven by means of innocence and charm like Emmy Hennings, I wasn't an international *homme de lettres* like Tzara. What was I and how could I express myself?

My strongly developed sense of reality made it difficult for me to become a fan of abstract art. Art as such became a problem for me in regard to human destiny. I was a child of my age, an individualist connected in some mysterious way with all mankind and its troubles. My fight for the personality and against the tyranny of the masses gradually turned out to be a family quarrel. I didn't want the old world, I wasn't looking for a paradise in the past. I was and still am a child of my age, with its technology and all its paraphernalia, but I wanted our age to have room for the creative man. This was the justification for our fight against the philistine, the bourgeois, and the insipid substance of middle-class life.

The natural meeting place of literati in Berlin in 1917 was the Alte Café des Westens. I headed there immediately and soon found my old friends—at least those that were still alive.

I can remember a thoroughly motley group that made up Berlin's literary Bohemia in clouds of cigarette smoke behind tiny tables. Gottfried Benn,[50] Else Lasker-Schüler, Resi Langer,[51] Baron Schennis, Taka Taka, and the skin-and-bones drug addict Höxter,[52] a master moocher. I met the Herzfelde brothers, who later joined the dada movement—Wieland, the head of the Malik publishing house, and John, who had changed his last name to Heartfield and is credited with inventing photomontage.

I saw George Grosz again. He had returned from the front, and we became good friends. He introduced me to Max Herrmann-Neisse[53] and Theodor Däubler.[54] I was also introduced to Franz Jung,[55] a strange mixture of superpolitician, string puller, and *littérateur*.

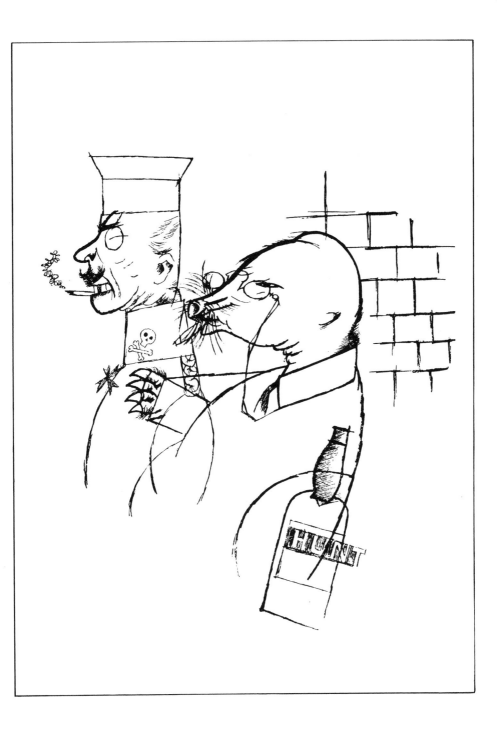

It was almost as if all these people had been merely waiting to hear the cue "dada." I decided to have a reading together with Max Herrmann-Neisse, Theodor Däubler, George Grosz, and others in the Galerie I. B. Neumann[56] on the Kurfürstendamm, the main thoroughfare of Berlin. We read poems, but beforehand we had to show our manuscripts to the police. At the station, there were a bunch of elderly, white-bearded officials who could barely read or write, but who tried to blue-pencil any antipolice words in our verses. Generally, however, we could talk them into leaving our writings intact. Since they didn't understand anything we submitted to them, they acquiesced and their consciences never bothered them.

The reading took place in a small room on the first floor of the building. I told Herr Neumann I would give a brief introductory speech. Which was all right with him. Then, without his or my friends' knowledge, I spoke about dada. I said the reading was dedicated to dada.

At the time, I myself didn't know what dada was (it was only much later that I did know), and it may have been the incongruity between my aggressive statements and my ignorance that excited the audience, my colleagues, and subsequently the press. Here in Berlin, as in Zurich, I played the part of the drummer, flourishing my cane, violent, perhaps arrogant, and unmindful of the consequences.

The most hostile of all was Herr Neumann. He lost no time in threatening to call the police and had already lifted the receiver when my friends began protesting. He didn't call the police, but he has never lost his aversion to me nor has he forgotten the embarrassment caused by my announcement and by the fact that he wanted to have the police remove a spokesman for a now famous movement of art and thought. Later, Neumann lived in New York and had a gallery on Fifty-seventh Street. Whenever I ran into him, he eyed me suspiciously. Däubler and Max Herrmann-Neisse were undecided as to whether they wanted to go on. But then, when the audience started growing riotous and demanded that the reading continue (because they wanted to hear more about dada), these writers reluctantly gave in. Grosz read his poems. Then I came on and read. The audience remained silent. I recited the *Phantastische Gebete*, and no one knew whether this was dada.

The next day, the newspapers ran huge headlines, which is unusual for readings of this kind. Most of the papers were indignant, others tried to make fun of dada. A good deal was said about the word "dada"; it was called baby talk, jungle noise, parrot chatter. Much to Däubler's and Herrmann-Neisse's sorrow, a number of critics earnestly discussed dada, which forced the two of them to print a public statement against it.

George Grosz, who while living in America turned into a great enemy of dada, was very much for it in those days. He dubbed himself a "Dada Marshal," gave us his drawings for our publications, and joined our sessions. In his memoirs, *Ein grosses Ja und ein kleines Nein*,[57] he tries to ridicule dada and, although not in so many words, to slander all the people involved. In this collection of curious anecdotes, Grosz seems to lack any understanding of the cultural significance of dada and modern art.

Generally, dada was rejected for very understandable reasons by all those who regarded it as an assault on the "sacred values of European civilization." Such people were and are conventionalists, who simply do not realize that values change. They regard culture as something absolute. Everything has to be the way it's been handed down from their parents and grandparents. Any change is looked upon as blasphemy.

But one has to realize that cultural values sometimes change as quickly as the weather. As soon as one realizes this (and considering our knowledge of history, there can be no doubt about it), then one has to ask oneself: Can art in our machine age, in which everything that used to be "right" has been turned topsy-turvy—can art still remain the same as it was? Since we're speaking about art (and I have emphasized that art was merely a field of projection for dada), we must bear in mind that the easel picture, with its perspective depiction of reality, is a very recent invention.

One can reproach dada with as many things as one can praise it for. If one regards it as purely destructive, one has to admit that if new values are to be created, old ones have to be cleared away. On the other hand, if one credits dada with primitive strength, one must be aware that in all ages of revolution, an anti-intellectual primitivism becomes manifest. If one connects dada with the development of "abstract" art, one must remember that the image of man and the human substance of Renaissance paintings and of all similar paintings corresponded to a religiously and morally structured era and that since Copernicus and man's sense of being "lost" in the world, no contemplative realism can exist.

If the sense of freedom, which our era imparts in technology and mass democracy, is linked to neurosis, then no one can be annoyed that we have no time to sit with our hands folded in our laps before the old masters. One can hardly blame dada if our period prefers a personal expression in art and morality to the earlier absolute structure. The step from academicism to dada is no more and no less than the ultimate task of the universal ideal in favor of personal responsibility.

The forced reintroduction of a saccharine academicism, which we admire

in Bouguereau's smooth-bottomed nymphs or in Grützner's[58] carefully detailed beer steins, is as impossible as the attempt to turn a dead mule into a living race horse.

Our struggle in art was aimed not at representational art—although we came out with quite a number of excited comments against it—but at academicism. To understand the tyranny of this mentality, one has to go through the history of modern painting and read, say, Manet's tragedy; all through his life he tried to break through a wall of bleak prejudice. Conventional rationalism (by way of parenthesis) has always been more powerful in France than anywhere else, and strange as it may seem, revolutionaries in art have always had a more difficult time there than anywhere else. French academicism was more tyrannical and more dreadful than that of any other country in the world.

I said that the struggle of modern art was aimed at academicism and not against any special form of art, whether representational or abstract. The problem of abstract art is much too complicated to be treated here in detail. I have already described my comical dispute with Arp, in which I defended Renaissance art. In my piece *En avant dada*, I make fun of abstract art. And I have felt the same way about "abstract literature." I often feel that literature has a purpose only if it comes from the wide concrete sensuality of the world, of everyday life, human habits, and universal emotions. Literature has to be a literature for all in the best sense, naturally not in the sense of the official socialist realism of the Soviets.

When we met in Berlin, we would discuss the organization of our readings and the *épater le bourgeois* element in our activities. The slightly sinister Franz Jung, who like Max Herrmann-Neisse came from Silesia, would occasionally invite us to wild drinking bouts. I recall one night that we spent in a bar near the zoo in downtown Berlin. Jung, I, and the two Herzfeldes were there. We were drinking, and one of us had cocaine. We all tried some and became noisy and aggressive.

We talked the waiter into letting us spend the night in the bar, and the session was continued uninterrupted the next day. When the cleaning women came in the morning, we were all sitting or lying at the table, drinking, and swallowing cocaine. John Heartfield, our "Monteur dada," as we called him, became so unruly that we had to hold him back forcibly. We finally dragged him off to a taxi and drove to Wieland Herzfelde's studio on the Kurfürstendamm. It was located high up on the top floor, right under the sky, and only a few feeble iron banisters stood between it and a profound void. Here, among publishers' crates, rolls of paper, books, manu-

scripts piled up around the walls like bottles of wine, we continued our revels. John Heartfield was tied to a chair, and we teased him with words and poked him the way people bother an animal in the zoo.

I was so drunk that I suddenly thought of setting the whole place on fire. I ignited a small torch and headed for the manuscripts. My friends leaped upon me and grabbed my firebrand. After that I must have passed out for a while. But I still had a good deal of energy left in me. My friend Klapper, whose medical practice I covered and in whose apartment in Steglitz I was rooming, suddenly showed up. The Kurfürstendamm is about two or three miles from Steglitz. It was about six A.M. Klapper hailed a horse-drawn cab (Berlin had lots of them). Nobody could get me to climb in. Klapper sat in the old leather cushions. I trotted alongside the cab for three miles without getting out of breath, one, two, one, two.

I don't remember how I met Hausmann. Suddenly, Hausmann and Baader were there, just as all the others suddenly were there. They came from suburbs, from coffeehouses, they climbed out of the ground like miners, they got up from old beds—I don't know how or where and I didn't ask.

Hausmann was a short man, with thick eyeglasses and broad shoulders. He looked like a wrestler or a boxer and stared at the world boldly and perhaps brutally but was never brutal in any way. He was Ferdinand the bull, whom people are afraid of but who doesn't want to frighten anyone.

Hausmann was an unusually intelligent man with versatile interests. He was interested not only in dada but in so many different matters, facts, and problems, such as men's fashions, Hörbiger's glacial theories, and "abstract writing." He wanted to revolutionize both German trousers and the German language, he thought of theories that would shake the world to its foundations, and he would certainly have invented the atom bomb if the rascal Einstein hadn't anticipated him.

Hausmann was primarily a talented painter and sculptor. A few years ago, at the dada show in New York, I was glad to see some of his dada montages. They are unusually good and unusually dadaist. Hausmann was a constructor, a cerebral man, a thinker, whom Freud would have been afraid of. He was always on the point of robbing some really great man of his eternal fame but never managed to come out with any great accomplishment that would have convinced the world of his unusual gifts. He became bitter and resigned. In his last years he lived in Limoges, France, where, if I am correctly informed, the Vichy regime forced him to remain. He was poor and frail and certainly no longer young.

Hausmann had another quality (next to his intellectual ones): he pos-

sessed character and loyalty; you could really work with him, you were never afraid as you were with Baader that he would diverge from the general line for publicity's sake and transform his own craziness into reality. Hausmann and I started the magazine *Der Dada*, we wrote and planned it together. It was an extremely productive period. Hausmann restored a good deal of the sense of collectivity and camaraderie that I had missed so much since leaving Zurich.

Some time ago, I received a manuscript entitled *Dada Courrier* from Hausmann. It contains a lot of facts, recollections, and notes from the great period. We learn nothing about the tragic destiny of German trousers or the imminent destruction of the world by melting polar ice; but we do find out a good deal about "abstract poetry." Hausmann wanted very much to be remembered as the inventor of the so-called sound-poem in the annals of (dadaist) humanity. The sound-poem reduces words to letters devoid of sense and content and whose sounds symbolize emotions.

> AAAAAAA
> BUBUBUBU
> SHUSHUSHUSHU. . . .

I have little to say about it. Let me quote a verse from my *Phantastische Gebete*, which Hausmann criticized unfavorably:

> Soweit ist es also in dieser Welt gekommen . . .
> Auf den Telegraphenstangen sitzen die Kühe und spielen Schach . . .

> [The world has come to such a point . . .
> Cows sit and play chess on telegraph poles . . .]

When we gave our first big reading in Zurich, Ball recited his sound-poem "Gadgiberibimba." He talks about it in *Flight Out of Time*:

> I invented a new kind of poetry, poetry without words, or sound-poems, in which the impact of the vowels was measured and distributed exclusively in a ratio, in proportion to the value of the guiding line. . . . I had a specially designed costume. My legs were encased in cylinders of bright blue cardboard up to my hips so that I looked like an obelisk. I wore a high cardboard collar that was scarlet inside and gilded on the outside. The neck of the costume was constructed in such a way that

whenever I raised and lowered my elbows, I could move a kind of wing. I also had a blue-and-white-striped top hat. I recited:

> "gadji beri bimba
> glandridi lauli lonni cadori
> gadjama bim beri glassala
> glandradi glassala tuffm i zimbrabim
> blassa galassasa tuffm i zimbrabim."

The emphases grew stronger, my expression grew intenser as the consonants became more powerful. I soon noticed that my posture did not correspond to the pomp of my get-up. I was afraid I would fall, so I concentrated. Standing to the right of the music, I had recited "Labadas Gesang an die Wolken" [Labada's Song to the Clouds]; then, to the left, "Die Karawane der Elefanten [Elephant Caravan]. Now I returned to the lectern in the middle; the drawing rhythm of the elephants had just barely permitted me to reach a high point . . . I noticed that my voice, which apparently had no choice, had taken on *the ancient cadence of priestly lamentations*, that style of liturgic chant that reverberates through the Catholic churches of Occident and Orient . . . I don't know what this music did to me but I began to sing my vowel lines in recitative and I tried to remain not only serious but actually ceremonious . . . the electric light went out on cue, I was torn to the ground like an extremely perceptive magic bishop. . . . Before the poems, I had spoken a few fundamental words: In these sound-poems, we intend to reject the corrupted language made impossible by journalism. We seek to penetrate into the innermost alchemy of the word, and even give up the word entirely, thus safeguarding poetry's last and holiest realm. *We ought to stop composing poems for special occasions*, we should never take over words—much less sentences—that we haven't invented for our own use. We should no longer be satisfied with superficial impressions produced by devices that, in the last analysis, are merely the echo of inspirations or simply usurped agreements of cerebral and imagined values. . . .

The struggle for priorities in dada gradually gets on one's nerves.

I must say that my feelings in regard to sound-poems run counter to the sound level of the announcement. This is probably one of the many manifestations in our time of the primitivistic tendency. I am reminded of the rediscovery of Negro art, the drawings in the caves of Altamira and

Lascaux, the rediscovery of children's art, folk art, and so on. All this is in line with an aesthetic and moral renewal. As much as I see the point of the sound-poem, I don't really care for the cerebral efforts required. Furthermore, the dissection of words into sounds is contrary to the purpose of language and applies musical principles to an independent realm whose symbolism is aimed at a logical comprehension of one's environment. The roaring of the Ashanti and the babbling of an infant are interesting rhythmically —Gershwin and Stravinsky are the ones to use such sounds—but babbling is not language.

Language, more than any other form of art, hinges on a comprehension of life- and reality-contents, as Susanne Langer showed us; in other words, the value of language depends on comprehensibility rather than musicality. The application of aesthetic principles to language, as wonderful as it may seem initially, leads to a dead end. What remains is the intellectual exertion of artists alien to reality.

I have always tried to avoid this. I'm not interested in coffeehouse inventions, intellectual cramps, out-of-the-way truths. A truth can relate only to all of life, and thus it is equally beautiful and banal.

It is a fact that banality always had a strong appeal for the dadaists. Surrealism learned a great deal from them in this respect. Marcel Duchamp's paintings and ready-mades include banality in the most diverse symbols. In the *Phantastische Gebete*, I sang (making fun of "The Primitives"):

DIE PRIMITIVEN	THE PRIMITIVES
indigo, indigo	[indigo, indigo,
Trambahn, Schlafsack	trolley car, sleeping bag,
Wanz und Floh	bedbug and flea
indigo indigai	indigo indigai
umbaliska	umbaliska
bumm Dadai . . .	bumm Dadai . . .]

This is the basic attitude and mood of the *Phantastische Gebete*—ceremoniousness and banality. Ball discusses this when he says (as quoted above): "I noticed that my voice, which apparently had no choice, had taken on *the ancient cadence of priestly lamentations* . . . I tried to remain not only serious but actually ceremonious. . . ."

And then it happened: the electric light went out on cue. The banality of life destroys ceremoniousness, just as it has been said that the greatest philosopher becomes a bad one when his teeth ache. Sartre has often indi-

cated the paradoxical reaction of life. When you expect something good, the devil appears, and when you think you're safe, a crater opens. Death itself is a paradoxical reaction to the universal life drive.

What attracted me to dada and impressed me in Berlin in the face of the desperate political situation was the paradoxical reaction of life, the mixture of ceremonious lamentations and banality. I was the first existentialist, since all my poems and books of that period reveal the transparent duplicity of life. As I understand "modern" life, the feeling for a paradoxical reaction is the starting point for many new ideas, not only in art but in philosophy, morality, and physics as well. Here, at the innermost heart of the world and human nature, where no can also be yes, where fire can mean coolness, and goodness can mean crime (as Dostoevski realized), here was my place, my school, my beginning. It was from this vantage point that I understood Baudelaire, Rimbaud, Lautréamont, and others. A rationalism that dialectically dissects things never really interested me. So I admit that I don't have priority in regard to sounds, although there were certain kindred things as early as 1916 in my *Phantastische Gebete*:

CHORUS SANCTUS
aao aei iii oii.....

and so on ad libitum.

My comments are important for a possible definition of Berlin dada, which a third-rate hack in the aforementioned *Knaur-Lexikon für Kunst* claims was not as important as Cologne dada, in which Max Ernst and Baargeld, a Communist, played the major parts.

My dada, which I introduced in Berlin, was a philosophy that went beyond art into life itself, as Gauguin and Rimbaud had done before us. It was the over-all reaction to our age and not just to painting, music, and literature. Dada, as I understood it, was an over-all reaction, a response of the entire personality to the indefinable challenge of our era, and not just a rationalistic and aesthetic reaction. This reaction revealed the dichotomy that produced an antiart movement in dada, eliciting a goodly number of grins but little understanding.

The artist's position in our time has greatly preoccupied me, since I thought of dada as an assessment and possibly a reassessment of the artist. Dada contained a protest against the sentimental overestimation of the artist in our time, plus a protest against the concomitant underestimation. The official sentimental glorification was paired with an unofficial starvation

of the artist, a rejection (accelerated by the masses) of the personality and the artistic principle. How often did we roar: Art is dead, long live dada!

Today, with art being practically driven out by machinelike competence and gimmicks, with the course of the world no longer influenced by humanitarian ideas derived from art, with art and artists limited to a small professional in-group, with art being judged quantitatively and pluralistically (namely, according to its mass success), people may understand what we were saying. The paradoxical relation between art and life (which even the Victorian-minded Thomas Mann dealt with) was the mainspring of dada activity and mirrors the personality rupture in the aesthetic human being of our time. My quarrels with Schwitters were caused chiefly by the fact that I was a dadaist and an existentialist, and he was an artist and nothing but an artist.

In all my life, there was only one true (and great) artist that I could have as a close friend: Hans Arp. This was due to his special character, whose diplomatic and human traits made bearable a quality that is inherent in almost every major artist: a kind of rigid idealism. This idealism can wear various guises or express itself in lack of sophistication, in dogmatism, in negativism. It can also be a sort of striking self-complacency making it impossible to breathe in the presence of such people. Such people blow eternity through their buttonholes the way whales blow water out of their bellies.

That is the difference between Schwitters's "Merz"-orientation and dada. The infamous *Anna Blume* struck me as a typical product of an idealism made dainty by madness. These poems had neither cantilena nor anything of the art of lamentation that Ball speaks about. They weren't sacred or profane, they were simple and daintily banal. It was the sort of comical banality one finds in small-town sewing bees. Schwitters was a highly talented petty bourgeois, one of those ingenious rationalists who smell of home cooking, who come pouring out of the German woods or Spitzweg's[59] gabled houses.

Our goals in Berlin were higher and different. We loved to hunt down people, we loved the malice of cheaters, the false prayers of murderers, and the dust that collects on the breasts of dead whores. What good was Anna Blume, in back, in front, I love you not, and it would have been better to nip the bloom in the bud.

Let me make it clear that my esteem for Schwitters as an artist is in no way qualified by the above remarks about *Anna Blume*. But the difference

between Schwitters's "Merz" dada and my conception has not faded in the course of time.

Our personal relationship was characterized by these contrasts (which couldn't be formulated at the time). Schwitters, in his romantic idealism (which the petty bourgeois touch made rigid), was totally removed from my world of the international, the universal-intellectual, and philosophical.

Schwitters, together with his wife and child, lived in Hanover, a thoroughly German city, surpassing many other German cities in one characteristic: its petty-bourgeois mentality. When I was young, Hanover was a provincial city, dominated by an aristocratic military clique. The king no longer existed officially, but the people looked as if they were still standing with their hands on their caps, anxiously awaiting His Majesty. Hanover, where Hindenburg was stationed for a while as an officer, revealed the influence of the Prussian landed gentry, which by way of the king and the military had ruled the "people."

It is really quite amazing that an essentially revolutionary artist like Schwitters could live and work in such an atmosphere. This was possible only because he adjusted many of his personal habits to the environment. Thus, his revolt remained romantic (something we wanted to avoid under any circumstances). He had no choice but to play the "clown," whereas I wanted to be anything but a clown. I wanted to stand on (my own) barricades and fight for a new mankind, such as I expressed in a number of manifestoes, especially in "The New Man."* My intellectual legacy does not derive just from Picasso, the cubists, or modern architecture, it also comes from Goethe, Nietzsche, Husserl, Heidegger, and the American pragmatists. From this existential viewpoint, I couldn't care less who invented the sound-poem. Ball's "Karawane der Elephanten" is simply not as important to me as the eternal caravan of humanity, its destiny and its future.

Schwitters became famous through a collage show at the Rose Fried Gallery in New York. He recently had a retrospective in his home town, Hanover, and the exhibition caused quite a stir. Though the collage was invented by Picasso and Braque, the dadaists—particularly Arp, Hausmann, and Schwitters—developed it into its present form. Obviously, the collage contains many psychological and aesthetic elements that can be traced back to dada. The seeming primitiveness (the pasting together), the proclivity for basic colors (red, blue, and yellow), the new conception of space in the addition of paper, cork, wire (and other, so-called new, material)

* For partial translation, see Introduction, pp. xxx–xxxii.—Ed.

were all a logical expression for the dadaists. What they added was irony. Hausmann, in his photomontages (dada montages), specialized in a certain form of aggression that I had already practiced in my writings.

I remember Schwitters as a broad-shouldered, blond-haired man with a childlike face. His eyes were sly, expectant, and distrustful. He was taciturn but could become very animated. Whenever he recited his poems, his voice became stentorian and as sharp as a Prussian corporal's.

We spent a Christmas with him. The Christmas tree was glowing in the living room, and Frau Schwitters excused herself because she had to give one of the children a bath. It was family life with all the trimmings. Schwitters showed us his workroom, which contained a tower. This tower or tree or house had apertures, concavities, and hollows in which Schwitters said he kept souvenirs, photos, birth dates, and other respectable and less respectable data. The room was a mixture of hopeless disarray and meticulous accuracy. You could see incipient collages, wooden sculptures, pictures of stone and plaster. Books, whose pages rustled in time to our steps, were lying about. Materials of all kinds, rags, limestone, cuff links, logs of all sizes, newspaper clippings.

We asked him for details, but Schwitters shrugged: "It's all crap. . . ."

Kurt Schwitters died in Ambleside, England, in 1948. He was a great artist, a marvelous painter, an ingenious experimenter, and even a poet—all in all an unusual person. Unfortunately, he died prematurely, and unfortunately, his irritable and distrustful temperament prevented him from fully developing his talents.

In this brief account, I would rather avoid any overly detailed discussion of the aesthetic sources of our movement. If one likes, one can start with Gothic art, which made the first attempt to express movement in stone. Herbert Read writes penetratingly about it in his book on modern sculpture. I certainly should have mentioned Klee just to appear somewhat complete. Klee popped up in Zurich every so often during our dada period there.

Naturally, there'd be quite a bit to say about Herwarth Walden[60] and *Der Sturm*. Walden, who subsequently perished in Russia, was one of the great pioneers of modern art. *Der Sturm* ran poems by August Stramm, who influenced Schwitters and Hausmann.

I personally never saw much of Walden, who not only looked self-willed but *was* self-willed. The Sturm Gallery on the Potsdamer Strasse sponsored any number of talks under the auspices of a unique collection of modern paintings. It was there that I heard a lecture by the architect Adolf Loos,

who subsequently built a house for Tzara in Paris. Loos didn't talk about architecture, however; he lectured on modern male fashions. I was deeply impressed, especially because of the balletic way he moved about during his talk. Hausmann's concern with German trousers must have found some preparatory psychological material in Loos.

But let's get back to the dada movement. I mentioned Baader, and I feel I have to say a bit more about him. He died some time ago in Germany, and I think it is important to prevent a Baader legend from forming. Baader was a man with fantastic ideas; they were so fantastic that they had little or nothing to do with dada. I now see that he was interested in us mainly because of our unusual success.

Today, after fifty years, it is obvious that Baader's activities were quite detrimental to us. His self-appointment as "Oberdada" [Supreme Dada], his carryings-on in the Berlin Cathedral and in the Weimar Popular Assembly (he threw hundreds of dada propaganda leaflets on the heads of the deadly earnest delegates) made dada look like a metaphysical gag, a kind of universal joke, far removed from all art. It is important to repeat: although originally dada was an emotional reaction that could express itself in any form, it operated on a level from which art could easily be reached. Our position on art was dictated by hate and love, we were artists overwhelmed by the coyness of our mistresses. Baader, however, had absolutely nothing to do with art. He was a kind of itinerant preacher, the Billy Graham of his time, a mixture of Anabaptist and circus owner. While we wavered between inhibition and the lack thereof, Baader was imbued with psychotic exhibitionism and impulsiveness. I still can't figure out whether he was fighting for a renewal of Christianity, an improvement in public schooling, or dada.

There have always been people who wanted to take dada simply as humor and a liberating joke. Wit and humor are then praised as weapons against the "philistine." In point of fact, however, dada had little to do with the occasionally modern fight against the philistine.

When we protest against the things happening in our civilization, the philistine occupies only a tiny area of the target. Although we fought against him as a symbolic figure who wanted to save the world by restoring the "good old times," we were actually preoccupied with the over-all complex of altering civilization.

Through Baader's mediation, a Dresden "concert" agent arranged a reading tour through Czechoslovakia for us. The lecture troupe was made up of Hausmann, Baader, and myself—but friends joined us everywhere,

local dadaists, artists, and people who sensed that something was going on.

We began with a reading in Leipzig, then we appeared in Prague. After establishing our headquarters there, we took off for smaller Bohemian towns in areas where the people had naturally never heard of dada and almost never heard of art. We felt as if we were on a safari in deepest Africa.

To sum up our reading circuit in a single sentence: we annoyed and bewildered our audiences. The one thing common to all our performances was that we never knew in advance what we were going to say. I usually read the *Phantastische Gebete*, and Hausmann, as far as I remember, always had his sound-poems on hand. But this material naturally couldn't fill out an evening. So from the very start, we had to make the audience realize that it shouldn't expect very much.

It was my job to do this, and even today I'm still amazed that I could go through with it and not bat an eyelash. Before the performance, I would step over to the edge of the podium and call out:

"Ladies and gentlemen"—my politesse was emphatic, my voice formal— "if you think that we have come here to sing, or play, or recite something, then you are victims of an unfortunate error. It would have been better had you gone to the nearest motion-picture theater instead. . . ."

If the audience didn't react, I would get slightly more aggressive. I criticized the people who use art as a dessert in their bourgeois existence, and with the pseudo fervor of a pastor, I appealed to the consciences of those who believed that art had anything edifying about it.

The initial silence was now followed by more or less noisy protests. People called out that they wanted to see dada.

"Dada is nothing," I said. "We ourselves don't know what dada is. . . ."

Someone called out: "Crooks, we want our money back." Others took it as a joke and tried to go along with the mood. But there were always a lot of people who felt insulted and cheated, like Herr I. B. Neumann in Berlin.

Someone called out: "Get the police . . ." (à la Neumann).

"Ladies and gentlemen," I said, "not even the police can change the fact that we do not intend to offer you any entertainment such as you usually get in the movies or in the theater. . . ."

The audience became noisier and noisier, and soon the whole auditorium was in an uproar. In Prague, we had several thousand raging spectators. It was like the outbreak of a revolution, the mob was crying havoc. People were shouting for swords, chair legs, and fire extinguishers. It was the raucous bellow of a furious mass.

Now we had them where we wanted. It was time to pour oil on the

ENDE DER WELT

Soweit ist es nun tatsächlich mit dieser Welt gekommen
Auf den Telegraphenstangen sitzen die Kühe und spielen Schach
So melancholisch singt der Kakadu unter den Röcken der spanischen
Tänzerin wie ein Stabstrompeter und die Kanonen jammern
den ganzen Tag
Das ist die Landschaft in Lila von der Herr Mayer sprach als er das
Auge verlor
Nur mit der Feuerwehr ist die Nachtmahr aus dem Salon zu vertreiben
aber alle Schläuche sind entzwei

troubled waters. I spread my arms as if about to be crucified. I clambered up on a chair and shouted in false desperation:

"One 'moment, please . . . just one moment. . . . Be fair and give us a chance to show you what we are and what we do. . . ."

Sometimes (chiefly in smaller auditoriums), we managed to calm the people down; but sometimes, for instance, in Leipzig and Prague, the whole affair instantly turned into a brawl.

If we hadn't been in personal danger, we would have had a splendid opportunity of studying mass psychology. I realized that masses always consist of a troop and of a small band of fighters in the front rank. In our case, the front ranks began pelting us with solid objects. This was the signal for a free-for-all. Men sided with or against us, women reproached their husbands for having taken them along. Literati felt personally insulted, clergymen viewed dada as blasphemy, businessmen fearfully resented our attacks on the tried-and-true commercial system.

Of the many ways one can describe our behavior on these evenings, I shall select only a few. People unaccustomed to seeing actions as symbols will never stop criticizing us as madmen, criminals, or at best "presumptuous ruffians." But anyone able to interpret the "deeper meaning" of our actions must admit (perhaps in amazement) that hardly anybody on our intellectual level has ever been so skillful and so unusually courageous in frustrating conventional expectation.

One of my tricks was to propose a discussion of dada. My suggestion was usually taken, and a whole bunch of panelists wanted to have the floor. They were understandably and comically serious about trying to grasp the phenomenon of dada. The impossibility of defining dada only added to the general chaos, which in turn deepened the sense of frustration; and often, when we thought we had already won the battle, forgotten complexes burst to the surface.

All in all, we ought to sympathize with the audiences in their frequently impatient and even unruly attempts at understanding. No one can blame those people for condemning our "performances" in terms of their customary entertainment. They had acquired their intellectual stature through conventional values. Now they were suddenly confronted with people who deliberately severed the process of communication, the causal nexus between payment and ware, between expectation and fulfillment, insecurity and affirmation. We were irrationalists, but we weren't content with offering people "pleasant craziness" that they might take home like Christmas presents. We cut through the bond between credit and debit, between one

human being and the next, we asked about the necessity of the transmission of values when we removed all content from what we did. "Nothingness," or "nonbeing," which Sartre talks about so frequently, replaced "something." We displayed our scorn for conventional substance, we proclaimed the loss of any center.

We had a dadaist celebration in a Berlin theater, the Tribüne. Piscator staged a sketch of mine, which the audience greeted with a stormy response. Now that we had gotten into the theater and were assaulting the sacred cultural heritage, the critics became more irritable. Alfred Kerr, a leading theater critic, retained his sense of humor better than the others; he wrote: "When Huelsenbeck absconds with the cash, that is Dadaism." (Unfortunately, our financial situation was so bad that the night's "take" actually came from our own pockets, which were worn through with holes.) Things came to such a pass that in desperation I tried to pawn the drum that I had used for a reading. Naturally I didn't succeed, and the pawnbroker, a philosophically minded gentleman, shrugged his shoulders. "Well . . ." he said, "wait until you have a piano or, better still, two pianos. Then I'll see what I can do for you. . . ."

Piscator sympathized with us somewhat but took no further part in our doings. He staged Walter Mehring's play *Der Kaufmann von Berlin* [The Merchant of Berlin], and only two things about it have stuck in my mind. First, that one day, when all preparations had been made, half the rigging loft collapsed under the weight of Piscator's machinery; and second, that at the end of the play there was a kind of symbolic act of scorn: a military helmet was swept off the stage.

I met the poet Lania, who guided me through the theater. He was working there at the time. I subsequently saw him in New York. I also met Moholy-Nagy, who taught at the Bauhaus; he once put on a show at Piscator's theater. Then there was Wolfgang Roth, the set painter. I saw Moholy-Nagy at the Museum of Modern Art in New York shortly before his death. (Like Ivan Goll, he died of leukemia.) Wolfgang Roth and I became fast friends, and we saw a good deal of one another in New York.

Piscator's important ideas, which were related to dada, couldn't catch on in New York. It would require a long article to make the reasons sufficiently clear. For Americans, theater is entertainment, and it is practically impossible to gain a large audience for the kind of experimental theater that Piscator wanted to establish.

I should add that in New York, Piscator got all the financial help he might expect on the basis of his name and his credits. He founded a theater

school, which for a while was connected with the well-known New School for Social Research. In its heyday, Piscator's school supposedly had a thousand students; but these are rumors repeated at cocktail parties and thus not to be trusted.

As I see it today, Piscator's situation in America wasn't any different from that of all the other immigrant cultural workers. If anybody in the world had original ideas and wanted to carry them out, it was Piscator. We all wanted to carry out our own ideas, and we all had (and still have) a hard time realizing that America has its own ideas and isn't interested in ours. Dada—and let me repeat that Piscator's ideas originated in dada—certainly isn't one of the ideas that America cares to welcome. One reason is that dada doesn't fight for the masses but for the personality and that therefore, in the special condition of our civilization, the effect is often cynical and aggressive; dada refuses to conform, it is essentially cerebral rather than idealistic. I met Piscator in Herman Kesser's apartment in New York; Kesser, a Swiss writer who made a name for himself by writing radio and stage plays, had made up his mind to live in the United States. Piscator's impersonal and often arrogant ways made it difficult to talk about old times with him.

After all his efforts to become a great American theater director failed, Piscator returned to Germany. Despite all criticism, we shouldn't underestimate him, and Germany should have considered itself lucky to have him back. He had all the dada and existential qualities characteristic of the creative people of our time. He had a special relationship to the problem of the machine,[61] he was a radical thinker, he thought in social as well as aesthetic terms. He staged Brecht, Sartre, and Red [Robert Penn] Warren in America. Red Warren is an American author whose works simply cannot be adapted to mass entertainment.

After Piscator left the United States, I saw a good deal of Maria Piscator. She used to give a lot of parties in her home on New York's East Side. Her guests were celebrities, major artists, actors, movie VIPs, lawyers, and doctors, as well as darker figures. Next to a weather-beaten Archipenko, I saw Serge Rubinstein, whom the papers alternately referred to as a draft dodger and a financier. He was subsequently killed by gangster enemies.

But back to Berlin and the personalities who took an active part in dada. I have already mentioned the head of the Malik publishing house, Wieland Herzfelde, and his brother, John Heartfield, the inventor of photomontage. It may sound funny to call someone the "inventor" of photomontage, but we must bear in mind that this is more than just a paste-up of parts of vari-

ous photographs. Photomontage is related to the collage but far more radical. It is not content with beauty, nor is it complacently based on "inner laws." It has an everyday, sober character, it wants to teach and instruct, its rearrangement of parts indicates ideological and practical principles. Thus, photomontage is connected to life itself.

Heartfield helped us with his special gifts. He fought with us against romantic sentimentality and for a new objectivity.

He and I were good friends, he visited me in the Ticino, and I gave him a dog named Schnurz, who had a lot of good qualities and as many fleas. He became famous one day by holding up the Milan express at the station in Lugano; he tore loose from his leash and disappeared under the cars. A few old women screamed, "The poor doggy"; the conductor and the stationmaster stopped the train. After hunting for Schnurz, they finally found him and gave him a sound thrashing, although they couldn't help admiring him. No one else in the last ten years had ever managed to interfere with the punctual schedule of the Milan express.

My friendship with Heartfield eventually came to an end because of his political radicalness. He left me and joined Bert Brecht, a rising star in every respect. Heartfield did design the covers for my travel books *Afrika in Sicht* [Africa in Sight] and *Der Sprung nach Osten* [The Leap to the East]; but then the success of *Three-Penny Opera* convinced him of Brecht's literary and, last but not least, political value. Since Heartfield, like Hausmann, was a very loyal man, he told me little or nothing about his new friends, but I soon realized that his life was moving in other directions.

Even Brecht would not have been possible without dada. His plays and poems contain the elements of despair, the cynicism and aggressiveness characteristic of dada. I have often said that dada was an emotional revolution whose meaning could be projected into any area—art, culture, religion, and human relations. In Brecht's case, the area was politics. I have never been totally convinced that Brecht really believed what he advocated; but he did manage to express in his writings the dada conflict in its simplest formulation (poor and rich, worker and capitalist, have and have-not). His insincerity is apparent in the fact that his workers are always right and his capitalists always wrong. However, insincerity and talent are not only not incompatible, they sometimes also determine one another. If an artist wants to avoid being the victim of his times, he has to have (today more than ever) a certain Machiavellism to get something for himself and for others.

If earlier poets were not successful in their lifetimes, it was due to the difficulties of communication and transmission. Hölderlin is hard to under-

stand, Heine (who often works with the most banal means) is easy to understand; thus, Heine's success was always great and Hölderlin's limited, although Hölderlin was far and away the greater poet.

Brecht was the only one of us who possessed enough vulgarity to impress the proletarian masses. But it was actually his ability to do so with literary power that made him an important figure. Whereas Gerhart Hauptmann was, and remained, a romanticist of Neue Sachlichkeit [New Objectivity] till the very end of his long life, Brecht was always a realist. He saw the world as it was. This impressed us dadaists, all of whom wanted to be small-scale Machiavellis (see my manifestoes, especially "The New Man").

Heartfield was much more human and really easier to get along with than his brother, Wieland, who is now a professor of literature at the University of Leipzig. We loved Heartfield's anger and his fits of temper: he always carried folders, envelopes, and books around (which is why we called him "Monteur dada" [Engineer Dada]), and he would throw everything away, including articles of his clothing, and stamp on the ground with his rather awkward rear hoofs. Wieland was fundamentally cold and diplomatic, as well as dogmatic—a textbook Communist, a conformist and an (unconscious) opportunist. He lived in the United States for a long time, and I don't know whether he was a Communist propagandist here; but his stamp shop was probably a front for a propaganda center—albeit a small one. Wieland founded the Aurora publishing house in New York, but I soon saw what he was after, and I refused to participate in any way.

Wieland Herzfelde and the Malik-Verlag put out *Die Pleite* [German slang for "bankruptcy"], a magazine for which I wrote and which ran George Grosz's drawings. These drawings, like Brecht's writings, were based on the contrast between rich and poor, but they were much more than propaganda. People were amazed to see that Grosz, the dadaist and radical politician, was a match for Dürer. It was his unusually sensitive line more than anything that instantly made Grosz Europe's best-known graphic artist. Since I am focusing on dada and its history, I have to limit my artistic commentary. But I feel I have to point out the elements of primitiveness (in the best sense of the word), simultaneity, and abstraction that put Grosz on a par with the great artists of futurism and cubism, although his method was infinitely different. His goal was to change the world. This is not the place to go into Grosz's development, but his impulse to exceed his own limits ultimately took him away not only from dada and art, but also from himself, so that he took our dictum "Art is dead" seriously, and like a man wandering through sand and dirt for a long

while, he came to a total standstill. That is the difference between him and Arp, Picasso, Braque, Severini, and the others whose development has symbolic value for our movement. In contrast to Grosz, they all left the bounds of art only to hurry back in the end. Picasso's experimental changes, Arp's mordant irony, Severini's and Picabia's shifting styles never led them away from art but only deeper into it.

If Grosz, like Brecht and Johannes R. Becher, had moved to Russia or East Germany, he might have found sufficient ideological support and help for his hatred against the more fortunate classes. But this was impossible in the United States, where he settled shortly before I did. Here where everyone can become rich (at least theoretically), there is no hatred of millionaires. They are regarded as the elite of the nation. They are the exemplars and models of American morality, whatever that may be.

The situation of the man who had drawn *Christ in a Gas Mask* became problematic as soon as his hatred lost its target. In America there was no more conflict, only progress and optimism. His ideals were Bouguereau and Grützner, and perhaps even Makart.[62] He rationalized by claiming that in this world art is no more than any other everyday activity—laying pipes, paving streets, darning socks, selling cars. He convinced himself that an artist has to be "a good fellow, and not something more than other people. He has to talk like the masses and act with the masses. . . ."

That was his tragic flaw, a mistake that dada fought with almost sacred intensity from its very birth until the present day. I would like to repeat what I have constantly said. The despair, irony, and aggression of the dadaist came from the visionary realization that art was threatened by mass idolatry. The artist must therefore turn against the masses although it is his prerogative to find some form of adjustment in order to survive. This conformity has nothing to do with capitulation, it is an act of salvation, a part of the strategy that no creative person can do without. Thus, one can say that today's artist is like a man who has fallen into deep water. Obviously he hates the situation and curses the water. But he has to try to swim. Likewise, there are seemingly contradictory elements in modern art, elements of aggression and hatred and elements of adjustment. Among the many trends in our era, dada has a creative mixture of these two emotional directions.

Berlin dada, so often misunderstood, is in many ways more characteristic of the dada idea than Zurich dada. The former emerged in a period in which no one could be certain of his life from one hour to the next. Between gunfire and screams for help, I proclaimed a new world in Neu-

mann's gallery. One should not underestimate the symbolic meaning of that evening of poetry: a handful of poets, defending the personality against the metallic threat of cannon. The intellect arose against the assault of a mechanical world, life arose against paralysis, eloquent silence against all-devouring noise.

As for the representatives of Berlin dada, we ought to say something about Franz Jung, who was not only a stock speculator, a publisher of magazines (he put out *Die Freie Strasse*), but also a politician. Not in the parliamentary sense, but an adventurer and fanatic in grand style, one who knew how to intimidate the German authorities and embarrass the Russians.

Then there was Walter Mehring, who was known as a song writer and who wrote an interesting book about his father's library, which the Nazis had burned. He lived in America for a while but eventually returned to Europe. His poems are more in keeping with vaudeville than with dada. They are smooth, melodic, and popular in the best sense of the word. If we go by Ball's dictum ("the poet is not meant to write poems for special occasions"), then Mehring is a sinner; but we must bear in mind that he concentrated more eagerly than we on simplicity.

V

When I arrived in America in 1936, I was just a leaf in the wind, a cork on agitated water. Literature had little meaning in a time when survival meant more than anything else, including culture. America, the land of the golden future for immigrants of several generations, was a place of refuge for those of us who had been driven from Germany, and we hoped to recover from our fears.

The vastness of the United States was there for all to see, and day after day, the gigantic but sinister city of New York proved to us that we were nothing but statistics. Instead of some eight million-odd inhabitants, New York now had some eight million plus, and no one noticed the additions. Our sense of being lost simply grew in New York and its way of life, which, as has often been said, is not the American way of life. More has been written about New York than any other city in the world. But one thing is certain: no New Yorker lives with the statistics of inhabitants, the size of the highways and avenues, the splendor of the department stores,

Richard Huelsenbeck (from the second edition of *Phantastische Gebete*, 1920)

Raoul Hausmann, 1916

Richard Huelsenbeck and Raoul Hausmann in Prague, 1920

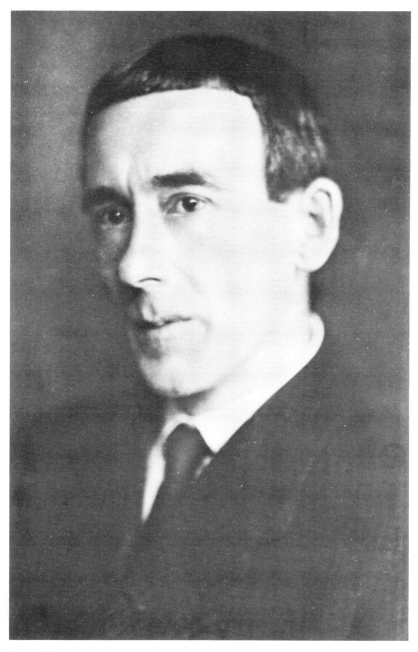

Hugo Ball, ca. 1920

Drawing of Huelsenbeck by Marcel Janco, 1916

Drawing of Huelsenbeck by Ludwig Meidner, 1918

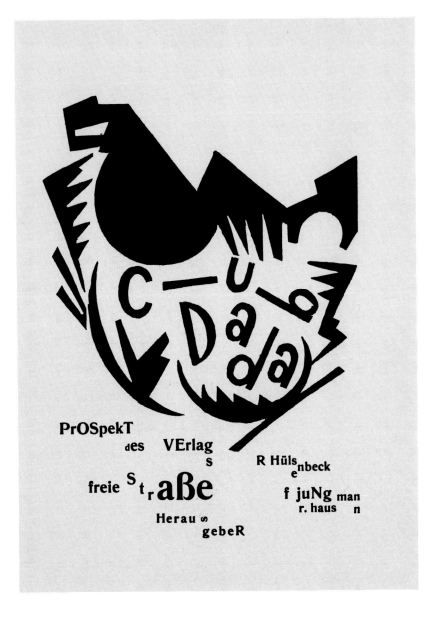

Title page of a special issue of the Freistrasse *Club Dada*, edited by Huelsenbeck, Franz Jung, and Raoul Hausmann, 1918

3 9 1

hans arp gewidmet

Aus den Versenkungen steigen die jungen Hunde und schrein

wie die Kühe schreien sie mit ihren lakierten Mäulern

seht die Geheimräte mit den eingefallenen Bäuchen

Messingkübel haben sie über ihr Gesäß gestülpt, auf ihren

Händen hockt die junge Seekuh, — eia, eia: es ist eine große Zeit

niemand weiß hinten wie er vorn daran ist

Haben Sie den Herrn gesehen der durch den Briefkasten steigt mit lächelndem Gesicht

Umba Umba sahen Sie die Kellerasseln mit gefalteten Händen

drei Tage schon geht die Prozession und immer noch flattert die Seele nicht

Ja ja Herr Doktor dies ist der Tag an dem ihre Großmutter unter die Indianer ging

O — O — O

Der alte Kirchturm — der alte Mond Spinnwebmond Fliegenmond

ich halte die Hand auf den Bauch

der Schleiermond der große rote weite Mond

die Flüsse hinauf über die Berge gestemmt an die Sterne gereckt

jagen die jungen Hunde und schrein

es ist eine große Zeit

Richard Huelsenbeck

"391," a poem by Huelsenbeck dedicated to Hans Arp, which appeared in *Die Schammade*, 1920

Huelsenbeck as a ship's doctor in the 1920s

Huelsenbeck with two children in a park, ca. 1919

Huelsenbeck and Arp in Arp's studio, ca. 1949 (Photo: Freie Filmproduktion)

A scene from *8 x 8*, a film by Hans Richter. From left to right, standing: Yves Tanguy, Huelsenbeck, Julian Levy; seated: Jacqueline Matisse and Marcel Duchamp

Richter, Huelsenbeck, and Duchamp in 1949 (Photo: Paul Weller)

Huelsenbeck, Richter, and Arp in 1949 (Photo: Paul Weller)

Arp and Huelsenbeck in Zurich, 1957

Richard and Beate Huelsenbeck, ca. 1970

and the supremely towering, dizzying height of the skyscrapers. For better or worse, you live with other people.

Supposedly, people are the same everywhere, but I feel that this is a platitude one can use fearlessly only on certain days. People are just as different everywhere as they are alike. The authorities treated us generously and very decently, there were groups, individuals, and officials who racked their brains trying to figure out how they could help us. But there were also people who hated us, rivals, others who simply didn't like foreigners, people with bitter characters, frustrated men. Our lives moved between love and hate.

It took a while before I could practice medicine in New York (I am now a psychiatrist). Since Albert Einstein had told the authorities about my literary past, I didn't have to take the State Board examination; but nevertheless, a year elapsed before I got my license. This is not the place to tell about the many adventures you have in New York if you want to make it. It is a difficult matter, and I must say that the trials lying in store for me were more complicated than any possible medical examination.

I forgot my literary existence for a good long time until one day—it was still before World War II—my friend Weisenborn came to visit us, and we had a taste of the spirit of friendly conversation that had been our daily fare in Germany. We were living in a small apartment on 114th Street, not far from Columbia University—and not far from Harlem, the Negro section, which was like a branch of the Congo. I subsisted on the generous support of a very rich manufacturer, who was virtually paying for my liberal frame of mind; he often praised my decision for refusing to live under Hitler even though I wasn't Jewish. On the side, I wrote a kind of family history for him, but it bored me stiff and to tears. In the whole family tree of successful businessmen, there was only one interesting figure, the black sheep of the family, a man who had moved to Madagascar and died (a failure) of heat and isolation.

I got a little publicity shortly after my arrival. The *World-Telegram*, a powerful but chauvinistic and not very perceptive newspaper, wrote an article about me and also mentioned dada. I received a number of letters, but no one asked about dada. They were written by Germans in America, vilifying me spitefully because of my emigration. In those days, there weren't just individual Nazis in America, there were also many Nazi groups (the most infamous being the Bund, led by a man named Kuhn).

Nevertheless, the article had one good consequence: the huge news agency King Features asked me to write a few articles on dada. My English

wasn't very good yet (let me speak cautiously), although I had already given a few public lectures and was about to take a language examination that everyone had to pass, even those exempt from the medical examination. The editors knew nothing about dada, but thought it might be of interest to their readers. They soon realized that dada alone—and they simply didn't know what it was or what it was good for—wouldn't "make it." They cast about for some point of view to make dada understandable for their readers and came up—as God is my witness—with Mata Hari.

How and why they stumbled on Mata Hari, I'll never know. They had probably asked me about the atmosphere in war-surrounded Zurich, and about spies. Spies, you must know, are the stock in trade of grade-B American movies (and even grade-A ones, as Hitchcock proves). The editors thought that Mata Hari, who had been in Lausanne in the dada period, could make dada comprehensible, because in America a *femme fatale* can explain a great deal.

I had a ghost writer, a young editor, because I needed help with my ramshackle English and because I knew little or nothing about writing sensational articles for American audiences. But as I worked on my dada piece, I felt very uncomfortable. It wasn't dada itself, as an art or philosophical trend or whatever one might call it, it was my own personality, a human being who had expressed himself in dada and thus had something in his character that became visible in dada.

In America, dada was initially as unclear as it had ever been; but then I was able to distinguish between the dada world and the American world, and the more I understood about America, the more I understood about dada. Today dada is recognized in the United States as one of the art movements determining our modern aesthetic thought, and Sartre's existentialism has made people slightly aware of its philosophical content. But like existentialism, dada is a formula here that people mention at parties but do not really understand. Americanism is essentially and intrinsically as alien to dada as, say, an Arab is to a man from the north, from Sweden or Scotland.

It would help toward an understanding of dada if we could thoroughly work out this difference. Although all my previous attempts have failed, I would like to try it again with greater patience and fairness.

I would say that America is essentially a country imbued with the Protestant, Calvinist, and idealistic spirit. Protestantism and Calvinism are expressed in the way of life, idealism in the direction of life. Americans are people pursuing a certain goal idealistically, they have the hardness of Calvinists and the rationalizing abilities of Protestants. They aren't so

much realists as people using things for specific aims. They are actually unrealistic, without much sense of the essential relationship between man and nature, his instincts, and irrevocable factors such as death.

The goal of Americans is an ethical one, they want what is written in giant letters above the entrance to the Supreme Court in Washington: EQUAL JUSTICE UNDER THE LAW. Like the Calvinists in Geneva, they believe that a man proves his capabilities by acquiring property, and that God is with him when things go well. As a result, poverty is not proof of spiritual superiority, and mercantile skill never interferes with even the most refined conception of humanity. Not everyone who is a good businessman is necessarily a good person; but everyone has to produce something or other in order to be thought of as a good person. Here, more than anywhere else, man is what he creates. Will power, energy, and fortitude are the essential qualities.

Dada, it seems to me, is something highly unidealistic. It has more of a stance than a direction, it is intellectual and thus possibly an offshoot of European humanism. Dada strives for total self-knowledge through the unique performance of the personality. The ethical goal of American idealism is equality, the salvation of the world through the constant advances of mechanization. American idealism believes that man can be saved from his fate, death, by further inventions, electrons, antibiotics, new airplanes, ships, cars, wider streets, better clothing, everything arousing man's practical sense. American idealism, with justified pride, points at the results of its efforts: a longer life expectancy, improved health, the gradual but certain eradication and outlawing of poverty.

Dada in Zurich, as I have described it, needed poverty for its development. As a hobbyhorse for museums or a proclivity of millionaires, it would never have become great. It developed out of nothing into something, but even in somethingness, it never lost the feeling of nothingness. Dada introduced simultaneous thinking into art and life, the simultaneity that Einstein and Whitehead speak of. Calvinist idealism is chronistic, materialistic, and progressive, but it is not realistic, and therefore it is progress-oriented. Progress is something that benefits the masses rather than the individual; it is thus libertarian rather than aesthetic or evolutionary.

I can imagine that those who regard dada as merely a kind of gag won't take my explanation seriously. All this seems to have little connection with the sound-poem or abstract art—but let me say, in all fairness to myself, that if one experiences great contrasts, one must probe deeply to understand

them as branches of the same tree. We dadaists were representatives of a historical period that needed cynicism to transform itself. Americanism needs no transformation, its ideas are ready-made, they change when applied. Thus American democracy, as we see it today, is totally different from the democracy of the pioneers; it has changed from an unruly desire for individualism to a mass democracy, and the causes are not bad intentions or negligence. The very opposite is true; the masses have won, because this country, more than any other in the world, firmly believes that it is the majority that should have everything.

The construction of an antithesis, such as I have attempted above, is justified by the fact that dada never really existed in America. This is true despite the many references to it in books and magazine articles. Dada, the laughing, weeping, half-cynical, half-blustering theorem, devoid of system and even substance, a mixture of clownery and religion, half writing, half art, dada, which wants to destroy itself in order to survive, this last *bon mot* that was sucked up along with leftover coffee in Zurich's Odeon and Bellevue—has pathetically little to do with a way of life that aims at material perfection. The description of this antithesis does not imply any negative judgment. But it does reveal why dada cannot exist in America.

This doesn't mean that there haven't been a lot of dadalike events here, or events preparing for or closely connected with dada. The famous Armory Show that took place in New York shortly before World War I was an absolute sensation, and it is a fact that ever since then the interest in modern art has not died out. Furthermore, abstract art, which Arp advocated and which Picasso's cubism taught us to appreciate, has spread through America and been received with mounting enthusiasm, so that today one can barely find any academic art in New York. It is probably true, as some cognoscenti claim, that abstract art has become academic.

At the Armory Show, one of the paintings that caused such a furor was Marcel Duchamp's *Nude Descending a Staircase*. Since then, Marcel Duchamp has been the matador, the dean, and the hero of modern art in America. I knew him for a long time. He helped me and Richter organize the great dada exhibition in 1954 at the Janis Gallery on Fifty-seventh Street, the art center of New York.

The book *Dada Poets and Painters*, which George Wittenborn put out as a standard work in 1951,[63] would never have come into existence without Duchamp's diplomatic help. In typical dada fashion, the trouble began the moment we started collecting material. The old feud between Tzara and myself reached such a pitch of discord that no one believed the book would

ever materialize. When Tzara heard that I wanted to put out a final dada manifesto, he threatened to withdraw all his manuscripts. He never withdrew anything (he would never have done anything so terrible as to neglect any opportunity to appear as a great man), but he did succeed in intimidating all the people involved. As a result, everyone who had been willing to sign my manifesto now refused. Max Ernst was the most energetic about refusing. But I didn't take it so tragically since I realized that he had always been on Tzara's side, personally, politically, and otherwise.

The book, the years of work, the laborious classification, the organizing, the collecting of paintings, the writing of hundreds of letters, all seemed to no avail. I was as disgusted as I had been on the evening when shortly before my arrival at the Museum of Modern Art, I was asked to let Dali replace me as speaker. (Alfred Barr had put on an exhibition of "Fantastic Art," introduced by a panel discussion. I was supposed to speak on dada.) I finally gave in, at Dr. Barr's personal request. But this time I was unwilling to yield under any circumstances. The warriors, armed to the teeth with arguments, faced one another in Wittenborn's bookstore. Then came Duchamp.

This is the reason I'm telling the story. Duchamp's diplomacy saved the day: he suggested that Tzara write his own manifesto. Both manifestoes were to be signed by their authors. Tzara, claiming as always to be the "inventor" of dada, instantly agreed. Thus we reached a compromise, and the book could go to press.

Marcel Duchamp participated in Paris cubism, his *Nude Descending a Staircase* is the work of a highly gifted, extremely sensitive artist combining cinematic and cubist elements for an amazing effect. Marcel Duchamp was not really a painter (just as Rimbaud did not want to be a poet or Gauguin wanted to be more than an artist). His was an experimental mind, a searching (and finding), unusual intelligence, which, wandering about in the enormous valley of life, encountered painting and left its traces behind like a dinosaur whose footprints still astonish us.

Marcel Duchamp had already left France in 1910. Why he left France, which was much (much) more of an intellectual world center than today, is unclear or seems so, until one realizes that his motive was a kind of malaise, a form of anti-intellectualism that one comes upon again today among dadaists. France and Paris were in every way too art conscious, too sophisticated, too learned, too knowledgeable. America with its faraway coasts seemed like an unintellectual country, where abstractions never collide because they're not very important.

In his resistance to art, Marcel Duchamp anticipated dada. The ironic elements in his paintings, his famous ready-mades are indicative of a mentality akin to dada. Duchamp's total abandonment of art, his predilection for chess, his diplomatic, vital nature made him one of the most interesting of modern personalities.

Duchamp visited me frequently. I became better acquainted with this important and extremely unusual man. He never drank or smoked; he seldom took part in conversation, but when he did, he had something essential to say. People realized that he was a man of the mind rather than a man of passions.

He was frail and delicate, and exhibited a charming resoluteness excluding any contradiction. He was interested only in "intellectual" things, but in a practical fashion. He liked to be considered the cerebral center of modern art. The simplicity of his home on Fourteenth Street was the expression of a certain philosophy of life. He didn't want to burden himself with anything. He didn't like elegance, yet his speech and his appearance were elegant. He didn't have much money, but he did get it (as much as he wanted). He relied on the strength of his personality, always saw the whole and the end.

For years on end, Duchamp didn't even touch a paintbrush; then he began to construct his leather "valises," which open to reveal miniature copies of all his important works. Duchamp was a craftsman, a leather expert, a valise expert, and a carpenter.

Duchamp had played such an excellent game of chess for so many years that he could compete with the master players of many lands. Max Oppenheimer also played chess, but he had none of Duchamp's talent or personality.

Duchamp and Katherine Dreier founded the Société Anonyme, a joint-stock company for the buying and selling of modern art. They also arranged exhibitions and published a bit. I visited Katherine Dreier at her country home in Connecticut. This woman, who was so important in international art life, was already very old, and the sister she lived with was even older. Their father, a German, had made a fortune in tobacco. The two sisters were like characters in *Arsenic and Old Lace*. In the stable, which smelled of horses and coaches, there were two strange-looking cars; and the house and the garden exhaled lavender, and the odor of Christmas trees and linen closets.

The meal we had was old-maidish. There was weak tea (nothing to smoke and nothing to drink) plus angel-food cake (a very sweet American specialty,

rather insipid and with long coconut threads that stick out like angel hair).

That was the day on which Frederick Kiesler, who all his life had been doing his utmost to outdistance Picasso, Braque, and Mondrian, pulled a manuscript out of his pocket and read a manifesto in French about the value of modern art. His theory was that all the arts belong together. People should stop gazing at art in museums. They should live in and with art. "Art to live with." Art that is part of daily existence. Instead of art for art's sake, art for everyday use.

Kiesler tried to make this theory of his, "correalism," understandable through an exhibition of sculpture in the Museum of Modern Art. I wandered through it. The whole thing looked like an elephant trunk, filled with shark's teeth and arranged into arbors. It was praised, and Kiesler "conquered" *Life* magazine. He appeared there in person surrounded by his "galaxies," as he called his correalistic sculptures. He wanted to go far, and the constellations were high enough for him, although he was physically very short, knee-high to a grasshopper as they say.

The way Duchamp arranged his exhibition in the Janis Gallery revealed his brilliant intelligence. It was all very dada, the paintings hung from the ceiling and the literary documents on the walls. Schwitters's sound-sonata played all day long. A porcelain urinal hung over one of the doors. The catalogue was printed on very thin paper that you could crumple in your hands like toilet paper.

The American press, intimidated by Duchamp's authority, adopted dada like a naughty but beloved child. Yet the opposition to art—an activity that entertains the public, provides the critics with an income, and plays along with the philosophy of rationalization in a basically harsh and ruthless age —remains incomprehensible. It turns out that art and religion are indestructible because they provide necessary prejudices. In an age in which beauty has been questioned more than ever, art has the stately task of preserving the illusion of a beautiful world, just as religion has the task of making people believe in a form of supernatural goodness. Otherwise, the state and the position of politicians would be jeopardized.

The fact that art is indestructible, as far as the public is concerned (people are still sculpting, painting water colors, and dipping their brushes, without the slightest qualms), has always caused the critics to return to the viewpoint that dada is nothing but an intelligent gag. The philosophical part of dada, disappointed humanism, resentment growing from the deposing of an absolute God—all that remains incomprehensible.

If art is nothing but a social game, one might find a vantage point to understand De Chirico's development. Dada anticipated the development of art into *Kitsch* when we said: "Amateurs, levez-vous!" ["Amateurs, arise!"]. Modern commercialism, with its TV sets, movies, radio, in which from morning to midnight human tragedies alternate with singing commercials, obviously believes that art is only supposed to entertain. It is something like a beauty department with a lot of employees. Beauty is necessary for the preservation of the system (which in itself has little beauty). So everyone has to do his or her best. All aboard. Pick up your shovels . . . I mean, your brushes. . . .

Believing that it could offer mankind something new, dada hit upon the ceremonious lamentations of the *Phantastische Gebete* and Ball's poems. Arp was the only one to approach the new forms with humor and open arms. But grief as well as humor was a reaction to the loss of the essential. The new art, abstract art, grew out of a lack. It was the search for a new way.

In the commercial state of the twentieth century—and now there is hardly any difference between East and West—the way is prescribed. Necessary conformity gave rise to De Chirico's love of *Kitsch*. Now, everything is smooth and confident, everything smoothes itself out. This is a direction visible in all political communities today, including Germany, France, and Italy, in which traces of an older humanism obscure the clear development.

The influences of the tragic dada conflict are still perceptible. You can hear them and feel them. Hemingway's language, his honing, his symbolism, the dialogue of ambivalence, would never have been possible without dada and James Joyce. T. S. Eliot, who believed that the old humanism could be restored, could never have written his *Waste Land*, without the experience of dada. Thomas Wolfe, whom I met in Berlin shortly before my escape from Germany, owed his creative will power, which transcended all earthly things and went far beyond art, to a philosophy containing elements of despair and cynicism that dada revealed to the world. Malraux, an adventurer in life and in all intellectual and aesthetic areas, is an eloquent contemporary of a dada world.

America is the land in which the desire for material improvement forced literature into a descriptive role. Literature has become an instrument for measuring and categorizing human beings and providing them with suitable philosophies.

Consequently, dada could never really take root in America since it had nothing to do with improvement.

Dada could never take root in America because it could never act according to the principle of "Give them what they want"—a principle destructive to culture, in art or in any other province. From this point of view, I once wrote an article for the magazine *Quadrum** in which I called dada the beginning of a new morality.

In Germany, I heard a great deal about Hans Richter, but I never had the opportunity of seeing him until I came to the United States. When he arrived in America, he had already completed his avant-garde film *Dreams That Money Can Buy*. He had asked me to write some of the titles and part of the dialogue. We worked together very well and subsequently saw a good deal of each other.

Richter had worked with Arp and Tzara after my return to Germany. He had witnessed the birth of the Galerie Dada and shown his paintings there. In Berlin, at the Café des Westens, he had been friendly with many of the artists and literati whom I knew, too. He had been a close friend of Däubler, and showed me an astonishingly faithful portrait of him. As a participant in Pfemfert's *Aktion*, Richter had been fighting for modern art quite early. His friendship with Carl Einstein, author of *Bebuquin*, had been of theoretical and personal use to him. When Richter met Viking Eggeling, a Swede, shortly after World War I, he became interested in film-making. Together with Eggeling, he made the first abstract and surrealist movies, which are now classics, and anticipated many aesthetic problems of our time. In America, Richter became a professor in the City College of New York's film department, which he founded and organized. It was here that he made parts of his film *8 x 8*, together with Arp, Cocteau, Duchamp, and Kiesler, and in which I play the part of a medieval knight. Jackie Matisse, the granddaughter of the painter, plays the female lead.**

Richter lived first on Eighty-sixth Street, near Carl Schurz Park, the East River, and Doctors' Hospital, in which Jimmy Walker died. Walker was the New York mayor who shortly before World War I had visited Berlin and absolutely amazed the Berliners with his lack of inhibition. Subsequently, Richter and his wife moved to Woodbury, Connecticut, near where Calder, Tanguy, Gabo, and other important artists had settled. I often visited Richter at his farm; he would show me his famous "scrolls"—abstract paintings that hung on the walls of his studio, but that you can easily put into a suitcase and that are surprisingly similar to Japanese and Chinese scrolls.

* For translation, see pp. 139–41.
** See pp. 108–126.

From Richter's farm, I was able to visit Tanguy, who died suddenly some years back. He was one of the best surrealist dreamers on canvas, but toward the end of his life, everything turned to stone, he painted the desert of nothingness, universal paralysis, and ossification. What a great contrast between Tanguy and Calder, a cheerful, corpulent man with foxy eyes. A kind of fairy-tale (or rather, Connecticut) smith, forging the wildest little steel windmills and air wheels at his anvil. Everything revolves, everything is in motion. When you enter his studio, you are overpowered by the thought that the (oh so serious) machinization of the world is a kind of children's dream, a chimera of geniuses wearing short pants, who, if they ever feel like it, will feed the whole business to the cows with their eternal appetite. Calder reigns above all his ideas like a Hephaestus whose cloud pajamas have grown too tight.

The difference among Calder, Tanguy, Richter, and Gabo is even more striking. Gabo and Pevsner are the great representatives of the constructivists, who, as Erich Buchholz, the German art pioneer, writes in his memoirs, came to Berlin shortly before World War I and collided with the expressionists.

Pevsner died, and Gabo emigrated to America, where he now lives (in a small house in Connecticut) and never deviates one iota from his mathematical dreams. Pevsner, Mondrian, and Van Doesburg have died, and he alone remains, a living bridge among art, mathematics, and architecture. He meticulously makes little symbols of wire, pieces of metal, and wood, which show us a new order, so ruthlessly disciplined that it inspires us with fear. We are lured by the brightness of a conviction that might, for all we know, suddenly turn into dogmatism. A totalitarian wonderland, in which Alices can be trapped like fish in a net. Gabo himself is a mild-mannered scholar of art studies (if I may term it thus), a professor of a mathematically determined art mythology, which Herbert Read has written about so strikingly in his *Philosophy of Modern Art*. When I spoke to Gabo about dada, he seemed to be waking up from a dream. "Ahahahah . . ." he said, "I remember, and you, hmmm, my memory goes back that far, you supposedly played a part in it. . . ."

In Richter's New York studio, I met Man Ray, who, together with Duchamp and his group, had had dadalike ideas. Man Ray is American and used photography as an early means of self-expression. Yet—akin to Moholy-Nagy—his idea of art is primarily intellectual. There is hardly any other artist in this era from whom so much theoretical coldness emanates.

On the other hand, we shouldn't be too hard on intellectuals. Dada had

to be "intellectual," since it had an experimental character, since it saw problems and weighed ideas. It is only in rare periods of human civilization that artists can plunge into their work like divers into water. It is only at rare times that their bed has already been made. It is only at rare times that they are secure and that they and their work are awaited and appreciated.

The fact that Marcel Duchamp switched over to chess playing cannot be valued highly enough. In an age in which base jokesters are the idols of the nation and earn millions of dollars, the cultural worker should devote himself to laziness, indifference, or some sort of practical work. Since "intellectuality" is not only not appreciated but totally misunderstood, one has to be careful not to let one's artistic work play into the hands of those whose guilt feelings make them look for aesthetic decorations. Art is not meant for people who believe that manufacturing shoes is more important than writing good books or painting. Nor does it suffice to fit the artist into society, as fascist and communist states have done. Art must either reign or die out. If the spirit of the personality and of the inner order is not accepted, then there will be no art. This is the deeper significance of dada and of all related thoughts. Dada's true goal is a revision in the face of the human ideal that makes art a mere symbol. To attain this goal, one must not make too much fun of oneself. The usufructuaries could easily believe in our self-ridicule.

People might object that I am exaggerating or pessimistic. But I can't agree with such objections. I really believe that dada's stance is as justified today as it was in 1916, the year it began. Dada was not limited in time. It is the protest of intellectual people, of the personality, of creative uniqueness against leveling and adulteration, which have led to the reversal of all values (although in a different way than Nietzsche expected). A good start took a bad turn. This holds true for all civilizations of our time and thus cannot be charged only against countries that have enthusiastically flung themselves into a process of depersonalization.

Dada is therefore not just the struggle of creative men against mechanization, the masses, comfort, but also against immorality, against letting oneself go, against bad jokes, against the Anna Blume instincts. Dada is rigorous, and the rigor of modern art expresses dada's inner attitude. The simplicity of our architecture, the absence of frills—this, too, is dada. Dada contains a rejection of shallow optimism and of the idea of progress, the acceptance again of eternity and death.

One might object that the individual and unique accomplishments of the

creative man have never brought him any influence. In other words, people claim that the stupid and the wicked have always been in power. I don't believe it, or I would like to say that I don't regard it as inevitable. There is a difference between the wicked fearing hell and believing that they are the ones to whom we owe life.

"The world has come to such a point . . . Cows sit and play chess on telegraph poles . . ."

Dada is "The world has come to such a point"-*Weltanschauung* with all its negative, positive, and creative reactions.

And to conclude: the utterances of two French painters, who I feel express well and positively what is probably every artist's *Weltanschauung*, whether or not he calls himself a dadaist, whether he protests or prefers not to protest, whether he expresses his protest clearly, half-clearly, or merely hints at it.

The first statement is by Bissière[64] and is quoted by Werner Haftmann in the catalogue of a Swiss gallery:

> I have never wanted to paint pictures in the pompous sense of the word, I merely wish to produce colored signs in which everyone might encounter his own dreams. When I place these signs, in which I would like to recognize myself, on a canvas, and other people are touched and try to offer me a fraternal hand, then I feel I have won and I need nothing else. Ultimately, I am convinced that the quality of a work of art is measured by the amount of humanity that it contains and elicits.

The second statement is by Alfred Manessier:[65]

> We must reconquer the weight of lost reality. We must make ourselves a heart, a mind, a soul as far as is humanly possible. The real, the reality of the painter, is neither in realism nor in abstraction, but in the reconquering of his weight as a human being. It is only from this reconquered position that I believe the painter of the future will gradually come to himself, rediscover his weight, and strengthen it to the utmost reality of the world. . . .

The contemporary artist's best chance to fulfill his mission is abstract art.

Notes

1 Ernst Stadler (1883–1914)—Expressionist poet and literary historian. Fell on the western front during the first fighting of World War I.

2 Rudolf Leonhard (1889–1953)—Socialist writer and poet. Belonged to the cricle of prominent expressionist writers and artists such as Johannes R. Becher, Walter Hasenclever, and Ludwig Meidner.

3 Alfred Richard Meyer (1882–1956)—Publisher in Berlin. Also active as writer and poet under the pseudonym "Munkepunke."

4 Christian Morgenstern (1871–1914) and Wilhelm Busch (1832–1908)—Sarcastic allusion to Morgenstern's *Galgenlieder* (Songs of the Gallows) and Busch's "educational" comic strips and lyrics. One or more albums of such pieces by Wilhelm Busch were the proud possession of many middle-class German families, to the delight of children of all ages.

5 Trude Hesterberg and Claire Waldoff were very popular actresses and cabaret performers.

6 Hugo Ball's *Flucht aus der Zeit* is about to be published in The Documents of 20th-Century Art series under the title *Flight Out of Time*.

7 Fritz Bondy (b. 1888)—Writer, essayist, and literary critic.

8 Gustav Landauer (1870–1919)—Influential political essayist, social critic, and translator. Important figure in the political (socialist) wing of German expressionism.

9 Marcel Janco (b. 1895)—Painter and architect. Co-founder of dada in Zurich. Lives in Israel.

10 René Schickele (1883–1940)—Poet, writer, editor. From 1914 to 1920 publisher of the famous literary magazine *Die Weissen Blätter*.

11 Franz Werfel (1890–1945)—Produced extensive poetic *oeuvre* in his early years. Later best known through his novels.

12 Johannes R. Becher (1891–1958)—Prominent expressionist poet, playwright, and essayist. Left a very extensive *oeuvre*, including many publications of a theoretical nature that are considered valuable contributions to an understanding of expressionism. A political activist with strong left-wing leanings, he eventually joined the Communist party. He was a colorful, flamboyantly aggressive personality who savored polemics and a good fight. See Kasimir Edschmid's description of him in *Lebendiger Expressionismus* (Berlin: Ullstein Bücher #465, 1964). Becher served from 1954 until his death as Minister of Culture in the German Democratic Republic (East Germany).

13 Rudolf Laban (1879–1958)—Dancer and dance pedagogue. One of the founders of the modern-dance movement and a leader in developing dance notation.

14 Walter Serner (1889–1928)—Poet, art critic, and author of detective stories. During the First World War, precursor of dada in Zurich. Published the magazine *Sirius*. Joined the dada group in Zurich and published, in collaboration with Tristan Tzara and Otto Flake, the magazine *Zeltweg*. Disappeared in 1928.

15 Max Oppenheimer (1885–1954)—Born in Vienna, "Mopp," as he was affectionately called, achieved prominence in his time primarily as portraitist and graphic artist.

16 ". . . the Cassirers in Berlin" were prominent figures in Berlin's theater and

art world. Paul Cassirer (1871–1926) held exhibitions of modern art in his salon, where art lectures and theatrical performances were attended by celebrities in the world of art and literature as well as by the rich and curious. An art collector as well as an aggressive art dealer, he added greatly to his prestige by publishing original graphics by contemporary artists, among them "Mopp," Oskar Kokoschka, and the leading impressionists in Germany, Max Liebermann (1847–1935) and Lovis Corinth (1858–1925).

17 Marcel Slodki (1892–1943)—Polish painter and illustrator. Came in contact with the Zurich dadaists during World War I.

18 Else Lasker-Schüler (1869–1945)—Leading poet of the expressionist era (1910–20). Left an impressive collection of prose, drama, and lyrical poetry. Emigrated to Israel.

19 Jakob van Hoddis (1887–1942)—One of the earliest expressionist poets, who was widely read at the time and exerted great influence upon young writers of his generation. His creative work came to a halt at the age of twenty-seven, when he had a schizophrenic episode.

20 Georg Heym (1887–1912)—Berlin poet who, like Hoddis, belonged to the earliest expressionist group.

21 Leonhard Frank (1882–1961)—Prominent expressionist poet and novelist with pacifist, liberal, and idealistic overtones. His books (*Der Mensch ist gut, Karl und Anna*) were enormously successful and influential.

22 Ferdinand Hardekopf (1876–1954)—Poet and outstanding translator who was close to Pfemfert and the writers of the *Aktion*. His own poetry remained influenced by the Jugendstil.

23 Klabund (1890–1928)—Real name: Alfred Henschke. Became popular during the expressionist era (1910–20) with his lyrical poetry, prose, and drama.

24 Fritz Baumann (b. 1886)—Swiss painter; lesser-known member of the Sturm group, directed by Herwarth Walden. His paintings combined cubist elements with cosmic symbols. Even the title of one of his works—shown in the Sturm exhibition of March–April 1917 at the Galerie Dada, in Zurich—*Traum vom Werden* (Dream of Becoming) reveals his preoccupation with finding ontological symbols. His final showing with Walden was at the one-hundredth Sturm exhibition, celebrating the tenth anniversary of the Sturm Gallery, in Berlin, in September 1921. Co-founder of the group Das Neue Leben (The New Life) in Basel. He also worked with dadaists in the Artistes Radicaux (Radical Artists) group. He later taught at the School for Arts and Crafts in Basel.

25 Ludwig Meidner (1884–1967)—Expressionist painter and graphic artist. In 1912, co-founder of the Pathetiker group; in 1918–19, member of the Novembergruppe. Emigrated to England in 1938. Returned to Germany in 1952.

26 Wilhelm Bölsche (1861–1939)—Between 1898 and 1902, Bölsche published three volumes on *Das Liebesleben in der Natur* (Love Life in Nature), describing the various modalities of sex life throughout the animal kingdom, which became best sellers.

27 Carl Gustav Carus (1789–1869)—Physician and painter, best known for his studies on psychology and physiognomy. His book *Psyche* was an early attempt to present a scientific theory of unconscious psychological mechanisms.

28 "We anticipated psychoanalysis": a highly personal statement, of course, since psychoanalysis was already a well-established psychological discipline in 1916. But the young medical student Huelsenbeck neither was familiar with the literature of that field nor had he been exposed to formal psychoanalytic training or a personal didactic analysis. Contrary to an often repeated myth, he

never approached Carl Jung while in Zurich and never became a Jungian. Arp, Ball, and Janco showed no interest in Freud and psychoanalysis at the time. And only after having joined Breton in Paris did Tzara discover Freud and psychoanalysis.

29 *Le Siège de l'air* (The Seat of Air) is a major French collection of Arp's poetry, 1915–45, published in the series Le Quadrangle (Paris: Editions Vrille, 1946). See *Arp on Arp: Poems, Essays, Memories*, ed. Marcel Jean. The Documents of 20th-Century Art (New York: The Viking Press, 1972).

30 Eduard Korrodi—Swiss literary critic whose pro-Nazi and anti-Semitic article in the *Neue Zürcher Zeitung* on January 26, 1936, provoked Thomas Mann's famous "Open Letter" of February 3, 1936, which was published in the *Neue Zürcher Zeitung* and led directly to Mann's "expatriation" by the Nazi authorities. This forceful and admirable document is reprinted in *Letters of Thomas Mann 1889–1955*, trans. Richard and Clara Winston (New York: Alfred A. Knopf, 1971), pp. 244–48.

31 *On My Way: Poetry and Essays, 1912–1947*, by Arp, was published in the series The Documents of Modern Art (New York: Wittenborn, Schultz, 1948). Reprinted in part in *Arp on Arp* (1972).

32 Alfred H. Barr, Jr., *Picasso: Fifty Years of his Art* (New York: The Museum of Modern Art, 1946).

33 Michel Seuphor (b. 1901 in Antwerp of Flemish parents)—Real name: Fernand Berckelaers. As a young man, very active in the Flemish movement. From 1921 to 1925, published the magazine *Het Overzicht*, which became almost immediately an important international art and literary magazine. In 1930, in Paris, he was founder of the group and magazine *Cercle et Carré*. In April 1930, with Torres-García, he organized the first international exhibition of abstract art. Following "a profound religious transformation," he withdrew with his wife to a village in the Cévennes and stayed away from Paris for fourteen years. Returned in 1948. Among his many publications: *L'art abstrait—ses origines, ses premiers maîtres*. (Paris: Maeght, 1950).

34 Herta Wescher—Has recently published a carefully researched and beautifully illustrated book, *Die Collage* (Cologne: M. DuMont Schauberg Verlag, 1968).

35 George L. K. Morris (b. 1905 in New York)—A founder in 1936 of the American Abstract Artists and its president from 1948 to 1950.

36 Albert E. Gallatin (1881–1952)—Born in Villanova, Pa. Founder of the Museum of Living Art, now housed at the Philadelphia Museum of Art.

37 Viking Eggeling (1880–1925)—Born in Sweden. Lived in Paris, where he was first influenced by cubism. In 1916, he joined the dadaists and became a close friend and collaborator of Hans Richter. Struggled with projects and problems of abstract art, such as "counterpoint and orchestration of the line." In 1920, together with Hans Richter, produced the film *Horizontal-Vertical Mass* and continued alone with experiments on abstract scrolls. He succeeded in 1921 in creating the first "absolute"—the first completely abstract—film, *Diagonal Symphonie*, which had its initial public showing in Berlin in 1923.

38 Raoul Hausmann (1886–1971)—Born in Vienna. Painter, important collagist, sculptor, and writer. Co-founder of the Berlin dada group, he published the periodical *Der Dada*, wrote many dada essays, invented the lettristic sound-poem, and experimented with photomontage. He was also known as "Dadasoph." Friend of Kurt Schwitters, whose "Lautsonate" originated with the stimulus received from Hausmann's poem "fmsbw."

39 *Anthologie Dada*: Appeared in May 1919 as double issue of *Dada*, no. 4/5, edited by Tzara, in two editions, a German one, printed in Zurich, and a

French one, printed in Paris. The contributors to this special issue were: Albert-Birot, Aragon, Arp, Breton, Gabrielle Buffet, Cocteau, Eggeling, Augusto Giacometti, Hardekopf, Hausmann, Huelsenbeck, Kandinsky, Klee, Picabia, Raymond Radiguet, Otto van Rees, Ribemont-Dessaignes, Richter, Serner, Soupault, and Tzara.

40 Albert Ehrenstein (1886–1950)—Expressionist writer and lyrical poet. Author of the novel *Tubutsch* (1919).

41 Willy Münzenberg (1889–1940)—Politician, member of the Communist party. In 1920, leader of the Youth International, organized by the Communists. In 1924, member of the Reichstag.

42 Erwin Piscator (1893–1966)—Actor and director. Created the political theater. From 1920 to 1928, director of the Proletarian Theater, Stage of the Revolutionary Workers of Greater Berlin. Made many innovations on the stage, such as the first introduction of photomontage and film in his productions.

43 Egon Erwin Kisch (1885–1945)—Reporter and author in Prague. Became popular with books such as *Schreib das auf, Kisch, Der rasende Reporter*, and *Paradies Amerika*.

44 Willi Baumeister (1889–1955)—Painter and graphic artist. An early exponent of abstract art in Germany, he had a major influence on the next generation of painters.

45 Max Beckmann (1884–1950)—Expressionist painter and graphic artist. His powerful, often violent work was first shown in the United States by the pioneering German art dealer Curt Valentin in his gallery at 32 East Fifty-seventh Street, in Manhattan. Beckmann came to New York in 1947.

46 Paul Baumann—Writer and publisher. Lived in Berlin and later in Munich.

47 *Lexikon der modernen Kunst*, ed. Lothar-Günther Buchheim (Munich: Knaur, 1955; reprinted, 1963). On p. 341, a special entry for Tzara reads in part: "The poet Tristan Tzara was born 1896 in Rumania. Just as Apollinaire was the prophet of surrealism, so Tristan Tzara was the one who—on February 8, 1916—allegedly coined the word 'dada' in the Meierei beerhall in Zurich. Also the term 'art abstrait' appeared for the first time in a lecture Tzara gave in the Kunsthaus in Zurich. . . . Tzara befriended Lenin and they exchanged ideas. . . . In the third issue of his magazine *Dada*, in 1918, appears the first dada manifesto, signed by Tzara. . . . To this work of purification [of art and literature] Tzara brought not only the magic of his language but also consistent courage and his extraordinarily serious over-all interpretation of everything." The fact that there is no separate entry for either Ball or Huelsenbeck (although there is a rather comprehensive one for "Dada") to counterbalance the panegyric for Tzara may be explained by the preponderance of French collaborators on this dictionary, such as Cogniat, Courthion, Dorival, Lassaigne, Lejard, Leymarie, Raynal, Roché, Rouart, Seuphor, and Soupault.

48 *Our Daily Dream. Memories and Observations from the Years 1914–1954.* Excerpts in *Jean Arp* (exhibition catalogue, New York, Galerie Chalette, January–February 1965). Original ed.: *Unsern täglichen Traum . . . Erinnerungen, Dichtungen und Betrachtungen aus den Jahren 1914–1954* (Zurich: Verlag der Arche, 1955).

49 Lucy R. Lippard in her recent publication *Dadas on Art* (Englewood Cliffs, N.J.: Prentice-Hall, 1971), p. 45, states that Huelsenbeck "was named Commissar of Fine Arts during the brief revolution of that year [1917]." That this statement is blatantly false becomes evident if we remember that the Spartakist rebellion occurred in November 1918 and extended into the spring of 1919, while in 1917, there was no uprising and no "revolutionary government."

Furthermore, there never was a "Commissar of Fine Arts" of the German revolution. Therefore, Huelsenbeck never held such a position nor did he ever aspire to become a political appointee. In fact, throughout his life, he has had no formal political affiliation.

Even Hugnet, who is usually considered the source of this information, changed his original (1932) categorical statement to read (in 1957): "*Le bruit a couru* que, durant la période de guerre civile qui éclata à la fin de 1918, Huelsenbeck aurait occupé, durant un gouvernement sans lendemain, le poste de commissaire aux Beaux-Arts" (*L'Aventure Dada [1916–1922]* [Paris: Galerie de L'Institut, 1957], p. 47. Italics added. Also in paperback: [Paris: Editions Seghers, 1971], p. 54). The "rumor," a typical dada joke, had been started by Huelsenbeck himself.

50 Gottfried Benn (1886–1956)—Outstanding poet and essayist who grew out of the expressionist era to develop into one of the most respected figures in the post–World War II German literary camp.

51 Resi Langer—Performed on the Berlin stage and in cabarets as *diseuse*. Was married to Alfred Richard Meyer. Emigrated to New York.

52 John Höxter (d. 1938)—Graphic artist. Those who knew him speak of him as an "unforgettable character," a real "original" in the Berlin Bohème.

53 Max Herrmann-Neisse (1886–1941)—Settled in Berlin in 1917. Became prominent as literary critic. Wrote plays and poetry. Emigrated in 1933 to France and from there to England.

54 Theodor Däubler (1876–1934)—Important representative of expressionist poetry. Settled in Berlin in 1916 and befriended many of the young artists and writers whom he encouraged in every way. Published *Nordlicht*, a volume of poems, in 1920. Was an eloquent advocate of modern art and wrote prodigiously about the theory of expressionist art and literature.

55 Franz Jung (1888–1963)—German writer and journalist. Became very active in the Berlin dada group. According to Huelsenbeck and George Grosz (who wrote about him in his autobiography, *A Little Yes and a Big No*), Franz Jung was a forceful character, a heavy drinker, an impulsive adventurer, and yet, a man capable of political scheming and "string pulling." Grosz felt that he "exerted his influence on the whole of the Dada movement."

56 Israel Ber Neumann (1887–1961)—Pioneering art dealer and collector whose gallery in Berlin was among the first to show the works of the Brücke group and, later, Kandinsky, Klee, and Feininger. Published the popular "Bilderhefte" (picture books) and a series of books on modern art. Emigrated to New York in 1931. (Was known in New York as J. B. Neumann.)

57 *A Little Yes and a Big No: The Autobiography of George Grosz*, trans. Lola Sachs Dorin (New York: The Dial Press, 1946). It is rather funny that Huelsenbeck made a slip and turned the title around to: "A Big Yes and a Little No," because it touches upon Grosz's crucial dilemma. He writes in his autobiography: "Life is really more beautiful if you say YES instead of NO. I can testify to that from experience. If the title of my book seems to have a different connotation, then it is a reflection of my past rather than of my immediate present." In America, he tried hard to change his outlook but, as he stated on the very same page (305), he failed in his attempts to become an optimist.

58 Eduard Grützner (1846–1925)—German "atelier" painter who was briefly popular during the time of the unification of the German Reich.

59 Carl Spitzweg (1808–85)—An "idyllic" painter who found his favorite subjects in the dreamy world of the provincial little town of his day, which he

frequently depicted on cigarbox lids. He had been a chemist before he became a painter.

60 Herwarth Walden (1878–1941)—Real name: Georg Levine. Born in Berlin, the son of a physician. Wrote music (his compositions were reminiscent of Debussy) and poetry that showed the influence of his first wife, Else Lasker-Schüler. In 1910, he founded the important expressionist periodical *Der Sturm* and won the collaboration of artists such as Kokoschka, Kandinsky, Kirchner, and the futurists, as well as Chagall and Robert and Sonia Delaunay, to name a few. Many avant-garde writers and poets contributed to *Der Sturm*, and the daring innovator among expressionist poets August Stramm was discovered and encouraged by Walden. In 1912, assisted by his second wife, the Swedish artist Nell Walden, he opened the Sturm Gallery with works by Franz Marc, August Macke, Kandinsky, Klee, Feininger, and some members of the School of Paris. He was the first to recognize the talent of many artists who in the twenties were appointed as masters to the Bauhaus. But his personality was eccentric, arrogant, "self-willed," as Huelsenbeck puts it, and he antagonized many fine people. In this connection, see Klee's diary for 1912, entry 914.

61 "He had a special relationship to the problem of the machine": see also Huelsenbeck's "Psychoanalytical Notes on Modern Art" (p. 161), where he says that the dadaists "were fascinated by technology, and they felt that the machine was the true symbol of man's new contact with the automatic forces. They accepted Freud's psychoanalysis because it was an attempt to reveal and free the unconscious automatic forces in the self."

62 Hans Makart (1840–84)—Like his French contemporary Bouguereau, whose paintings are admired and collected by the surrealist Salvador Dali, the Viennese "salon" painter Makart, highly regarded by Austria's Kaiser Franz Josef I, became soon after his death a byword for *Kitsch*. His paintings show a definite technical virtuosity—as do Bouguereau's—but a total lack of taste. Grotesquely baroque and theatrical settings form the backdrop for sensuous nudes, Makart's much ridiculed "female fleshpots."

63 *Dada Poets and Painters*, ed. Robert Motherwell (New York: Wittenborn, 1951) to be revised and reissued in The Documents of 20th-Century Art series (New York: The Viking Press, 1975).

64 Roger Bissière (1888–1964)—French painter who worked for many years in complete isolation. Later taught at the Académie Ranson. In 1952, he was the recipient of the Grand Prix des Arts.

65 Alfred Manessier (b. 1911 in Saint-Ouen)—Prominent abstract painter who excels as a particularly sensitive colorist.

Jean Arp

I met Arp for the first time in the Cabaret Voltaire, the famous cradle of dadaism, in Zurich. "This is Arp," said Hugo Ball. Ball was a writer whom I had known well in Germany and with whom I had been producing lectures and publishing little unnoticed magazines. I shook hands with Arp. I had no way of knowing then that this was the beginning of a friendship with one of the greatest sculptors of our time. As a matter of fact, I did not even know that Arp was a sculptor, and later when I asked Ball what Arp did, he said: "I believe he paints."

A certain anonymity remained characteristic of Arp during all the time I was active in the Cabaret Voltaire. Arp was, I felt, a shy and withdrawn personality, utterly sensitive, but jovial and ready for a good laugh. At first I did not pay much attention to him because I was wrapped up in our work at the cabaret. Every evening on a primitive stage, Ball, Emmy Hennings, and I were desperately trying to entertain the audience by dancing, reciting poems and giving all sorts of harangues designed to stir the bourgeois out of their conventional contentment. Arp seldom if ever participated in these anti-bourgeois activities. He was always deeply involved with himself and his art. In one of his books Ball reports conversations he had with Arp at this period: "He is dissatisfied with the fat texture of the expressionist paintings. He insists on lines, structure, and a new sincerity." Arp's sincerity was very obvious. What he wanted was not the noise of the

dada movement. His interest in publicity was small. He only cared about the revolutionary implications of our artistic activities and hence of art in general.

Arp did not cease to be detached from the cabaret after the word dada itself came before the public and brought the founders of the Cabaret Voltaire into the spotlight in Zurich and elsewhere. All of us felt the impact of our new publicity, and we often discussed the prospects of fame. Arp alone did not seem to be very interested in all this; he lived apart and only seldom appeared at the cabaret. At this time, Arp was already acquainted with Sophie Taeuber, who was working as an art teacher at one of the Zurich colleges. Arp introduced us to her, but Sophie also shied away from the noisy cabaret, filled with drunken students and intellectuals not unwilling to express their antagonism in an occasional fist fight. While Janco contributed posters for the walls of the cabaret and made masks we esteemed highly, Arp played the role of the counselor. He talked to us about abstract art, about the futurists, Picasso, Braque, and the cubist movement. Through him we learned about Picabia.

I enjoyed strolling with Arp often along the shores of the famous Zurich lake where the swans once had been envied by Ball and Hennings because they had regular meals. The lake was the natural meeting place for all of us, and many of our plans were discussed beside it. I remember walking with Arp one afternoon as he was telling me about his plans. He said he wanted to produce something entirely new, a form of abstraction expressing our time and our feelings about it. This "time," the impact of which we saw and felt daily in the war headlines of the newspapers, asked for, said Arp, a complete revision of all our notions about colors and forms. He talked to me about the Blaue Reiter group he had belonged to, about Kandinsky, Chagall, Marc, and others, only dimly known to us. When we walked together, Arp was always impeccably clad. Although his great feeling for elegance and female beauty made him observe people carefully, thoughts about his work never left him. One day he asked me whether I would like to go with him to his studio and see his pictures. I went. We entered the small apartment, and I was amazed at all the objects standing around and stacked up against the walls. There were dozens of canvases, cardboards, and unfinished works of sculpture. Since the first sight was rather confusing, I stood there and didn't say anything. "This is just the beginning," said Arp. "But look at this. It will probably help you to understand what I am after. . . ."

In the center of the room was an easel and on the easel a canvas of

medium size on which was painted a still life of potatoes. At this time in his career Arp was still doing occasional representational pictures.

"They are ghostlike and anemic," I said.

"This is just what I am after," said Arp.

A few weeks later Arp made some severe woodcuts for my *Phantastische Gebete*, which was published in the series called Collection Dada. After this he made a few semi-abstract illustrations for another book of mine entitled *Schalaben Schalamai Schalamezomai*. Our friendship became closer, and I now understood why he didn't want to participate very much in our activities at the cabaret. He was still struggling violently to make up his mind what direction his work was to take.

In Zurich things often happened which have important implications for us still today. One day Arp and I were talking about the law of chance and the problem of simultaneity, and Arp was experimenting with pieces of paper, letting them fall to the ground and then pasting them together in the order they had chosen themselves. Another day we discussed the problem of cooperation among artists as the great need of our time. He said that the artist had to find means and ways of emerging from the isolation imposed on him by our era of anti-intellectualism. The topic of cooperation as an experience was always present while we worked together in the dada group, and not only then but also later Arp was intensely interested in it. He related it to the idea of complete objectivity, *la réalité nouvelle*, a notion the full impact of which came out years after.

This was the miracle of dada, that it gave all of us the courage to say what seemed to be so impossible to convey to anybody, and this courage benefited Arp more than any of us, as he was shy and detached by nature. "It was," he once said to me, "like having waited for a long time in the dark and then having been aroused by a loud signal. I stepped forward, and I thought there would be nothing but catcalls. But there were all of you, friends, interested and full of praise."

In a way, dada was for Arp a sort of clarifying and intensifying possibility. Here in Zurich with all his friends around, he was able to bring into pictorial and sculptural reality what he had been thinking for a long time. Arp was always and, of course, especially at this time full of the essential dada spirit, the irony, and the critical attitude, not only toward art but also toward the world as such and the world within ourselves. "The dadaist," as Hugo Ball has said, "is a man who laughs about himself."

Though this existential and paradoxical attitude appeared in many of his remarks, letters and poems, Arp never lost his basic seriousness. He tended

in general toward a certain severity. Even when he was associated with Schwitters, years after, he seldom worked with the shock technique of what we used to call the new material—matchboxes, eggshells, hair of dolls and dogs pasted directly onto the painting. Arp's personal nobility, his classical, pure approach to art as well as life, made it difficult for him to produce that bit of vulgarity we see so often in dada works.

There is another characteristic of Arp which should not be forgotten—his playfulness and a certain childlike joy, his wistful understanding of embarrassing situations. Once after he had been a guest at one of the luxury hotels in St. Moritz, he told me, laughing, about something which had impressed him deeply. He had seen American women dancing without shoes. "Think of this," he said, "they get rid of their shoes and dance." "Why?" I asked. "It's very simple," he said, "because they dance better without."

The playfulness is easily seen in Arp's work and in his constant experimentation. He was always willing to give a new idea a chance, in art and in life. But underneath, Arp has always possessed, more than anybody I know, a tremendous singleness of purpose: he never plays and forgets himself playing. Under the charming outside is always a great intensity moving toward a goal. He knows the limits of fun, and he does not hesitate to say so when he thinks the hour has struck. This unusual ability to transcend himself constantly without going astray made it possible for him to participate in a whole series of art movements without really identifying himself with anybody or anything but Arp.

("Arp and the Dada Movement," 1958)

"What was important to me then," Arp once said to me in New York, "was a new clarity, a new simplicity, a reduction of all complications to simple forms. I identified complexity with the intellect, escape from one's own personality, involvement in the affairs of the world. I wanted to create a kind of new monastic attitude, and when Sophie died, I did enter a monastery for a while. As I understood dada—at least in relation to art—it was an attempt to bring sculpture and painting in line with the new architecture which had just started radiating its influence from Holland. De Stijl, to which Mondrian belonged, was founded around the same time as dadaism, although Theo van Doesburg didn't publish his Stijl magazine until later. Since I was in search of the personality, I had no interest in the uproar of the cabaret, although I don't deny the value of the noise."

("Arp in New York," 1959)

Never and nowhere has so much been written about any art movement as surrealism. Arp was a logical leader of surrealism, but here, as always, he applied his energy more to his own work than to propagation. He concentrated on his form, his world, and created his highly personal "Arpland" in Meudon, France, where he lived with Sophie Taeuber.

There are many forms of surrealism. De Chirico, more or less objective, stressed the uncanniness of the unknown. Space (the nonbeing of the existentialists) became a person without whom modern man is lost. Max Ernst was an artist of luxuriating imagination; he painted the jungle of the world, the dangerous entrapment in existence, solitude in plethora. Delvaux in Belgium became the Edgar Allan Poe of surrealism. He is the painter of impersonality and of the lack of contact between human beings.

Arp's work has none of this. His world appears safe and joyful. As he himself jestingly put it, he strolls along the shores of the Mediterranean, the shores of the ancestors of his choosing, with his lyre or rather his chisel and his scissors. The sun, the powerful contour, the flat surface of the sea are transposed into his works. The result is clear-sightedness and inner calm.

Arp's form, technically speaking, is organic abstract form. Man and the existence of man reduced to the essential premises. A childhood dream with adult significance, to the utmost extent. Ergo, not just art but, also, a statement on human existence, in which, here, the eternally significant is manifest.

The reintroduction of the significant into a chaotic world devoid of all meaning—that was Arp's vocation and artistry, executed with the composure of a great master. That was why he became a sculptor and not just a painter of pictures to be hung on the wall. And that's why his works are dreamlike aspects of his own creative nature. In every one of his works, Arp exists once and a thousand times as an artist, a human being, a philosopher, and a friend.

Because of this deep meaning, the attachment to inwardness, the essentiality, the tenderness of the unborn, the hope of a future, Arp could never be a coarse practical joker like Dali. He was never a slapstick artist, although this Chaplinesque note is discernible in the lives and art of many dadaists. For example, Kurt Schwitters.

Arp never had to march through a show window to attract attention. He never had to be photographed in his bedroom with an ox. And despite his industry and his remarkable cunning, he never had any commercial leanings. Arp's publicity was never due to clowning but to quality into which his aggressive attitude toward his age is woven.

Arp, despite all his concern for ability and perfection, never had to be overly precise like some of the constructivists, who can boast of nothing but their clean working methods. He was not a frustrated mathematician like Mondrian; and the hidden monumentality of, say, Archipenko, Brancusi, and Lipchitz was alien to him. With a divine lightness, he followed the trail of truth, a minion of the gods in a solid Swiss milieu.

When I visited Arp in his home in Meudon a year ago, he had just recovered from a serious illness, and we both felt that life doesn't last forever. Art, however, does last forever, because it expresses human nature in its yearning for the endless. Art is thus the truest and I think most important human effort toward superhuman perfection.

We were sitting in the garden room, which also served as a living room, and which offered a view of the edge of the forest. Here in this room, Sophie Taeuber's paintings and constructions hang on the walls. Arp lost his wife prematurely. She was everything for him, a companion, a colleague, a beloved, and a mother. Overwhelmed with gratitude, he helped bring about her fame. Arp is Taeuber and Taeuber is Arp.

We sat there, drinking the pleasant local wine, with Marguerite, his loyal friend, Magnelli, Michel Seuphor, and Sonia Delaunay.

I thought of the great things Paris had produced, people, ideas, projects. And I thought we should be careful not to reproach the French for not having repaired their houses. Or for overthrowing their government every Saturday. They have a stability that comes from other depths.

("The Sculptor Jean Arp," 1954)

Tristan Tzara

Tristan Tzara, one of the fathers of dada, died at the age of sixty-seven in Paris at Christmas [in 1963]. The news of his death was a monumental blow for me and the entire dada movement, and the effects will be obvious only after a certain length of time. Tzara was an unusual man, and his loyalty to the basic ideas of dada greatly contributed to its survival. He came to Zurich from Rumania in 1916, filled with a sacred fire, if I may say so, to make something unusual out of the world, literature, the Cabaret Voltaire, and last but not least, himself. He was a great poet, even in a language with which he had not grown up, an organizer with unusual abilities, a demonstrator, a politician, and also a human being. He had Jewish brilliance, the ability to think, the vitality and recklessness that we were all supposed to have.

I am writing an obituary, a kind of encomium, and at this moment I would like to leave aside many things I might have said otherwise. Tzara was a "natural dadaist," a sort of self-styled barbarian, who wanted to put to fire and sword the things that we had designated as the goals and objects of necessary annihilation—a whole collection of artistic and cultural values that had lost their substance and meaning.

It was easier for Tzara to carry out the work of destruction than for Ball, Arp, or myself, because Tzara had never experienced the preconditions for the whole mass of false values that we so greatly opposed. Tzara drew part of his admirable energy from a nonexistent reservoir. Unlike

Ball, Arp, and myself, he had not grown up in the shadow of German humanism. No Schiller and no Goethe had ever told him in his tiny native town that the beautiful, the noble, the good should or could rule the world. Tzara never suffered from a conflict with the fear that if culture were destroyed, something essential could be destroyed along with it, something irreplaceable, precious, mysterious, that might possibly never rise again out of the ruins. In his uninhibited (and justified) feelings against culture, he never felt the need to bow with his torch before the basic ontological problem of man and society. As a native of the Balkans, he couldn't feel this need, and he lived and rode on like the leader of an invisible army of Langobards who are indifferent to the good things that might be wiped out with the bad. Tzara was a barbarian on the highest mental and aesthetic level, a genius without qualms. Dada would never have survived without this lack of qualms. No matter how one may judge it.

The necessary lack of creative inhibitions often led Tzara astray, sometimes in a dreadful way. Thus, he permitted himself to live all his life off a fame for an arrogated founding of dada, a fame that was only partially acknowledged. I mean Tzara's claim to having discovered the word "dada," which in point of fact was accidentally discovered by Ball and myself. Yet it was this lack of inhibition in regard to proprietorship, this transcendence of ordinary morality (the same is evident today in the works of Genet and Burroughs), that is part of what is known as a leader's personality. Tzara was less interested in the rights of the individual than in the part that he had to play within the movement. This resulted in the conflict between him and Breton, who accused him of internal lack of law and order.

Tzara was a man who understood the nature of our era far beyond the cultural problem. To what extent can man exist today with no inner ties, no sense of obligation toward himself and others, and to what extent can and should he express it aesthetically?

Tzara changed in the course of his life without essentially abandoning his position. When he discovered the group centering on the periodical *Littérature* in Paris in 1919, the thing that attracted him most was the idea of nonart. The various demonstrations that Tzara led in Paris testify to this philosophy. And it wasn't a joke, it wasn't a sentimental and ironic assault on the *status quo*; it was a revolution, a total physical and mental revolution. People not only demonstrated out in the street and on the stage, they destroyed objects and people (Vaché had committed suicide). They not only smashed lamps, they also struck out against people, opponents and friends. It was the love of a good fight, the love of action that made

Tzara's campaign so famous. It was the intoxication of destruction, and the brutalization of art was only one aspect of it.

All this was necessary, and Tzara himself was nothing but the product of a dehumanized and depersonalized era. It was the despair encased in aesthetic destruction at the production of *Le Coeur à gaz* [The Gas Heart] that sent Paris into a state such as it had not known since the days of Robespierre. Tzara-Robespierre (not Danton). Heads must roll. They had to roll. But then, like everything in the world, like storms and sunshine— everything passed, and Tzara, growing old, charming and intelligent as ever, ambitious to the last breath, found himself walking alone through his enormous wealth of art, Picassos, Giacomettis, and Mirós. He walked from statue to statue, from painting to painting, and perhaps he recalled that Rumania is closer to Greece than to France.

("Tristan Tzara," 1964)

Hans Richter

I don't know how long dada will shadow us. So far it doesn't look as if the fathers and grandfathers of that movement will ever be able to retire. Those who have tried are experiencing an extremely pleasant and exciting disappointment. This is true of Hans Richter, who tried to settle down in Southbury, Connecticut, but who now, despite his being seventy years old, is more active than ever before.*

Hans Richter is one of the most complicated and most interesting men of dada. He came upon dada in Zurich in 1916; after I had returned to Germany, he became friendly with Arp, Tzara, and Janco and has ever since managed to integrate the essential knowledge and insights of those turbulent times into his constantly growing personality. Richter was and is one of the dada artists more interested in the solution of artistic problems than in the struggle against convention. Thus, he didn't much care for the Berlin dadaists because of their disorderly and political wildness, and the mitigating influence of time was necessary for Richter and myself to become real friends.

For Richter, the problem of the "new painting" was always the meaning of his personality; and considering Richter's many other activities, it is about time that we gave him credit for being one of the fathers of abstract painting. The fact that subsequently Richter, together with Viking Eggeling,

* This essay was written in 1960; Richter was born in 1890.—Ed.

turned to film-making in Berlin should not be interpreted by critics as a predilection for Hollywood. For Richter, a film was nothing more or less than a canvas, albeit a moving one, on which he projected his dreams of new forms and colors. Richter was never interested in storytelling; from the very outset of his career, he wanted to discover the essential in the objective world and was at times more devoted to objects, as in the surrealist films, and at times at a greater distance from the reality of his paintings and his classic films, as in *Ghosts Before Breakfast*, for example.

In the terminology of existential psychoanalysis, there are object-oriented and self-oriented people, with the latter being given preference. In reality, however, an intellectual man seeking his personality can never fully devote himself to either things or his own self. This is true of Richter. He varies his experience from the subtlest intellectuality to a paradoxical love of reality, he plays with ideas and abstractions as well as with the changes of everyday life and feels as at home in philosophy as in a world in which hats and plates in chaotic flight impart some sense of the essence of the universe.

Richter's paintings, like all his art and his thought, are ruled by two basic elements, the linear and the organic; this is the endless struggle for us and the artist, which he has depicted in his famous scrolls. The symbols of the scrolls, beginning with mathematically cryptic signs and ending with polychromatic, organic ones, represent the incessant, the endless image, endless life, endless art. Man is in a process of wandering, the beginning is dependent on chance and the end is lost in the twilight of paradox.

The changing symbolism in Richter's paintings concerns the man who lives with one foot in art and the other foot in life. The essentially human is neither the beginning nor the goal; it exhausts itself in tension. Richter's life could be summed up in the phrase "the tense or, rather, essential and intense man." This is the man of our era, expressing himself in Richter's art and perhaps even more in his life—ambition and accomplishment, little relaxation and a great deal of activity, detachment that feels obliged to go forward, intellectuality that life demands. For Richter, his artistic work, perhaps more than for anyone else, symbolizes the integration of the personality. He is not a classical man like Hans Arp, in whose lap the gods threw a great deal. He is not a completely spontaneous man like Picasso, or a calm man like Braque. He is really the fighting man of our age.

Hans Richter uneasily paces up and down between art and life and, as a veteran dadaist, ultimately decides that art and life are merely two aspects of a single great voyage of discovery. Yet Richter's personality contains so

many positive elements, so much constructiveness, both artistically and emotionally, that he never misses his real aim; there is something undauntable in his personality, something almost dogmatic, the result of a deep moral stance. Thus, in his life, Richter, mainly through the symbolic statements of his painting (where he never jokes at all) is a moralist, perhaps the greatest moralist among the dadaists.

("Meeting Hans Richter," 1960)

A Knight in Connecticut

I never had more than the slightest involvement with knighthood. When I was a boy, my grandfather sometimes told me about medieval Germany. He was an old man, who usually sat behind a huge piece of cardboard that served as a lampshade; he was tired, pessimistic, and expectant of death. He had wanted to write, but ended up as a (subterranean) land surveyor. Consequently, he was always melancholy, but his interest in poetry and history never waned even at the end. When he died, they found him holding Dante's *Divine Comedy*, with his finger between the "Inferno" and "Paradise."

My grandfather used to tell me about the *Ritter* and their tournaments, about lovely damsels and cruel ladies, about Ulrich von Liechtenstein and Ulrich von Hutten; he also owned a library of hundreds of books on medieval history. It was in this library that I spent a part of my youth, at night, lying on my stomach and inhaling the dust of old pandects.

I would often tell my son, Tom, about the age of chivalry, but when we moved to America, it became more and more difficult for me to talk about knights. America is undoubtedly not a country for knights, and it's better to tell stories about cowboys or the famous Indian hunter Davy Crockett. The knights gradually faded from my memory. There were actually few occasions for thinking about them, for example, when, as a doctor and psychiatrist, I thought about the peculiar mentality of the knights, who at the command of their ladies had themselves sewn into bearskins or played other— today we would call them pathological—jokes.

I was reminded of knighthood from time to time whenever I visited the Metropolitan Museum in New York. The Metropolitan contains a huge room devoted to knightly armor, and even the most indifferent American businessmen stand there marveling at early German and French armory craft.

Every human being is a product of his environment and Americans, who possess many charming traits, simply cannot imagine that anyone desirous of being a hero would clamber into an iron container. The American pioneers shot from the hip, and speed was of the essence. The man who shot first usually won, because his enemy didn't have enough life left in him to reply.

Naturally there are no knights in Connecticut, and there never *have* been. A hundred and fifty years ago, it was inhabited by Indian tribes who dipped their arrows in rattlesnake poison to fight against the white invaders. It didn't help them any, as we all know today, and now every farm in Connecticut is provided with snake serum, which can be ordered at no great expense from Sears, Roebuck.

Considering all this, one may imagine my astonishment when my friend Hans Richter asked me to be a knight in Connecticut. Richter is a well-known film-maker and painter. He made a name for himself as a pioneer of the abstract film, and his surrealist movie *Dreams That Money Can Buy* received an award at the film biennale in Venice.

The first thing we had to do was rent the armor for the movie part I was assigned. We finally found a full suit in a theatrical costume agency in New York, in romantic surroundings among costumes of all periods, masks, old rifles, swords from the time of Marie Antoinette, and cartridge belts of the Canadian Royal Mounties.

It was a genuine suit of armor, the owner assured us, "the kind those guys wore when they went dragon hunting to win some lady's favor."

That's what the man said, but Richter added persuasively: "You have to look good as a knight," he said. "I've got a great part for you. You'll be a knight, and—now you'll be amazed—you're going to lift Matisse's daughter or, rather, granddaughter from a tree. . . ."

This isn't the right time to discuss Richter's film, but it is certainly an excellent one. Many famous people are in it—Hans Arp, Jean Cocteau, Marcel Duchamp, and others. I wasn't just impressed, I felt honored.

And so I decided to accept my friend Richter's offer and be a knight in Connecticut—in a movie, but nevertheless in authentic armor and working with people whose names meant something to me. Lifting Matisse's grand-

daughter from a tree struck me as the only possible action, and I looked forward not only to meeting the famous painter's granddaughter but also to viewing the tree from which I was to lift her.

I must say that my engagement as a knight was no match for Jackie Matisse's beauty; furthermore, I had to be heaved up onto a table to carry out the assignment successfully. By way of excuse I must add that my knowledge of knighthood, as I have described it, had greatly waned, and second, the armor was "authentic"; it was so heavy that I could barely move, and unfortunately I am never fully aware of the comical aspect of any situation that I may be involved in.

I found out that the difficulty of playing a knight is due not so much to any incapacity to go back in time as to the physical effort required to drag the iron armor around through the cursed summer heat of Connecticut. The knights of yore may have been physically stronger, although it has been proved that people have been growing taller and more powerful since those days. We Americans start the day with oatmeal, whereas the knights of olden times ate sausage broth and drank innumerable beers at the crack of dawn. But this difference alone does not explain the modern knight's lack of pep. The difference is a mental one.

Lifting a woman from a tree, even just in a movie and in jest, is different for us than for a medieval knight. Likewise, such unusual adventures as tumbling into a brook or tripping over a woman's foot and collapsing clitterclatter—all of which I had to do in my armor. None of this makes us feel like heroes. God knows why, but it's sex without any future when we lift a woman from a tree, even the beautiful granddaughter of a famous painter. Or falling into a brook. (To be honest, the only thing I could think of was the word "penicillin." I thought that if I should catch pneumonia, I could in all probability be cured speedily with penicillin.)

Film-makers are a special breed as far as I can judge. Naturally they're concerned with making a good film. Understandably. But they have a bad temper and they assume that the people they are dealing with are slow, and so they push them about, boss them, and constantly correct them.

The situation in a movie studio or on location is like an army camp, even in America, and there is general agreement that obedience is the loftiest virtue. I was never able to understand why Hollywood stars earn so much money until I started to be a movie actor myself, albeit moonlighting. I would like to let my readers in on the secret: film actors have to give up their personality and their freedom for as long as the movie is being made. They turn back into little boys and girls who do bad and forbidden things and have to steel themselves for reprimands.

In a movie, one feels that democratic freedom is something idealistic that always arrives when least expected. The movie I acted in is a surrealist one, closely linked to modern art and its leading personalities, but also, as I came to realize, to chess and Marcel Duchamp. Marcel Duchamp, as we know, is the artist who gave up painting for chess. I am, as I said, a practicing psychiatrist. I owe my involvement in the movie to my being a writer and a founder of dada.

I look forward with great delight to seeing the film. I will then find out why I lifted Jackie Matisse from a tree. It was a very old and beautiful tree on Richter's Connecticut farm, and it had a gigantic hole in the middle, in which the great master's granddaughter sat waiting for me. I am as ignorant of how the hole came into the tree as of what I did in the movie. But one thing is certain: the same laws do not obtain in art as in life, and the question as to why this should be so (especially in surrealist movies) should be limited by self-censorship.

"It is the story of the beautiful Melusina," said Richter. He offered this explanation without being asked. I wouldn't have dared. Then he added: "And now we'll all go to the sand hole."

After leaving the table successfully and not drowning in the stream, I looked forward with great confidence to further difficulties. What else could happen to me? Things will take their logical and consistent course, I thought.

Late that evening, en route back to New York, my son asked me: "What was the sand hole like, Dad?"

"Oh," I said, "it was not much different from being in the tree hole. It was very tiring but very interesting."

"You're simply not an actor, Dad. You ought to stick to psychiatry."

"That's so true," said my wife.

"It was the story of Melusina," I said, "somewhat changed, but very recognizable. She stuck her foot out of a bush, I was supposed to trip over it. Which I did. I collapsed, the old iron jangled, and I couldn't stand up again. . . ."

"Those stupid knights' tales," said my son. "As if anyone were still interested in them in this age of atomic bombs. Why didn't you at least bring some psychoanalysis into it?"

"I was told psychoanalysis had a great deal to do with it. Melusina, the granddaughter of the famous Matisse, trips me; I, the knight, supposedly a strong man, fall over a tiny foot. It is the symbol of my end. My armor is removed, or rather she removes it from me, and throws it piece by piece into a sand hole."

"You can tell me a lot of things," said my son, "but that I simply won't believe."

"It's just as I say," I assured him, rubbing my swollen feet.

"People shouldn't concentrate on the past so much," said my son.

"And the Connecticut summer climate doesn't help these tales of knighthood much either," added my wife.

("A Knight in Connecticut," 1955)

Marcel Duchamp

The large retrospective show of Marcel Duchamp's works at the Cordier & Ekstrom Gallery had an extraordinary effect on New Yorkers, and not only on them. Duchamp's influence has been increasing steadily through the years, although as he has often said himself, he has not painted seriously in the last forty. He comes from a family of artists; his brother Villon, who died on June 9, 1963, made a name for himself in Paris, and another brother was an important sculptor. Marcel Duchamp himself came to New York with Picabia a few years before World War I, and joined the Stieglitz group. Stieglitz was the kind of gallery owner who has grown rare in today's era of advancing commercialization—an alert man, a true friend of the artists, a writer who put out a magazine, *Camera Work* (Stieglitz was mainly a photographer); subsequently, the name of his review was changed to the gallery's house number, 291. The group of friends was joined by Walter Arensberg, a wealthy art collector, who bought Duchamp's famous painting *Nude Descending a Staircase*.

Duchamp, who painted in an impressionist style at first and later like a cubist, was already seeking new directions for himself. As one of the exhibitors at the Armory Show, which became an essential cornerstone of American art, he won prestige and recognition, although—as is usually the case with a genius—no one had even a remote idea of the full scope of his personality. Duchamp has a mathematical mentality—he was, incidentally,

one of the best chess players of his time, already studying the possibilities of a new physics. He was interested in various objects in their three, four, and more dimensions. One may say that Duchamp's entire life revolved around the theory of objects. I mean the subject-object relation, the extent to which an object is what it appears to be, the ways of extending our knowledge of the object, the phenomenality of the object, and its relationship to other objects, the world, and human emotions.

Duchamp, with the help of his friends in the Stieglitz group, put out the magazine *The Blind Man*, then *Rongwrong*, and finally after World War I, *New York Dada* (1921). Marcel's interest in dada always remained keen; the exhibition presents him as a proto-dadaist. Which is true. By creating his ready-mades in those days, he not only anticipated many dada ideas, he also actually created something the dadaists never succeeded in producing: dada art works. Outside of Schwitters, there is only one real dada sculptor: Marcel Duchamp. Richter expressed his tremendous experimental joy in his movies, Arp in his poems; but the main transcendental strength came from Duchamp and was expressed in his ready-mades, which so many years later are now influencing pop art.

The title of the Cordier & Ekstrom show is characteristic of Duchamp and allows us to go into his personality. It is called *Not seen and/or Less seen.* Duchamp developed a theory opposed to the retinal activity of painters. In other words, the painter should not give in to his retinal impulse, he should see less or even not at all. But then what *should* he do . . . ? When Picasso (as Françoise Gilot reports in her book, *Life with Picasso*) was asked about the peculiar development of modern painting, he said: "A painter is nothing but a painter, he's supposed to paint." Duchamp's answer would be quite different: "A painter is first of all not a painter, he has to distrust his senses, he has to know what he's doing first, and his task is to investigate not the reality but the transcendental quality of the object. His doing this with 'artistic' means is merely a coincidence."

Duchamp is possibly more of a scientist than a painter, his enormous importance rests on the fact that he struck a blow against the naïve artistic approach to the object. Duchamp has always denied being an antiartist, his judgment relies on neither philosophical, sociological, nor other external knowledge. He doesn't want to be anything more than a man of this age, totally in the world and completely filled with the problems and doubts of our time. Duchamp, in contrast to German and other European artists and writers of a similar kind, is neither romantic nor sentimental. One might say that he has limited the simplicity and the naïveté accompanying any crea-

tion to a minimum of personal and artistic motion. Once, when asked what he was doing at the moment, he replied: "I'm breathing."

Duchamp *is* breathing, he lives with his wife, Teeny, the former wife of Henri Matisse's son, in a modest little apartment in Greenwich Village. He appears modest and quiet, yet he is fully aware of his major importance. He has the amazing sensitivity of Cézanne, Bonnard, or Picasso, but he has even more sensitivity in the .sense that he weighs and feels the heaviness of his brush, whenever he has to take it in his hands. Duchamp is greatly liked by Americans, first of all, because they consider him an interesting personality, and second, because it is greatly to his credit that as an artist and thinker he did not fall for the myth of Paris like so many less important people, but instead settled in the United States. Just as, almost in accordance with Zen philosophy (which he is quite familiar with), he wishes to nonact, nonsee, and nonpaint, he loves to be "crude"; that is to say, not rude or vulgar, he simply doesn't care to live with people who make him sick with their ambition and their false sense of importance. Duchamp (in strange contrast to his love of publicity) prefers the anonymous life, although one has to regard this desire more than anything else as an expression of his wisdom.

("Marcel Duchamp," 1965)

George Grosz

I first met George Grosz in Berlin in 1919, a time when rats were scurrying through the streets, shots bursting on every corner, and the lost war filled all the people with a deep despair, the like of which had never previously been experienced by an entire nation. In crowded coffeehouses, poets and dealers in illegal cocaine could be seen in conversation until the great influenza epidemic brought unexpected death to many people who had rejoiced at surviving the war. In Berlin, death was furnished with all the bad instincts, and the rats replaced the symbol of the German eagle, who had been smashed on the battlefields. George Grosz's awareness of social distinctions had been heightened in Stolp, Pomerania, where he had grown up in an officers' casino run by his parents. He was never to forget the arrogance of the "ruling class." Here, in the twilight of the wine cellar from which he had to bring up bottles of champagne for the cuirassier lieutenants, his first observations took shape as permanent images. Here he intensely experienced the conflict between power and helplessness, a conflict so impossible to solve that it disturbed his sleep even in America, where he himself had become a member of an elite class, a class of talent and intellect, which made the earlier elite look like a bunch of beggars.

It was in the Berlin of those days, the Berlin I have just been describing, that we founded dada, and Grosz, known as "Dada Marshal," was an active and enthusiastic member. Grosz was simply made for dada. He not only

116

drew, he also wrote poetry, and whenever he got on the podium in a cabaret and shouted his poems at the audience, his enthusiasm positively and negatively knew no bounds. Grosz had the courage of a conviction, but none of us was clear in our minds about its definition. He demonstrated with us against an enemy who surrounded us day and night.

Evening after evening, Grosz and I would enjoy the wine and good food at Kempinski's (as long as they could be had for money), and Grosz told me about his aspirations. I have a very precise recollection of what he told me about the magnificent snobbery of the English artist Beardsley, and his numerous suits, shoes, and ties, and the servant who trotted behind him caddying his paints and pencils. This was an idol for a man flirting with the proletariat and willing to take the political consequences.

George Grosz, as long as I knew him, was a man of contradictions. Whenever he said yes, he would usually mean no. He lived the irrationalism and the paradox of dada intensely, and since he was brilliant and talented, dada shook him more deeply and influenced his life and his personal behavior more tellingly than it did the rest of us. He was so tormented by the tug of war of his opinions that he had to benumb himself with alcohol to go on living. He often said to me: "That's the only way I can bear living."

Grosz's desire was fixated on America. He had read a great deal about America, he particularly loved Charlie Chaplin, he imagined America as the great land of freedom where each man could develop his talents to the point of perfection. It was Grosz's fate that he could go to America as early as 1932, when Hitler was already imminent. Grosz spent twenty-five years in America, but he never succeeded in fulfilling his dream. He was forced to realize that America was totally different from his romantic conceptions. Grosz's aggression and his sharp critical eye, nourished by his unusual faculty of observation, were unable to find an object in America. There was nothing in America to get artistically stirred up about as there had been in Berlin. Grosz discovered that America is no country for angry young men. It is actually a land in which you either conform or become so unpopular that you ruin yourself.

This discovery was painful, but Grosz tried to salvage as much of his dream as possible. He never complained about his lack of success; he lived in almost total isolation in his small home in Huntington, Long Island, near the metropolis of New York. He owed it to his sensitivity not to live in New York itself, but he never felt comfortable in his isolation. He tried to surround himself with congenial friends, but there weren't many. Grosz was constantly in search of people with whom he could talk and drink. I spent

many evenings with him out there in exile, as it were; I felt as if I were talking to a man who had dreamed about the beauty of a landscape for a long time, only to discover that it was an artificial landscape.

("Remembering George Grosz," 1959)

The day would wear on gradually; behind the hovering treetops hung the endlessness of the American sky. The house grew livelier at night, friends came from nearby and from New York. The house lay directly in the shade of a forest, and cars drove up a small sloping terrace as if they were entering a castle. Actually, however, it was a reconstructed garage, not very homey, but sufficiently so for Grosz, who—despite his wild desires for luxury, as expressed in his writings and drawings—preferred to live simply. . . .

Any man concerned with the intellectual and cultural issues of our age may become bitter and resentful to such a point as to believe that such feelings are an essential factor in creativity. Creation, however, is independent; it is contingent on neither friendship nor enmity, neither riches nor poverty. The creative is the independent, it is the faculty of transcending something and everything, and mainly oneself. . . . Grosz believed—and this belief contained the true tragedy of his life—that his art would keep on growing in a world of freedom.

("In Memoriam," 1959)

Since Grosz didn't find anything in America for his brilliant talent to criticize, he fell back upon what he called his positive talents. He did his very best to replace hate with love. In summer, he would settle in the dunes of Cape Cod; he lived in a "saltbox," one of those houses characterized by the simplicity of the Puritan Fathers. He associated with the artistic colony of Provincetown, with Dos Passos, with well-to-do and well-known writers and painters, and he envied them for the "normality" of their careers. He never spoke a word of criticism against America; he said he loved America, and he added that if he hadn't as yet made it, it was his own fault.

It was often a torment for his friends to watch Grosz trying to deny his own past. "I hated much too much," he would reiterate. He admired the easiness of optimism, an organic component of the American way of life. He wanted to emulate these optimists, and he endeavored to give up or at least subdue the graphic quality of his talent; he wanted to become a real painter. In the dunes, the yellow of the sandy soil, the spotless blue of the

sky, and the evening purple of the ocean, he looked for a personal color scale and a new life, but he failed. No matter how much force he applied to his contradictory nature, the great critic Grosz never became a great optimist or a great painter.

("Remembering George Grosz," 1959)

Grosz's drawings, which radiate an intensity unknown since Gavarni and Daumier, have lost none of their significance or effectiveness, although the contents of Grosz's hatred have long since disappeared. The times have changed as much as the stance of the intellectuals to whose circles Grosz belonged. Communism, which once seemed a kind of "paradise," has revealed its true face as the Gorgon of our era, the abysmal horror and terror of total loss of freedom and ruthless totalitarian leveling.

Grosz's own change, his abandonment of earlier ideals, is evident in his *oeuvre*. He began as a social critic and draftsman. Life and its content were far more crucial for him than form, and for this very reason he succeeded in finding a particularly ingenious form for his contents.

This form was caricature on its highest level, a kind of social realism, but highly individual. Grosz, who later always asserted that he was no cartoonist, made the mistake of underestimating his works by likening them to the drawings in the German satirical magazine *Simplizissimus*.

What Grosz really wanted (a wish that coincided with his moving to America) was to paint. He wanted to be a great painter, not a cartoonist and not even a graphic artist.

Grosz began to paint in America, the land that offers the most amazing possibilities of variety and color, and is thus an astounding object for a painter. But all he actually accomplished was to add color to new drawings. The graphic detail remained the crucial thing for him. And thus the paintings that he did during his early days in America are at the same time critical observations, sharp depictions of humanity, comments on American ways, on New York and the artist's environment.

Color has a special effect here; it tones down the artist's mordancy instead of underscoring it as was the case earlier. As a result, the effect is somewhat cloudy, and the whole thing shifts from the terrible to the comical. The apocalyptic thunder vanishes; the terror of Berlin becomes a universal Human Comedy.

The expressionist character of Grosz's art remains visible throughout his entire development. We see not so much his problems of form and color as

a human expression. This does not mean that the artist did not understand his craft. Quite the opposite. There is hardly another modern artist who, technically, attained the perfection that was George Grosz's.

I mean: in his paintings, neither color nor form follows its own laws as we are used to seeing them do in modern art, where the purpose and essence of all artistic creativity resides in abstraction.

In Grosz's paintings, this would have meant the abstraction of precisely the things that play the major part in his *oeuvre*: human reactions, sociology, cultural problems. Thus the subordination of the painterly elements to the human intentions is crucial to Grosz's art.

The subordination and the superordination are what attract us here, love and hate, coming and going, growth and diminution. All this expresses the insecurity of the human position. We find many changing orders, but no *one* order to believe in or go by. We hear the voice of an artistic contemporary of Spengler and Toynbee and the existentialists. We see a subjective picture of the world, an almost aggressively blissful persistence in nihilism.

In other words, all the oils, as well as the water colors and the drawings, can be understood only in terms of the thoughts, feelings, reactions, aggressiveness, critical views, and positive and negative attitudes of the artist.

On this basis, the artist's personality interests us as much as his work, which mirrors his feelings so accurately in the tiniest of strokes. His personality exerts an almost Strindbergian power of self-revelation, a destructive fury, an enormous death wish, skeptically countering all life. It reveals a great skeptic of our century, as he colorfully garbs a despairing world with brilliant technique.

In such a personality, paradox and contradiction play a major role. One of the most difficult contradictions in Grosz is his temporary love for academic beauty. Yet one clearly senses that Grosz's love for Bouguereau and Grützner and his attempts at imitating their glib facility for narrative are not based on a real predilection.

What we see here is the deliberate reintroduction of a romantic realism based on personal motives, such as we find in some of the surrealists and the *trompe l'oeil*. It is a kind of reaction against transcendence, an escape into *Kitsch*, a replacement of the spiritual with "reality," which we collide with, which we smell, taste, and feel.

Yet we cannot overlook the romantic elements derived from German romanticism (Caspar David Friedrich) and expressing a kind of melancholy

over personal destiny, a vague nostalgia and yearning. We also see a child-like, almost perverse desire for a Victorian age, in which the pretense at a solidity of order was obvious and transparent. People clung to it, loved it, but were able to fight it with impunity and creatively criticize it.

("A Painter of the Modern Inferno," 1954)

This strange psychological fact, that Grosz had to move from the small to the great, from the ugly to the beautiful, frequently deprived him of direct experience and the accompanying creative energy. This was the deeper reason for his inability to become a great and successful painter, as his talent had promised. He had to take a circuitous route before reaching his destination. It was the journey he had to take and which made it impossible for him to reproduce the freshness of direct experience. And thus it happened that George Grosz, for all his enormous talent in drawing, found color in very few of his oil paintings.

This was the deep and tragic conflict of this unusual and in certain ways peerless man. George Grosz, stranded for twenty-five years in a land in which he could not find himself either humanly or artistically, was a tragic figure. He was part of the great mass of people who, despite sincere and honest striving, are unable to solve their conflicts—with one essential difference: unlike the others, Grosz was a genius. It was precisely the tragedy and helplessness of his personality, shining from his eyes, that made Grosz a charming man and conversationalist. He loved his family, and I have rarely met anyone more loved by his friends than this master of mordant criticism. We all loved him, although none of us could help him, and so today we stand at his grave, abashed and with a sense of incompleteness, a feeling that regards not only the dead man but also and perhaps even more the survivors and the living.

Grosz was an admirer of Picasso's, but the last time I saw him, shortly before his final return to Europe and Germany, he admitted that nothing in his life had bewildered him as much as modern art. Nothing was more remote from him than abstraction. He never wanted to remove himself from things, he wanted to go straight to them. It had always been his way to deal with the object as intimately as possible, he had to converse with things, he had to know every detail. His natural urge was to register the most minute details graphically. Technically speaking, a good part of the quality in Grosz's drawings derives from his observation of the most minuscule things. Here, in the minuscule, his art felt at home, and it was here that his caricatural sense emerged and had an effect. Grosz tracked down

the human being in those details that people like to conceal and dislike talking about, he saw the chock-full bellies, the wrinkles in a face, the dangling pince-nez, the crumpled hats and trousers. No matter how much Grosz's art has been designated as social criticism, it was, after all, essentially a critique of man. Grosz saw the ugliness, not because he liked ugliness, but because it was a part of beauty that no one could see or understand—as yet. This was the only way that he could approach beauty: from the ugly side with timid proposals of love. Only Grosz's friends knew how deeply and essentially he loved beauty, how profoundly he admired the old masters.

("Remembering George Grosz," 1959)

August Stramm

I have a very clear recollection of Herwarth Walden's art salon on the Potsdamer Strasse in Berlin. It was in the days before World War I, when we used to take horse-drawn trolleys to the Hotel Kempinski, and Giampetro's high collars ruled the male fashion world. Life was relatively simple, compared with the present time: there were no atomic bombs and no anxiety neuroses. Nevertheless, there were portents of an essential change in the world and of a new life feeling.

In literature, the revolution had slowly but surely been prepared by Dostoevski, Ibsen, Strindberg, Halbe, and Gerhart Hauptmann. The Blaue Reiter exhibited at the same time that Rilke, Proust, and James Joyce were writing. Herwarth Walden, with his huge mane of hair, dashing about between paintings of Kandinsky, Chagall, Marc, and Kirchner, was as relentless a theoretician of modernism as Franz Pfemfert, whose magazine, *Die Aktion,* was a rallying point for all revolutionaries in art and literature. Walden enthusiastically welcomed expressionism, which was hazily mixed with social programs.

August Stramm's poems are a typical utterance of that era—the start of expressionism—because of their emotive intensity, a form of irrational romanticism that at times seems almost religious, a deliberate formlessness, and something known as the "Oh, Man" attitude, a kind of aesthetic ethics meant to blend art with sincerity in order to make the world more brotherly.

In this new form of poetry, which anticipates a number of elements in later versecraft, there is a surprising and effective directness. The poet vir-

tually gets out of his armchair and comes to the footlights of his stage. He wants to look his audience straight in the eye, he wants to talk to the spectators by means of his art, as if art and poetry and the written word, no less than a painted picture, were emblems of something deeper and more essential. Just as the painter enters a new subject-object relationship with his subject matter, so the poet creates a new I-and-thou situation, as if he meant to say: "I was gone for a long time, but now I'm back."

It is this directness, this absolute honesty, that moves August Stramm in his poems, the explosive temperament freeing itself after lengthy suppression, the use of signs and symbols—all these things are elements that subsequently, in the time of dada, led to the sound-poems of Ball, Hausmann, and Schwitters, and to my own (in *Phantastische Gebete*).

Stramm's true lyrical tone will often elude the reader who confuses lyrics with lyricism (and bases his ideas on a sentimental observation of nature). The reader has to accustom himself to the violent and the demonstrative that are hallmarks of all modern art and poetry. Stramm was certainly far less inclined than Benn, Brecht, or the later dadaists, to sermonize the audience, and in place of direct aggressiveness, he offers imploring lamentations. Benn's pungency, so often expressed in whiplash verses, Brecht's cynicism, and the bomb-throwing fury of the dadaists appear, in relation to Stramm's poems, as the terminal point of a development that with him was limited to emotional persuasiveness.

Arp took over the principles of the expressionist tone but rejected the excess emotionality characteristic of the painters known as the Brücke and exemplified in Stramm's poetry. The so-called new plasticity in painting matched poetry's search for a new objectivity, which indicates a clear limitation in Stramm's poems in comparison with those of Benn, Brecht, and the dadaists.

Stramm's world, in all its honesty, seems small, and its limitation is manifest in the naïveté of a stance often reminiscent of Spitzweg. Stramm, a post-office official, was unsophisticated and knew little of the world or the evil of mankind. August Stramm seems like the antipode of the poets who have most strongly influenced modern verse, for example, Rimbaud, whom we so greatly and eagerly venerate.

August Stramm's poems are not so much those of an adventurer (physical or mental) as those of an implorer. He apostrophizes humanity to lend him an ear, yet he doesn't know whether humanity is at all able (or inclined) to listen to him. Thus Stramm speaks to an abstract mankind.

And thus his poetry, for all its effective beauty, lacks something that

greatly impressed the modern age after expressionism and has been held in high esteem. The postexpressionist poets agreed on one thing: they wanted to speak only to an audience that they were sure was *listening*. Something came into poetry that the expressionists were indifferent to or ignorant of: the problem of communication.

This relation between the poet and the audience, whether on a stage or in books, led to what is known as the antiart stance. It was an aggressive and perhaps destructive attitude. Naturally, the postexpressionist poets did not really want to abandon art and poetry, but one could detect a certain distrust in their tone. Something demonstrative and perhaps dogmatic came into it. And it was also apparent in the irony of, say, Schwitters or Arp, and even Klee or Picasso, and in such works as my *Phantastische Gebete*, Schwitters's *Anna Blume*, Arp's *Pyramidenrock* [Pyramid Jacket], and his famous *Wolkenpumpe*.

This stance is apparent in the tone; it is an existential tone, to be found in Benn and Brecht as well as in the dadaists. But a poet like Stramm was different. Stramm's approach to mankind, whom he apostrophizes, is more trusting and perhaps even naïve. Poetry per se has not yet become a problem, whereas form *has* become one. Stramm is thus a poet seeking a new form but unchanged in his basic human attitude. He is, if one may say so, both a poet and a lyricist.

The problem can also be regarded as a conflict between poetic universalism and a more objective art form more concerned with individual things. When medieval poets approached God with their inwardness, they had in mind a living person with whom they communicated in their poems. The modern poet is faced with a much more difficult situation, so that, when speaking of God, he yields to an endless universalism, and when concerned with individual things or people, he sinks into a cynicism of details. Universalism is obvious in such poems of August Stramm's as the following:

> Dein Schreien bebt
> im Schauen stirbt der Blick
> der Wind spielt blasse Bänder
> du
> wendest fort . . .
> den Raum umwirbt die Zeit.

> [Your screaming quakes
> the gaze dies in looking
> the wind plays pale ribbons

you
turn away . . .
space woos time.]

The flood of symbolic sentiment leaves the poet and goes far into the universe, whereas in Rimbaud, T. S. Eliot, Ezra Pound, and the poets I grew up with, the conflict between earthly need and universal surrender can never be fully resolved. The individual urge becomes as important as, and sometimes more important than, death.

("August Stramm's Monologue," 1957)

Joaquín Torres-García

The concept of genius has greatly changed. The genius enjoys greater recognition than ever before and his mental scope is seen more clearly; yet he has to put up with being treated as one of the many marching along in the army of culture creators. Supposedly, there are more geniuses alive now than ever before; the press, the radio, and all modern media have been spreading their fame. Picasso the painter, Heisenberg the physicist, Heidegger the philosopher, and all the others stand, grotesquely enough, next to film stars and great entertainers. Picasso earns millions, but so does Elvis Presley; and in all certainty, if the teen-agers of America could be induced to do anything at all, they would kneel respectfully before a famous jazz musician as well as a Nobel Prize laureate. The genius, albeit still a genius, has been deprived of the celestial clouds that drifted about his head in the postclassical era.

We are speaking of the small group of geniuses who have made it, and we are neglecting the others who have remained relatively unknown. Many fail to gain recognition, and it is hard to puzzle out why some managed to make it while others remained obscure. The secret, I believe, lies in the personality. To achieve fame as a genius today, one has to be more than a genius; one also has to be one's own PR man; a bit of Madison Avenue is indispensable if an artist wants to reap and enjoy the benefits of his work during his own lifetime.

Such are my thoughts whenever I think about the fate of a brilliant

painter whose glory and recognition are still in abeyance even though he died in 1949. Torres-García, the great South American painter, was born in Uruguay more than eighty years ago.* Although certainly a genius among painters of our time, Torres-García was unknown for a long time—so unknown that in Paris he became frightened of his own anonymity. Thus, Jean Cassou, a Paris museum director and art historian, writes in an introduction for a recent New York showing of Torres-García's works: "Torres-García, who lived in Paris for a long time, was surrounded by the fauves, the cubists, the orphists, he existed in an orchestra of colors and forms, there was no lack of great personalities such as Picasso, Braque, Delaunay. But the lonesome man from Montevideo preferred finding himself. He pursued his own theories, penetrated his own inner being, sought and found his own laws."

Torres-García was a great South American painter, perhaps the only really true genius of painting that South America has ever produced. It is important to know that he came from a continent in which primitiveness is still alive and yet in which, on the surface, the movement of civilization from Europe and the United States is reaching a faster and faster and thus more and more oppressive tempo. It is also important to know that Montevideo has never had any sort of puritanism, any kind of pragmatic mentality restricting or critically rejecting creative activity. People have always been free there to a certain degree, the development of the individual was usually unhampered.

There were two essential spiritual elements that influenced Torres-García in his creative activity. Out of a basic feeling of simplicity, a nearness to conditions independent of the complexities of civilization, he developed a new form of aesthetic humanism. Torres-García feared increasing chaos both in human society and in painting. He regarded this chaos as a confusion of the Tower of Babel and saw his own mission as creating new forms of communication on an aesthetic level.

Torres-García began his aesthetic labor under the influence of Gaudí, whose fantastic architectural works deeply impressed him as monuments by a freewheeling spirit. The shock was generated by a special form of romantic metaphysical thought, the attempt to give a deeper meaning to the relationship between man and eternity. Gaudí was an architect, but the stones were simply his pretexts for dreams; he was a great experimenter, and it was the spiritual experiment that attracted Torres-García. The result

* This essay was written in 1962; Torres-García was born in 1874.—ED.

was a new abstract painting; and in this world of creative phantasm, he began to love an artist who went from one new creativity to another on both the flat canvas and the wood block: Paul Klee. Torres-García was fascinated by him, and until 1930, the South American's works are distinctly similar to Klee's.

But then came the powerful stirring of South American blood, the relationship to the primitive Indian earth, and Torres-García began using the ancient Aztec and Maya symbols as direct means of communication in his paintings. These paintings are like painted letters, tablets such as may have been carried by Aztec couriers from one city to another at the command of the caciques, the omnipotent chiefs who were ruled only by heaven, the pyramids, and man-devouring gods. Torres-García's paintings, like the ancient tablets of communication, contain symbols, fishes, moons and suns, limbs, and primitive instruments, as well as forms that we no longer understand and that arise from the depths of the collective unconscious—arranged in tiny boxes. These boxes are comparable to paragraphs in a letter; they are to be read and seen in succession. And thus these paintings involve a time sequence; they draw us into the chronology of a specific experience.

Torres-García's paintings, which were shown at the Rose Fried Gallery a while back and are now on brilliant display in the Royal Marks Gallery, are done in dull colors, very few of them glow, they are not meant to convince by means of contrasts, or basic complementary colors, they do not form a world distilled from mathematics, they are painted voices, pressed into archaic forms. They are a communication from the painted canvas to the beholder, addressing something in him, something of immense importance for man's situation in our time.

("A Genius Succeeds," 1962)

Jean Tinguely

Recently, here in New York, Jean Tinguely, from Basel, appeared on the scene with a machine that he said would destroy itself. Jean had managed to do something that rarely succeeds: after a show in a modern gallery, he had talked the director of The Museum of Modern Art into letting him perform. Together with a young, highly gifted physicist named Billy Klüver, he had built a machine consisting of eighty big and little wheels, plus tubes, valves, old drums, and a piano, which, when things were going wrong, kept on playing, with a final sobbing, so to speak, as if it were really sorry that it could not destroy itself totally. A few spectators (the performance took place before a select audience) compared the machine to a classic Greek sculpture, cold and beautiful; others called it a put-on, although even the opponents couldn't deny that, initially at least, the monster had been emitting smoke, music, noise, and (taped) threats. Unfortunately, as indicated, it all ended prematurely when the minimax apparatus failed to douse the burning and whimpering piano, and the firemen, who had been watching with wooden expressions, joyfully interfered. The contacts and motors were blanketed with foam, and that was that. The better part of the machine cooperated almost without a hitch, the large brown weather balloon, which was supposed to float off, rocked cautiously on its mast, and a miniature baby carriage, seemingly forgotten, mechanically roiled back and forth. Nevertheless, the goal was reached, albeit perhaps too quickly; the machine

destroyed itself or was destroyed by unfortunate accidents, perhaps sooner than planned, and yet so thoroughly that the spectators—overwhelmed by a sense of the short-livedness of even such lasting lifetime parts as, say, metal tubes—melancholy, but also cheerful, swept up by Jean Tinguely's ingenious folly, made for their cars and drove home.

I think that the mood and the excitement of the originators, as far as I could judge, were equal to the excitement of those who had witnessed the spectacle. People were and still are convinced that Tinguely's demonstration, characteristically titled *Homage to New York*, was really an unusual event of great concern to us all. Jean Tinguely is an artist, a sculptor, whose creativity collided with the machine; he is dealing, as he constantly reassures us, with motion. He is almost fanatically convinced that nothing stands still—not just the wheels, the piano keys, the baby carriage rolling back and forth, the weather balloons and the moving tapes with changing letters, but mainly and primarily man himself. Man is motion in a Heraclitean nature, only change has permanence; and (this is the true warning and perhaps threat) if man does not know how to adjust to change, he is lost.

Jean Tinguely's philosophy is the philosophy of shock, he wants to make men realize that all their efforts toward finding the absolute have failed and will continue to fail. He calls himself a metadadaist, he laughs at stabilized values, including—or perhaps chiefly—cultural ones, so far as the ideological philosophies of our Western civilization have produced them. In this respect, he is a true descendant of the troop of the Cabaret Voltaire, *panta rei*, everything moves, turns, destroys itself. Jean lives not only in the twentieth century but in the next one as well; he is really an artistic rocketman, a rocket sculptor, an artist with an almost uncanny vision of the future. And the neodadaists feel that this future will have an art born out of momentary needs. The paintbrush and the canvas have done their duty; we need stronger incentives, and in terms of movement, the aim is always to startle and to arouse alertness against the ever-present human tendency to bestow a false permanence on the objects, words, and products of his own hand and brain. Art, therefore, has one single function: it is a kind of watchdog that is supposed to bark at the approach of the absolute.

("The Problem of Motion," 1961)

Tinguely, who claims he knows nothing about machines, is nevertheless a brilliant engineer or at least a maniacal watchmaker whose projects seem to run away from him like the broom of the sorcerer's apprentice. Tinguely's

imagination encompasses the entire problem of modern technology and presents it to us in the fragments of his pseudo machines. He demonstrates, instructs, evokes, and comforts—an itinerant preacher unique in his class. Anyone attempting to understand his work in accordance with conventional notions of past aesthetic doctrines would soon realize the uselessness of Tinguely's efforts. One can speak of neither beauty nor ugliness; there is no conscious or unconscious compromise with the audience; there is no attempt at entertainment. One might even say that the goal is to terrorize us. Obviously, a shock effect is aimed at. We are meant to be aroused from sleep, by serious methods and also by jokes.

There are two important elements in this demonstration: the element of motion and the element of construction. The element of motion was introduced into modern art by the futurists. It was they who first did paintings of a landscape as seen from a moving train or an aircraft. They were also the first to understand the destructive component of the fact that everything is in a state of flux, and thus they advocated the destruction of museums and monuments and everything decaying or even slightly musty. They were Nietzscheans in their aesthetic practice, they loved battling, warfare, and some of them (including Boccioni) even died in active combat. Their goal was not just inner motion but moving reality, too; and thus in their paintings during the first decade of our century, the futurists actually invented cinematographic motion. Marcel Duchamp's *Nude Descending a Staircase* was important as the first in a long series of kinetic attempts by that artist. Duchamp made Tinguely machines long before Tinguely; he was one of the first to introduce noises into sculpture, and as a protodadaist he (like Tinguely) revealed the deeper sense and nonsense of mechanics.

The second element, apparently an extremely important one for the explanation of kinetic art of this kind, is the element of construction in the sense of Mondrian's concrete art. Although Tinguely's works always have a perceptible subjective vestige, his annoyance or his enthusiasm, this vestige is regarded as peripheral. The machine—its usefulness and its productiveness—is presented not as a human work but as a happening, an irrational invasion of an indefinable something that we have to put up with. In other words, kinetic art treats the element of motion as a fourth dimension, as something happening in time, a process, a series of experiences on one's road through life. The subjective is bracketed in these constructions and viewed as an ultimate reality, a result one comes to when coping with the experience itself.

The relationship between the aim of kinetic art and the aim of experi-

mental science is obvious and close. Both want to research certain facts of reality (e.g., motion) while limiting the subjective. Tinguely's machine art is an experimental constructive art, which, however, in contrast to Tatlin's, never ignores the human factor. Tinguely shows that the machine—which in reality, and not just theoretically, works for the masses—actually has a relationship to individuality. Not only are the masses supplied with what they need, transported, and pushed along by historical progress; the individual, too, is changed by the machine. The mass influence of the machine was eagerly studied by Daniel Spoerri, a friend of Tinguely's. Spoerri showed what can and will happen when works of art are reproduced in great numbers. Tinguely himself, for all his recklessness, turns out to be a rather worried man who feels mankind is worth more than the jingling of a cowbell.

("Tinguely's Useless Machines," 1961)

The evening of the performance (March 17 of this year), a young—no longer very young—man named Goeritz came up to the brightly lit doors of the museum. He is a sculptor from Mexico, but of German background, a refugee from Hitler; he first fled to Morocco, and then to Mexico, when the Nazi bloodhounds were trailing him and his talents down. I met him only later. He was opposed to motion as the basic principle of life and propagated permanence and lastingness; his pamphlet (which he distributed in front of the museum since he wasn't allowed to hand it out inside) referred to one of my early dada manifestoes "The New Man."* We discussed the matter, and I felt almost like the founder of a religion, who receives the leaders of various sects; all of them want to be dadaists, but as it turns out there are religious dadaists, I had no idea, and dadaists, meta-dadaists like Tinguely, worshipers of different gods, stillness and motion. Permanence, said Goeritz, is the irrational, whereas shortly before Tinguely had assured me that only motion can be identified with the irrational.

When everything was over, I went home, hunted through my old dada writings, and finally found "The New Man," which had been published in 1917 in *Die Neue Jugend* by Wieland Herzfelde, who had drawn his own conclusions from dada: he had become a political agent. I picked up the yellowing paper and thought about the transience of all earthly things, including human ideas, I thought about the Cabaret Voltaire, the birthplace of so many creative inventions, I thought of Zurich, the world as it had been

* For partial translation, see Introduction, pp. xxx–xxxii.—Ed.

then and as it no longer was. I wondered what all these young men had understood about dada. A lot and yet little, I thought; the good thing is that you cannot and probably should not understand dada. It will always remain a living part of the essentially inexplicable.

("The Problem of Motion," 1961)

Postscript to Dada

Here I sit in New York at my typewriter and look at Central Park, which appears so mild and green and fresh, as if not a drop of water would ever stir. And yet at night, women are raped there, and anyone out for a breath of air will be mugged by gangsters. That's what dada is—a movement with inner danger. When you approach it, it's like a purring cat. You'd like to caress it and draw sparks from its fur. But if you try, then the sparks turn into nuclear catastrophes. *In 1916, dada was what is occurring now in the heart of the man in the street.* Then only a very few of us felt it; now everybody feels it on his back: *the fear of the irrational.*

Way back then, we flew to the moon and shot at Mars, even though, unlike President Eisenhower, we didn't have time to play golf. As a matter of fact, we knew nothing about golf in those days. We wanted to shake up the world. We shook and shook, and the whole thing turned into an energetic tug of war. If anyone has anything on the ball, then it's dada and its enemies.

Thus, we veteran dadaists are starting to age, our hair has turned hoary, and our legs aren't as straight and fine as they used to be. Outwardly we look quite good, we wear good suits, glasses, and galoshes (when it rains). We don't scream any more when we see a beautiful girl (although we do still scream). And yet and yet, it's a nice feeling to have annoyed the world. Speaking from experience, I might say that it's the only feeling for which one can stake one's life nowadays.

("Postscript to Dada," 1958)

The Case of Dada

The case of dada is very complicated, and as the years pass, it seems more and more difficult to write about dada. Although dada always claimed that it didn't mean anything, many dadaists have tried to interpret dada (and who can blame them?). My present goal is naturally or unnaturally an interpretation, and thus my attempt will have a subjective character. I will therefore begin with an observation or, if you like, a fact that I and, I'm sure, many other people have noticed.

Dada, in contrast to constructivism, surrealism, and cubism, was the only art movement to continue spreading; it has never grown old and even today, after fifty years, it shows no symptoms of old age or senility. My question, which I have often asked myself, is: Why did dada succeed in surviving when the others failed? One could say that the other movements concentrated more on a *theory* of art or of life rather than on life itself. The futurists, as I remember, had little insight into life. They were fascinated by the new, the modern, the technological side of life, they worshiped the automobile, everything that revolves and moves, the wheel structure of present-day existence, the self-revolution of human life. Yet they had no conception of Man's situation among all these changes. They thought they might reform Italian art by introducing certain pictorial repetitions. "Motion" was the religion of the futurists, Boccioni, Carrà, and others. Thus they very nearly invented cinematography, but the essential part of life, insofar as it concerns a change of being, remained a closed

book for them. It was their prerogative to hate the staticness of ancient and medieval statues accumulated in Italian museums, but the difference between static and motion, as conceived of by the futurists, resulted from a special form of naïve thinking. (Marinetti was an aggressive man, and when the war with Ethiopia broke out, he showed the world that he was also a naïve politician.)

Cubism was the first abstract art movement. Braque and Picasso felt that modern man, not to mention the modern artist, in order to find a way out for his creativity, has to deal with a new reality either above, below, or behind objects. Dada, in the works of, say, Janco, Arp, or Richter, was also interested in abstract reality; but its stance, in contrast to that of cubism, was more subjective, more aggressive, and in every respect more personal than that of the cubists. The cubists knew that objectivity is a dangerous aspect of modern life and runs directly counter to the artist's creativity. Thus they became the first relativists; they viewed an object not just from one side, and while superimposing, accumulating, and thereby re-experiencing the various sides, they also experienced the new reality. They were subjectivists, they sensed the fact that in our age of technology, the human personality has been led to the verge of destruction; but they expressed themselves in art alone, they saw only their canvases and brushes, they never left their studios, they abided by Picasso's rule that a painter should be nothing but a painter. They were not *morally* concerned about the disintegration of the world; they knew the laws of painting but were indifferent to whatever laws obtain in our world. Politics didn't interest them, sociology was a closed book for them. The dadaists were different. Dada was not only the contrast between art and antiart, although this cogently expresses the paradoxical situation and the essential conflict of the dada artist. Dada, mainly at the outset at the Cabaret Voltaire and then later in Berlin, was a violently *moral* reaction. When Emmy Hennings sang "They kill one another with steam and with knives" in Switzerland, which was encircled by fighting armies, she was voicing our collective hatred of the inhumanity of war. This beginning of dada was really a humanitarian reaction against mass murder in Europe, the political abuse of technology, and especially against the kaiser, on whom we, particularly the Germans, blamed the war. I would like to say that dada developed into an artistic reaction after starting as a moral revolution and remaining one—even when the artistic question seemed to dominate.

The only art movement to share dada's moral reaction is surrealism, yet the latter never managed to join morality with dada's spontaneity. Unlike

Breton, we were never committed to Communism or any other ism; we never made our moral reaction into a *Weltanschauung* or an institution, as the surrealists did; our reaction was personal. We never threw anyone out of the "club," as Breton threw Dali and other disciples out because of a person's unsuitable marriage or unsuitable *Weltanschauung*; we let each individual believe, think, and act as he liked. We all know that Ball, initially connecting his moral reaction with free thinking—as the name Voltaire indicates—subsequently wrote *Byzantinisches Christentum* and *Zur Kritik der deutschen Intelligenz* and returned to a mystical Catholicism. Nothing would have been more alien to us in Berlin, to Hausmann, Grosz, and myself, I say nothing would have been more alien to us than Catholicism in an age when we were protesting against reactionary social democracy and I wrote *Deutschland muss untergehen!* [Germany Must Fall!]. In purely philosophical terms, I would say that we were not Platonists; we embraced an idea but we also saw the danger of ideology, the possible deadlock, the institutionalization, the inevitable intolerance in the realization of any idea. Surrealism, although very perceptive in detail, was on the whole an organization with definite, I might almost say bureaucratically committed ideas. (I need only mention Breton's Freudianism.) In dada, anything was possible, everything was loose and left to chance. Dada, in both its moral reactions and its artistic insights, was able to combine definiteness with indefinite possibility; it insisted on nothing, it never stuck blindly to any rule, it never clung to anything. It is this element of experienced and constantly re-experienced conflict, such as we grasped and took from cultural and sociological conflicts, that made it possible for dada to survive all the others.

The paradox expressed in art and antiart is a dada experience ultimately going back to the experience of the specific present-day human situation.

We are humanists with a critical attitude of humanity, we are advocates of technology and its consequences, yet filled with hatred of what technology is doing to us. We are and were protestants of individuality, steeped in disdain for the sentimental side of individualism, the search for the soul, the expressionist yearning. We lived and still live on the stage of the world in a state of absurdity, in a constantly reconceived conflict characteristic not only of our existence but of that of all people in our time. Dada is the philosophy of our age, and this is why all artistic people have to cope with dada if they want to create something essential and characteristic.

("The Case of Dada," 1966)

Dada

Any attempt on my part to take dada seriously was always howlingly rejected by the dadaists. Nothing was so difficult as convincing the dadaists themselves that dada was anything more than a gag. Years ago, Tzara wrote: "Being a dadaist means being against dada." In the catalogue of the dada show at New York's Janis Gallery in 1954, I wrote: "Take Dada seriously."

After forty years, dada's significance turns out to be philosophical and emotional. The aesthetic plays only a partial role, mainly at the outset, and becomes fully visible only in surrealism. The founders of dada were literati and philosophers: Ball, Huelsenbeck, Arp, Hausmann. I include the latter two, because both of them, despite their relationship to the aesthetic, were strongly involved in psychological knowledge and exploration. Arp's art can be explained as an expression of his theory of chance. The theory of the "new material," which reached its high point with Schwitters, can be traced back to the doctrine of transcendence. Hausmann's dada montages are products of a phenomenological *Weltanschauung* characteristic of dada. Arp's love for the pre-Socratic philosophers expresses his opposition to rationalism, his closeness to nature and the psychological instruments that can grasp nature: all forms of imagination and fantasy.

The dada attitude is basically the paradox of forgetting the human in order to reveal it all the more penetratingly. The relativity of everything human is shown, and art has to adjust to it. Inhumanity is viewed as a part

of the human. This is why the Marquis de Sade played such a major role in surrealism. Both the surrealists and the dadaists developed the ideas that had become unavoidable in the West since Dostoevski. The division of human life into good and evil was rejected as a dangerous psychosis characteristic of the commercialized middle class in the nineteenth century. The "new man," whom I talk about in one of my dada manifestoes,* is a man of transcendence, by whom good and evil are no longer viewed from different standpoints. The moral and the immoral are the relativized components of a total personality.

The paradox in the stance of the dadaists, symbolically represented in the variety of material, is part of their aggressiveness, which aspires not to nihilism (Tzara) but to a new integration. The new man was joined by the new art work, made of new material, expressed in a new consciousness of human totality. Thus, the rebellion of the dadaists becomes a revolution against a doctrine that places the part above the unified whole. The antiwar stand of the Zurich and Berlin dadaists was joined to an antiart attitude. Man is at the center of all activity, and as long as man is threatened, art is destructive. The dadaist destruction of art is not just a clownish imitation of terrible events, but also an analytical anticipation of the process one has to go through to reach the premise of all future artistic activity: the total, human personality.

The basic paradoxical position of the dadaists, eluding all logical definition, can nevertheless be explained psychologically. Carl Jung's theory of complementary psychological antitheses describes the dada stance as well as the stance of modern man. One is opposed because one advocates, one hates because one loves, one turns pious because one has no faith. Existentialist nonbeing is the starting point of a vast plethora. In art, rejected because of our bondage to it, the object becomes the very problem of reality, and so objective elements (surrealism) mingle with abstraction (Arp). The trenchant irony of, say, George Grosz becomes a surrealist sense of loneliness, accompanied by symbols of the ephemeralness of life. For De Chirico, the railroad and the windjammer are symbols of hours ticking away. Man and the artist are so deeply affected by their own lostness that they make a last-ditch effort by embracing everyday banality and end where they have begun. The bourgeois, a target of hate because he represents a commercialized and mechanized age, returns, although in a different form. Social realism, a means of deadly criticism in Berlin dada,

* For partial translation, see Introduction, pp. xxx–xxxii.—ED.

is raised to an academic level. Fanaticism develops into an obtuse faith in the rightness of all existence.

The prophetic utterance of the Berlin dadaists, "Amateurs, levez-vous!" ["Amateurs, arise!"], is more than an imitation of a radical *profession de foi*. It makes the entire problem of art into a part of the mass psychology of our day. It contains hostility toward psychologism, which was first fought against by Husserl, and led to the anti-intellectualism of our time. Rimbaud, who fled literature in order to trade his intellect for action, is not gratuitously a god for the dadaists. In *En avant dada*, I define dada as life itself. Simultaneity, bruitism, outwardness of any kind are depicted symbolically. Lectures, readings, parades are as important as museum shows (which are cloisters) into which one retires for hours of meditation. Life itself becomes a testing station for the individual. One adores danger, the unusual, the unknown, the surprising, the versatility and variety of life, which both attract and destroy.

The self-destructive stance of the dadaists is nevertheless accompanied by a deep longing for form and structure. The confusion of change generates symbols of permanence. Behind virile presumptuousness and aggression, maternal signs ascend as silent as stars. Arp's sculpture abandons rectangular form and ends at the roundness of the primeval egg, the world uterus, the universal ovary. Immaturity, lauded as an expression of genius, is now recognized for what it is, a kind of puerility that cannot do without motherly sternness.

It is the Faustian character of dada that made it an essential part of Western civilization. It is one of the movements within the Western mind in which the unclarity of aims was accompanied by a deep knowledge of personal insecurity. Thus, in contrast to Tzara, I would like to say: Being a dadaist means saying yes to everything that dada was committed to: insecurity, lostness, the paradox of the human attitude in an age seeking new forms, not only artistically but also and mainly morally. *Dada is the desire for a new morality.*

("Dada," 1956)

Dada and Existentialism

In the many years since its foundation at the Cabaret Voltaire in Zurich in 1916, dadaism's fortunes have been varied. The reaction of the Swiss was not exactly friendly, as might have been foreseen, but in retrospect it seems that they were actually our most benevolent critics, for all they did was to take us for a bunch of rather crazy cabaret employees. Later developments were far worse, from political threats in Berlin to supercilious rejection in America.

In the United States, dadaism was thought to be some kind of psychosis with artistic intentions, until it suddenly acquired—as it possesses until this day—an international reputation. When people realized that there was more to it than just fun and games they grew wary, for there is nothing worse than that form of ignorance which can be interpreted as backwardness. So it came to pass that dadaism is enjoying a somewhat paradoxical esteem in the U.S.A. Its deeper meaning is now accepted as a psychological rebellion, a nonconformism, something that is generally demanded here, but rarely observed. Be that as it may, the Americans have become conscious of the most serious danger to civilization, the tendency toward a general leveling, and there is great admiration for the audacity of a handful of writers and painters who as much as forty years ago dared to shout down most vehemently all, literally all, cultural values.

It seems to me worth while to understand the meaning of dadaism from what has remained, which is, I think, its philosophical content. When Sartre, in one of his essays on his existentialist philosophy, loudly proclaimed: "I

am the new dada," people pricked up their ears. Why did he not hesitate to profess to be the descendant of a small group of painters and writers who were smiled at by all intellectuals? Where is the spiritual connection between Sartre, existentialism, and dadaism? This is what we want to investigate in the present essay, for in it is contained the historical acceptance —or rejection—of dadaism. In other words: Either dadaism fits into some trend of modern thought, or it will soon be forgotten.

I am quite conscious of the fact that I am treating dadaism as a living idea, as if it still existed. I have often given expression to this, for example in an essay I wrote for the periodical *Transition*, shortly after emigrating to the United States. "Dada Lives" was the title of that essay, and I believed then, as I do now, that there exists a kind of a dadaist man, a dadaist fundamental way of life, which is not only characteristic of our time, but is congruent with many assertions of modern thought.

Outside observers of our movement, like everybody else, first of all looked for results and cared little about dadaist philosophy and less about the men who stood for it. This meant that they cast about for works of art. What was dadaist art? What had the dadaists, who had once caused such a hullabaloo, achieved in their own spheres?

It was obvious that the yield of their quest was not commensurate with expectations and that the critics returned from it burning, as it were, with a holy wrath. They were convinced that the dadaists had been nothing but arrogant amateurs, who had stolen the voice of genius and the thunder of the prophets. "Épater le bourgeois!" had been their intention, so the critics said, a wicked, an overweening, perhaps even a criminal intention.

A nation like the Germans, which can associate in the oddest fashion materials of low provenance with lofty idealism, must, it would appear, reject out of hand an existentialist movement like dadaism. Indeed, Alfred Kerr, a noted German critic, wrote in 1919, after we had given a performance at the Berlin Tribüne: "When Huelsenbeck absconds with the cash, that is dadaism. . . ." In those days the secret police, with their methods of torture, were still in a primitive stage of development, but they had heard of dadaism and took it to be a movement that was implacably opposed to the German soul (which, so it was claimed, was to bring salvation to the world at large). The opposition was certainly a fact and thus, oddly enough, the judgment of policemen was nearer the mark than that of the learned men of the arts. Here were our adversaries and we knew what we had to think of them, while the journalists in their papers and art periodicals were writhing and screaming as though we had given them poison.

Sartre once said that the French were freest when occupied by the Germans, a remark that seems to be as harmful to the state as it is paradoxical. Later I grasped its meaning—when I better understood Berlin dadaism. In Berlin, at the time of the revolution, into whose caldron of hate and revolt we threw dadaism like a block of marble, one could voice one's opinion. The people had lost much—the war, their fathers and sons, their money, their obesity—but they also had gained something: the chance for a free decision. They had once more become their own masters in the sense that they knew the enemy to be not at some faraway frontier but in their own homes, so to speak. Friend and foe stood eye to eye. The question called for a simple yes or no. The fact that the dadaists said no was less important than the manner in which they said it.

What people so much took offense at was that we no longer believed in art. Ever since the Germans had found out that even Dr. Martin Luther's "Safe Stronghold" had become little more than a birthday anthem in honor of a money-making average society, they laid greater stress on the idealistic significance of art, which they identified with love for beauty. At the time when we dadaists were performing in Berlin, expressionism was as little known as the love for a free order of public life. The general public laughed at the jokes and gaped at the blaze of colors of Liebermann, the old painter, who was sitting like a walrus forsaken by its herd on the banks of the Wannsee. Grützner's beer-swilling monks populated the seats of learning at the academies in Berlin and Dresden, and the classic ideals, so long the pride of German Christmas-gift tables, lived on ineradicably in the dutiful hearts of the November revolutionaries, no matter what Worringer may have written.

And then came the dadaists, endowed with the acuteness of sleepwalking alcoholics, to attack the arts, that last refuge of idealism. Even critics favorably inclined to modernism had to admit sorrowfully that here a capital crime was being committed. The "most sacred possessions," of which the kaiser had spoken in the old days, were being desecrated, drugged, and poisoned. The ideal of beauty was brought up against life, ugly life, earth, being, even not-being. It was worse than what Rimbaud had done when, at a soiree given in his honor, he had punctuated the recitation of every verse of his "Parnassiens" with the loud call of "merde alors."

At the first dada evening, at the Neumann Gallery, Berlin, when the proprietor was about to call the police, I said that the war was not bloody enough by far. Horror! An invalid with a wooden leg got up and the audience rose to their feet and accompanied his exit with applause.

At that time a case of lynching almost happened in Germany. The audience not merely rose to their feet but moved toward the rostrum in order to hurl themselves at me. But as is usual in such situations (I went through many like it in my dada time), public fury was checked by a kind of awe. What manner of people were these dadaists daring to risk with verse and word the many-headed attack of a multitude?

It was that absolute audacity which brought dadaism so close to existentialism in those days, the fantastic heroism of a group fighting it out with symbols; propagating war, but not war as commonly understood. Rather it was a better fight, the revolt against conventionalism, against a sated middle class crammed full of Victorian half-values, the war against spiritual death, against satiety, against the liberalism of intellectuals, against good people, against rabbit-fanciers in philosophy, against the members of church-women's organizations. In New York a shrewd theologian, Professor Tillich, wrote a book entitled *The Courage to Be*. Simple existence, the restitution of the rights of instincts, the praise of sexuality, the adoration of strength, even (to my shame I must admit it) the adoration of brute force from Rimbaud to Mickey Spillane, brutality as shown in the films of Hitchcock—all that, horribile dictu, was part of our program.

A wild tangle of contradictions and paradoxes which was, however, held together by its very discrepancy. It was that two-sided, perhaps even double-tongued form of existence taken from life itself, which despises ideals. It was dadaism in its existentialist version.

The existentialist attitude, as we know it from Leon Chestov, Berdyaev, and Sartre, this creative tension face to face with life, creative irrationalism which assigns the same place to both good and bad—these were brought into the open in our dispute with Kurt Schwitters.

Kurt Schwitters, of Hanover, living among the remnants of a military society of the lower-middle class, in a town in which Hamann, the sexual murderer, lived and wrought not far from the superfather Hindenburg—this Kurt Schwitters discovered the symbolic meaning of his movement in a syllable of the "KomMERZbank," on a neatly painted signboard not far from his home, where he was leading a normal existence with his wife and child. Since that monumental event, which befell him one day as he was walking about town, he called his art "MERZ-art."

The principle of chance, which played such a large part in the dada movement and which had insinuated itself into our life through the discovery of the word "dada" in a dictionary, had become revealed to Kurt Schwitters in his "MERZ"-adventure. This would have been to our complete satisfac-

tion, but there arose an antagonism between Schwitters and the Berlin movement on account of the difference in our conception of the meaning and value of art. To us art—as far as we admitted its existence—was one expression of human creative power, but only one—and one in which a person could but too easily become entangled. Art, to Schwitters, was as important as the forest is to the forester. The remodeling of life seemed to us to be of prime importance and made us take part in political movements. But Schwitters wanted to have it expressed only by means of artistic symbols. His predilection for the "paste picture," for "foreign" materials (stones, cork stoppers, matches, scraps of cloth, love letters, pages from prayerbooks, income-tax returns) showed that he had recognized the deep hankering after the primitive, the simple form. He wanted to get away from the complicated, overcharged, perspectively seen present.

At the same time, he lived like a lower-middle-class Victorian. He had nothing of the audacity, the love for adventure, the forward push, the keenness, the personal thrust, and the will born of conviction, that, to me, made up most of dadaist philosophy. To me, at that time a very unruly and intolerant fellow, he was a genius in a frock coat. We called him the abstract Spitzweg, the Caspar David Friedrich of the dadaist revolution.

Since then the question of what dadaism is and who may be called a dadaist has occupied me more than ever. If dadaism is nothing but a trend in art, a trailblazer, say, for surrealism, then there is little to be said about it today. Abstract art, brought to life by synthetic cubism, found rich confirmation in the persons of Janco and Arp. Breton extended the field by adding automatism to painting. Chance, structural form, the neoplastic aspect of the new art, simplification, primitivism (used by Schwitters, Hausmann, and myself, in the "sound-poem")—all these, it seems to me, acquire value and gain recognition only when seen in the light of modern thought and together with the problems of philosophy and physics.

Dada, in other words, is but one symptom in the great spiritual revolt of our time. It may be called the existentialist revolt, for all its elements can be understood through human existence, by means of psychology. What dada wanted in its heyday, and what it still stands for today, is the reforming of man in a new world, exactly as I put it in my manifesto "Der Neue Mensch" ("The New Man"), published by the Malik-Verlag, Berlin, in 1917.*

* For partial translation, see Introduction, pp. xxx–xxxii.—Ed.

But what kind of man do the dadaists want to shape? When Sartre says that man wants to be God, it means no more than that he has realized that the creative force within him is identical with the universal creative force. In other words, man is no longer the product of some conventional morality. He can no longer suffer himself to be pushed this way and that by political, economic, or religious catch phrases. He is what he is because he has become aware of his own value.

When we organized a grand dada exhibition at the Janis Gallery in New York, I frequently had the opportunity to talk with Marcel Duchamp. He turned out to be a man of great shrewdness and deep insight into the world of dadaist problems. He had long since abandoned art and, so he claimed, replaced it by chess playing. When I looked him up one day at his little flat on Fourteenth Street he showed me a chess table he had built himself, equipped with every conceivable gadget—built-in clocks, electric bells, hand rests, and foot rests. This table resembled nothing so much as an electrical computer, a machine that might, perhaps, solve the most intricate chess problems without human aid.

Duchamp, called the dadaist prototype by the American press, is a true existentialist. His personal conflicts are the conflicts of our time at large in which, as Duchamp hinted, art is overrun by mechanics and made impossible. When Duchamp showed his ready-mades about 1910, at a time, that is, when the world was still fast asleep in its prewar slumber, he was animated by one thought which, to me, is of the greatest significance for the existentialist conception of dadaism. What he wanted to show symbolically is now most readily recognizable in the United States, and in this country more than elsewhere contributes to the sense of suffocation, of the insignificance of the individual, of frustration and neurosis. It is the idea of the finished and complete, of the perfect product, of machinelike capability. What is shown here symbolically and condemned is the inferior situation forced upon man by a society that has still to learn what freedom really means.

The contempt for art, which Rimbaud had, and which Duchamp also demonstrated, our dadaist reinterpretation of art, indicates the true character and existentialist scheme of the Berlin dada movement. This character is so hard to define, and so essentially spiritual, that even here I have difficulty in speaking about it. It is THE GREAT SECRET in itself. Not the end product, be it a motorcar or a collage by Picasso or Kurt Schwitters, is the essential thing in the creative spirit, in the movement of forces, in the universal trend upward, in which man and beast take part. In all my Berlin manifestoes, I have stressed the immaturity of the movement, the amateurish

creativeness of all human efforts. Decisive is the volcano and not the lava, the symbol-making power and not the rigid symbol, the ethical will and not the conventional morality, the individual in the mass and not the mass around the individual.

In our hands, then, dada became a problem of personality. It was fighting for a creative life, for growth and becoming, for what may only be divined, not what may be calculated in advance. In this divination, art was but a part, just as existence, in the judgment of Heidegger, is only one possible form of being.

("Dada and Existentialism," 1957)

Psychoanalytical Notes on Modern Art

Both psychoanalysis and modern art stir the depths of the personality. But more than that, they tell us the dark truth about ourselves and the human situation in the chaotic twentieth century. Both psychoanalysis and modern art are also, down to the very core of their being, insistent. They are out to persuade. They have a program and their tone is revolutionary—or at least so it was in the beginning. As modern art has grown more and more aware of its cultural message, it has, like modern music, had to rely more and more on psychological interpretation. Like modern music, modern art—and their brother in arms, psychoanalysis—cry out for interpretation.

Desirable though it is, an attempt at a psychoanalytical interpretation of modern art has many strikes against it, first, because psychoanalysis itself has obviously failed to be generally accepted and, second, and even more important, because it has also very obviously failed in all its attempts to interpret and explain any art, especially modern art.

From what point can we proceed in our discussion of modern art, which is, as we have said, so badly in need of interpretation? Naturally, we are hesitant about saying we have a point of departure since it is a controversial one. I refer to the self.

In modern psychoanalysis, there is no subject more often and more readily referred to than the self. But when we try to substantiate our knowledge of the self, we soon sink into despair. Still, there are certain

things we can say about the self that will deepen our insight into it. First, we can say what it is not. The self is definitely not the ego—that is, Freud's principle of reality, the psychic organ between the superego and the id. Second, we can say that it is something within ourselves and loosely connected with outside reality, and that it is something operating under its own power and firmly connected with the creative unconscious as it expresses itself in dreams and reaches out toward reality. However, we have still not said anything clear or exact about the self.

We can perhaps deepen our insight into the problem of the self further by following the various stages of self-development in man. In doing so, it will be useful to see the self as separate from the personality and from the process of individuation. And we can go further yet if we think of the self as originating in need. We are convinced that man needs the self as much as he needs food. Anything we need, we live and experience as part of our being. Since we experience the self in so many ways, we must recognize it as a part of ourselves. If we look at the self genetically, we think of it as born from specific need, from individual want, from the individual person's difficulty in orienting himself in the world. Though a common human device for survival, the self is in its very essence an organ of the process of individuation. It doesn't show the way to the many, but to the individual, not to say to the single and the lonely. Socrates talked about this inner voice, the daimonion, telling him what to do and also what not to do. Buber speaks about the dialogue between the I and Thou, the Thou being the self. But the self is the I and the Thou at the same time, the mountain guide and the mountain climber; the self is the entire party, sometimes splitting into several voices, talking to each other, searching for orientation. Sartre talks about the In-itself and the For-itself, both being the same person engaged in the process of mental development.

The split of the self into the I and the Thou is a part of human nature, a necessary process both in the historical and the permanent human situation. But there is another important problem that directly affects any interpretation we might hope to make of a cultural phenomenon like modern art. I am thinking of the historical or cultural setting. This setting changes constantly, like a backdrop in the theater, and when we look at the history of Western civilization, we can see the setting shift. Obviously, history follows some rules—it operates with some consistency and regularity—but if we would understand man's need of the self, we must concern ourselves with the breaking of tradition. As Toynbee and Spengler have shown us, there are great and dramatic climaxes in history when the accepted ceases to be

valid. These are the high points of history: the introduction of Christianity, the Renaissance, and today, industrialization.

There have been times in history when the self was hardly needed. Such were probably the early Middle Ages, when the structure of the church was firm. Able to integrate into a spiritual system, man was not, as Jung has put it, "in search of his soul." The soul or the self was given to him, although there were only certain conditions under which it could be attained. Man's belief in God excluded the self to a great extent, and the place destined for the self was occupied by God. When God disappeared, around the end of the eighteenth and the beginning of the nineteenth century, the need of the self came up. Man, as Sartre has said, wanted to be God himself. He wanted to have something to hold onto within himself, because there was nothing for him to hold onto or believe in outside himself. After the impact of this reformation had been fully felt, man looked around for God and finally thought he had found Him within himself. But in this development, the self became nothing but a replica of God's creativity. It seems obvious that man cannot live without God. After he had dethroned Him, he had to erect a throne for Him within himself.*

The discovery of the divine power within himself was as much of a shock to man as the additional discovery that there is no God without a devil. The self as the divine creative force within ourselves can only be understood as a dynamic force, a constant movement back and forth between the divine and the forces of destruction. The self was felt as opposing powers working within ourselves. The self, we discovered, was composed of the self and the nonself, the first driving us toward self-realization and the second away from it, a self-alienating urge, as deeply rooted within ourselves as the divine and the creative.

When we investigate language, we find expressions like self-punishment, selfishness, self-destruction, as well as self-confirmation and self-assertion.

* Hannah Arendt, a disciple of the existentialist philosopher Karl Jaspers, says: "The historical evidence . . . shows that modern men were not thrown back upon this world but upon themselves. One of the most persistent trends in modern philosophy since Descartes and perhaps its most original contribution to philosophy has been an exclusive concern with the self, as distinguished from the soul or person or man in general, an attempt to reduce all experiences with the world, as well as with other human beings, to experiences between man and himself. The greatness of Max Weber's discovery about the origins of capitalism lay precisely in his demonstration that an enormous, strictly mundane activity is possible without any care for or enjoyment of the world whatever, an activity whose deepest motivation, on the contrary, is worry and care about the self. World alienation, and not self-alienation as Marx thought, has been the hallmark of the modern age" (*The Human Condition* [New York: Doubleday Anchor Books, 1959], pp. 230–31).—ED.

The self remains as the intangible behind such expressions, and in them we discover the dynamics of this self, the workings of the two opposites. In his book *Abstraction and Empathy*, Wilhelm Worringer claims that abstract art as such appears in certain periods in history when a strong urge toward self-alienation manifests itself. Perhaps it does, but we can say as well that abstract art appears when there is an exceedingly strong urge toward self-confirmation. These are times when the inexplicability of the universe, the terror of the infinite, and consequently a deep fear of self-destruction pervade man's awareness of himself.

The forces driving toward self-alienation and self-destruction are the ones Freud named *Todestrieb* (the death instinct). The death instinct is opposed by Eros, and together, in constant alternation, these constitute the forces of creativity: they work together and against each other like Ormazd and Ahriman (the forces of light and darkness in the Persian religion), or the Yin and Yang in ancient Chinese philosophy. The self creates its world by self-activization, day by day, but like Penelope it has to destroy and to dissolve its work at night. In fact, only if we accept the divergent and contradictory drives of the self are we able to understand its work. We can call this work of the self material produced for documentation. Theoretically, this material can be anything, not only art but also very ordinary activities. There is no emotional difference between the genius and the ordinary man as far as the urge for self-expression is concerned. Of course, we run into an impasse here if we conclude from this fact that all men are equal. Their inequality, which is overwhelming, is in their sensitivity toward their "own medium"—that is, in their sensitivity toward the voice of the self. José Ortega y Gasset claims that every man's life is essentially tragic in the sense that it never leads to a full expression of his possibilities, and he tries to prove this in an extremely interesting article, "In Search of Goethe from Within." Even Goethe, Ortega claims, did not have enough sensitivity for his needs.

Accepting the existentialist terminology, I would say that the self, which contains as a possibility both being and nonbeing, works "for himself" as well as "against himself." This, the basic paradox of human existence, is the real tragedy, life being obviously a rational proposition turning into an irrational game. The meaning of life, which we assume can be fully realized in art, reveals itself as an uncertain proposition, and all values—artistic, cultural, and ethical—become the documentation of man's basic uncertainty about himself, suspended as he is between light and darkness, between the rational and the irrational. This *condition humaine* is felt more intensely

in our time because we live in a time of crisis. We are actors on a stage that may collapse at any time. Auden's age of anxiety is the age of anxiety only because we are busy uniting the forces of God and the devil within ourselves. We are externalized to a high degree, but are also extremely introspective. The self of our time not only created the H bomb, threatening our own destruction, but also Nietzsche's and Heidegger's philosophy. The awareness of the self becomes immediately an awareness of the need for, and the drive toward, self-realization that is being counteracted and neutralized by other forces. What we call chance is a sentiment about the uncertainty of man's inner situation. We don't know what the outcome of our self-realization will be.

In man's deepest bitterness, in his hour of defeat, when his pride is gone, he confesses his need for the creative forces of the universe. Though man feels the alternating aspects of the self pushing him toward destruction as well as toward creation, he is not without hope. This is what Tillich in his book *The Courage to Be* calls the God behind the God. A creativity that accepts all the destructive forces—this is man's own experience, and in his experience he transcends the mechanism of his own self.

Man's ultimate transcendence of the mechanism of the self explains the feelings of guilt and fear attached to his existence on earth. Not only does man have to side with creation and the creative forces in the face of the obviously senseless game of life and of the alternation between creation and destruction, but he also has to feel anxious and guilty about the fact of his involvement in destruction. If he did not have this dual destiny, he would not feel guilty. The fact that most of his crimes escape his consciousness is of no help to him. Man cannot exculpate himself for anything he does, not even in situations where his lack of power is obvious.

Modern art is a psychic state of special awareness of man's situation as a human being. Though it is, of course, not a new situation, there is a higher awareness of the play between the creative and the destructive forces at this moment in history. This awareness expresses itself in radically new modes. Of these, abstraction is not the most characteristic mode, but it is a particularly interesting one. Its fractionalization, elimination of the object, its abolishment of perspective, and its denial of beauty all express this higher awareness. Much of abstract art, like other modes of modern art, cannot be judged by the old standards of beauty. The concept of beauty seems to have suffered particularly from man's new awareness of *la condition humaine*.

When the revolution that produced abstract art hit the aesthetically con-

ventional and quiet bourgeoisie shortly before and after the First World War, the process of individuation had advanced to the breaking point in a few individuals. This breaking point is the point when man as he exists in history and in the single individual must document his awareness of what is going on within him. When, in the isolation of country life in southern France, Cézanne suddenly became dissatisfied with conventional aesthetic expression, he had reached this breaking point. He said he felt rationality and irrationality, being and nonbeing, the creative and the destructive forces, the subjective and the objective, colliding within him. He wanted badly to find the "objective" in art. What he found by giving in to his fractionalizing, destructive, creative trend was a new reality—*la réalité nouvelle*. Aesthetically and psychologically, he found a new world where the forces within him could achieve a new balance.

In his work, Cézanne found the proof and the certainty beyond uncertainty that the positive and creative principles within him had been victorious. But, of course, the "nil" was right underneath. Like Job, Cézanne had joined battle with God and the devil: the society of his time was by no means ready to accept the fact that man is being and nonbeing at the same time. As is still largely true today in the United States, common morality was goody-goody. It presupposed that man was born for the good and that the good would eventually come to the fore. No one realized that only by accepting himself as a whole—both the positive and the negative qualities of his character—could he bring about a balance and give the creative forces a chance of victory. This moral conventionalism extended even to aesthetic matters. Culture, especially in Germany, was conceived in bothersome moralistic terms, and since the values it upheld helped to keep the masses in a certain order, the artist had to deliver them. Extreme rigidity and strictness prevailed. Unfortunately it was not the spiritual rigidity of the Middle Ages; it was a blind rigidity, accompanied though it was by some lip service to liberalism.

When Cézanne decided that life and the world—ordinary reality—should not be copied, but should instead be structuralized, he started a trend that has not yet come to an end. This structuralizing is partly an expression of man's new fractionalizing attitude toward the world; therefore it is negative and a part of nonbeing. But structure is also construction; therefore it is a part of the positive and the creative that leads to the experience of transcendence that we have been discussing.

From the beginning, modern art had a great feeling for "objectivity." However, Cézanne's drive toward objectivity cannot be compared with

what is commonly called objectivity in science, which is a sort of impersonal attitude destined to make it easier to relate to nature or things, as these reveal their "deeper meaning" in experiments. What Cézanne wanted to do was to break out of his ego fortress. His immense sensitivity had turned inward; he felt he was separated from reality, and he tried to figure out what was the impediment, the subjective error, that gives a distorted view of the world. Innocent subjectivity, the naïveté which believes that the world and things are what they appear to be, was under scrutiny. This subjective approach, with its concern for the "objective" nature of things, had been one of the major incentives of the impressionists. Monet had painted his haystack dozens of times in different lights—in the morning, under the midday sun, and at dusk. Though the impressionists had said they were interested in the way things change under the changing light, it was not really a question of optics that drove them on; it was the urge to find the thing behind the thing. In this sense, their work was not unlike Cézanne's. Though Cézanne denounced impressionism, he also wanted to see behind the thing. He was concerned with the "essence" of things, and light with its various shades was, he felt, an outside phenomenon. The structural secret became the secret of creation because it seems to answer the question: How is the thing made?

To us it seems idle to ask whether light is a surface problem or not. But it remains a fact that Cézanne would not have been able to do his work without the work of the impressionists. In contradistinction to David and Ingres, the classicists, and the romanticist Delacroix, both the impressionists, on the one hand, and Cézanne and his followers, on the other, were affected by the human situation in the industrial age. We cannot believe that they saw any real philosophic or even sociological problem with reference to the situation of the individual in society, but they must be credited with a sense of it. However small it may have been in comparison with the quantity of anxiety we see today in neurotic and psychotic patients —in fact, in all modern men—they must have felt something working within themselves.

The impressionists are like Cézanne, who is the real father of modern painting, in other ways. Whereas the artists who preceded the impressionists had never doubted the painter's full control of color and canvas, the impressionists put the painter's tools—color, brush, and canvas—under scrutiny for the part they played in the subjective approach. Of course, Cézanne did so more than the impressionists, but the impressionists had also questioned the position of the painter in front of the canvas and had

started to feel the effect of the classical and traditional twosome of the artist and the easel. The dialogue between these two, which started at this point in time, has not stopped yet. Seurat, the pointillist, had all sorts of theories about the relation between the painter and the onlooker, whom he wanted to see creatively, as if in a composition of complementary colors. Now that the painter had started to move, he also wanted the onlooker to move. This principle of movement has been developed in our time until, as with Tinguely's painting machine, visitor, originator, and machine work together to produce the work of art.

The principle of movement in its relation to man in our time is felt in all of Cézanne's pictures, where the forms of nature are made to reveal their underlying structure. Out of the conventional deadness of nature that imitation results in, a new, dynamic element destined to influence all art in our age arose.

Feeling decomposed and fractionalized, modern man seeks himself in the act of creation. He not only creates and re-creates the self in himself—that is, brings the self more fully into consciousness—he also projects the process of self-creation or individuation into his work. Art is expression, and the piece of sculpture that appears in the museum today expresses man's anxious search for himself and his great desire to realize himself as a whole through creation. This picture or piece of sculpture is an insistent, even aggressive, document of man's attempt to find this whole. It is the "found object": the artist's attempt to put himself together symbolically through the medium of color, stone, wood, or metal.

Expressionistic elements in art are themselves symbols of a specific stage in the process of individuation, a stage preceding the real creative work of integration. Through structuring the work of art and relating the parts to the whole, the artist attempts to construct his personality and make it whole. The work of art is a symbol of his unity, the proof that he can integrate the parts of his fractionalized being. The proof of the character of modern art is illustrated in the manifestoes that the various art movements have produced, the exaggeration of certain art elements, the preference for the distorted and the grotesque, the artist's outright action and aggressiveness. But in addition to serving as the artist's proof that he can integrate himself, modern art also expresses his fear and trembling, his preoccupation with the uncanny and the morbid, his masochistic flattening out, his enjoyment of the coprophilic, as in Dubuffet. In rejecting expressionism on the ground that art is a process of reification, modern art asserts that all the psychological elements that besiege man in his search for himself go on with this process.

Art is above all optimistic. It is the only human activity that does not sink into entropy.

But let us go back to Cézanne and his revolutionary approach to painting. We have said that Cézanne strove for the objective, as distinguished from the conventional and the romantic. We have also said that Cézanne's search for structure introjects the notion of a dynamic force that integrates the picture. There were two other artists whose aims were similar to Cézanne's but who achieved something quite different. Gauguin and Van Gogh are important here because both strove for the unconventional, both projected the sincerity and intensity of their search for themselves into their work, both were typical exponents of a troubled human situation, and both were out to find the personality in its entirety by any means and with all necessary sacrifices. It might be said that they tried to force the issue by acting out their problems, Gauguin by leaving his family and Van Gogh by committing suicide. Though Gauguin was less methodical, both men made great contributions to modern art. And any incompleteness in the art work of both men impressively documents the incompleteness they had to endure in the process of individuation in themselves.

In cubism, Cézanne's aims came to a classical conclusion. Cubism, a movement founded by Picasso, Braque, and Juan Gris (though other painters like Marcel Duchamp became cubists and still others went through a cubist period), shows the analytical and searching quality of what may be called a new spirituality. The various and conflicting emotional states experienced by man in our time can be related to the various aspects of the object as explored in cubism. The so-called analytical period of cubism shows the painters walking around the object, which is flattened out of its three-dimensional environment. It is as if Picasso and his friends were cutting various sides off the object and superimposing one side upon the other. In doing so, they are exhibiting their heightened consciousness of the distorted nature of the world. Their early pictures document this heightened awareness.

These early cubist pictures stress the fact that man's ability to grasp the essence of things is relative and incomplete, and we feel the sincerity of the assertion. The question which imposed itself on the cubists was not different from the one Cézanne faced. Creative men in search of the impossible, these artists all subjected the "thing in itself," that Kant had said could never be seen, to severe attack. As it happened, the thing they found was something that Kant had not thought of: the self which, unlike "truth," could only be experienced in time. In synthetic cubism, the essence of the object,

the new form, reflects the whole self, the entire personality. The process of individuation in its entirety, the moving back and forth, the play of opposites, the In-itself, the For-itself—all this we see in the work of the cubists. Their works are mainly analytical and structural. Color is subdued and almost negligible, as if they wished to emphasize the seriousness of their aims.

There is little anxiety revealed in the work of the cubists. It is interesting that Picasso went through a period of regression before the cubist period and that he moved on to the period of the Giants, so to speak, after cubism. In both the regressive period, when Picasso fell in love with Negro and primitive art, and the Giant period, there is a haunting quality, as much as to say that here the artist transcends reality with an uncommon and violent sincerity.

The question whether modern art is art or not is a dialectic one. As long as one thinks of art as a well-known activity, executed with well-known material and well-known tools, many of the achievements of modern art and modern sculpture could better be termed nonart. What we must realize is that, though artistic activity as such may be an archetypal effort, art is subject to historical changes. The echo of the great art revolutions—for instance, the revolution brought on by the introduction of three-dimensionality in the time of the Renaissance or of oil paint—can no longer be heard. We can guess that the arrival of oils must have hit the painters who had acquired great skill in tempera very hard. They probably protested vigorously. They probably said, as is said in other contexts today, that oil painting was not art and they were probably supported by most painters. But to us it is now clear that art in all its "eternity" is an activity deeply dependent on social situations that are themselves deeply dependent on what we are calling here *la condition humaine*.

When Nietzsche said "God is dead," he meant to attack the rationalistic naïveté of organized religion. But while God as a figure was being destroyed, the creative spark in man with its desire to be realized was being discovered. To say "Art is dead" is simply to point to the historical changes that an archetypal function can undergo. Aesthetic values change fast, and when beauty is considered identical with harmony, a man in our civilization cannot see or feel what beauty is. There is no harmony in modern man, and there is no harmony around him. And there will not be any in either place until the process of individuation which he is having to undergo as a result of the historical situation which he finds himself in has been completed.

With all its demonstrative schools and movements, modern art is there-

fore a particularly impressive piece of evidence that all art is a self-realizing activity. The process of self-realization or individuation that it documents is partly archetypal and permanent and partly temporary and historically conditioned. The anxiety that the process creates arises from two sources. It comes, on the one hand, from the relinquishment of the ego in favor of the self that is never there and that must always be realized anew and, on the other, from the contact with "reality," the world of objects around us that can also never be fully realized—the "going into the world" or "being in the world," as Heidegger puts it.

The establishment of the self in the midst of a world of chance is tantamount to working out the meaning of life. Since the self is dynamic—in essence nothing but creative movement—it is from some points of view identical with self-development or "growth." Personality as such is an aspect of the self. By "personality" we mean what Jung calls the persona, that is, the self as it relates to the world, which is, we must remind ourselves, a world of chance that is constantly confronting us with new situations and therefore demanding movement and adaptation. Modern art gives us an ontological interpretation of the status of the self in its relation to this world. It differs from other ontological interprepations in its aesthetic implications, but as we have stressed, we are less interested in the aesthetic than in the emotional status of man in our time as he seeks himself through artistic activity.

A great deal of attention has recently been given to Descartes and his rationalism. His famous statement "Cogito ergo sum" has been termed the major impediment to the realization of a true twentieth-century philosophy. As we know, this philosophy started with Husserl's phenomenology and has developed through Heidegger, Jaspers, Gabriel Marcel, and others into what is called existentialism. Modern art may be called an expression of existential feeling and thinking in that it is a search for a reality outside the rational ego, something independent of any rational system, whether religious or philosophical. Both God and art are dead as far as they depend on a system of cultural approval. But God is not dead within ourselves as the creative power and as the creative search for meaning. God is now the deglamorized movement of man toward himself and toward the recognition of the self, as well as the responsibility of the self, which is nothing but the Tao, the way toward the realization of potentiality, the endless wandering toward a necessary but indefinable aim.

In modern art, the movement closest to existential thinking has been the dada movement. It began in Zurich in 1916 and was founded by some of us

in the now famous Cabaret Voltaire. In the beginning, dada stressed the fight against rational and conventional values and emphasized the uncertainty of man's existence—the First World War had convinced the dadaists that the Victorian world was rotten inside. But as dada went on, it directed itself against all concepts of permanence. The dadaists were interested in two main facts: shock and movement. They felt that man was in the hands of irrational creative forces. He was hopelessly wedged in between an involuntary birth and an involuntary death. Although the dadaists knew that it had obviously always been so, they felt that the world they had grown up in had made man's ordinary situation more than ordinarily absurd.

Aesthetically and philosophically, the dadaists anticipated many of Heidegger's statements. Violently opposed to any stability, the dada painters used any means at hand to reach *la réalité nouvelle*. Richter introduced the endless picture on scrolls of canvas which, not unlike the oriental kakemonos, used signs and forms symbolizing the opposites that man experiences on his way through life. Schwitters became a master of the collage, which the Cubists had introduced. Using pieces of ordinary life—corks, nails, sponges, cloths—he initiated what is now called *art brut*. In contrast to Schwitters, Arp tended toward the structural. Though his abstract sculpture reminds us of Greek forms, it reveals an intense sensitivity toward the real behind the real. Arp loves the organic form, but he still belongs to the constructivists, who constitute one of the main branches of modern art. Arp has never surrendered to action as have the abstract expressionists; he has always held that aesthetic logic and reflection are one.

Dada had all sorts of aesthetic and philosophical features, but the public has been interested mostly in what may be called the Nietzschean character of the movement—its nihilism and its love of paradox. What the critics did not see was dada's vitality and its love of life. Life, as the original dada held and as the dada revival of the immediate present emphasizes, cannot be lived on the expectation of the permanent. The dadaist sides with Heraclitus against Parmenides. He began doing so long before Zen became fashionable; he sees life as change and motion.

The dadaist's admiration of the automatic forces in life is especially interesting. Automatism may be called the philosophy of the nonhuman. When Ortega y Gasset wrote his famous article called "The Dehumanization of Art," he meant to show that rationalistic humanism, as we have known it, was over. As modern art developed, the artist felt a growing desire to know more about the forces that are functioning automatically

around him and in him. Of course, this interest in the automatic antedated dada. Tatlin and the Russian suprematists had also been very interested in the machine. After the First World War, one of the first dada exhibits in Berlin included a poster with the following inscription: "Art is dead. Viva la Maschinenkunst of Tatlin." (Although the original inscription was all in German, I give it as I have here because that is the way it comes to me now. I offer it as a dada symbol of my dada existence in Switzerland, Germany, France, and America.)

The automatic forces of nature are the forces that support the self, as we feel these and their regulatory influence in our bodies and in our daily lives. They work in the unconscious, regardless of our conscious presence and in spite of our blindness or willful interference. The dadaists, more than any other people of their day, felt that life lives us as we live life. In their philosophy, life was always in flux and growing. Like Tatlin they were fascinated by technology, and they felt that the machine was the true symbol of man's new contact with the automatic forces. They accepted Freud's psychoanalysis because it was an attempt to reveal and free the unconscious automatic forces in the self.

The interest in the machine is particularly well represented at the moment in the follower of dada, Jean Tinguely. Since the machine projects the stage of self-realization that man has achieved in such an important way, we ought to discuss it here, but it is actually a subject in itself. Suffice it to say, the machine disintegrates under our eyes. If it is to keep functioning, it requires continual maintenance. Art requires no maintenance. A work of art conducts a creative dialogue with the onlooker. It has, in fact, as many originators as onlookers. Tinguely's painting machine dramatizes this fact at the same time that it represents a threat against the creative principle. In its expression of the creative and destructive principles in the self at one and the same time, it is the best possible example of the psychoanalytical implications of modern art that we have been discussing here.

The artistic interest in the automatic is one of the most significant manifestations of man's growing awareness of himself. If I were to make a prophecy about art, I would say that it will continue in this direction.

("Psychoanalytical Notes on Modern Art," 1960)

On Inspiration

As times change, poets change, and with them the conception of poetry. The forms of poetry, no less than their significance for the general public, are contingent on individual and collective psychological premises. Poets can be regarded as angels and devils, they are loved and they are hated, and these varying attitudes of "others," those for whom the poets write, depend on the generally accepted idea of what a poet is, or rather what makes him a poet.

What makes a poet, and how does he work? How does he manage to produce poems that are admired or despised by the general public? What is the psychological stance behind the figure of the poet? What makes him tick? What is the psychic clock he carries within (if one may put it that way)? Well, people have asked this question for many generations, but it has never been satisfactorily answered. Neither the admirers nor the haters, neither the learned nor the laymen, have been able to agree on the spiritual "machinery" of poets.

We have neither the time nor the space to go into historical studies of various conceptions through which men have tried to explain the essence of poetry and thereby of poets. One thing is sure, however: from Plato to Lessing, Goethe, and Schiller, and from the classic age to the most recent moderns, such as Martin Heidegger and Ernst Cassirer, the argument about the meaning of the poetic has never eased up. For all the differences, there has been agreement that the poetic, as a part of human capacity for

expression, is not limited just to poets and artists and that its significance goes far beyond the range of aesthetics. In other words, men have agreed that the nature of the poet and its explanation are important both for individual psychology and for an understanding of reasons for universal human behavior.

In his very externals, a poet is generally different from "other people"; the Greeks wrote about this. They discovered that poets did not get involved in everyday activity, they were not interested in the business of life the way "normal people" were; they loved freedom, retreat, they could be seen walking alone, they talked to themselves as though they were in company, and aroused suspicion by apparently not being "quite right" in that part of the body where one generally expects the seat and the sense of everyday reality to be, namely, in what is popularly known as the "belfry." The ancients concluded that there was something different about poets, and that something was happening in their belfry that others did not see, know, or experience. The poets had something special about them, and so it was obvious that they had a "special spirit," a companion, either a demonic something or a peaceful spirit, or an inspirer of an unknown species.

Poets in all periods (and I include the present age) have always made themselves so suspicious through their peculiar attitude that people regarded them as "in league with someone"; they spoke in secrecy with someone, they got mysterious advice from someone, to whom normal people had no access. Who is it? With whom do poets converse? In *The Republic*, Plato offers no elucidation, but he does conclude that poets because of their connection with the other "something," the spirit, the ghost, the daimonion, are of no use in managing affairs of state. They are neither reliable nor trustworthy although they admittedly produce the most marvelous works of art.

The Greeks, for all their enormous aesthetic gifts, were a lucid, politically oriented nation, and as long as no one tried to let the enemy into the country or overthrow the government, they never got too excited. They did nothing to the poets, but they did admit that their claim to peculiarity was not rationally comprehensible. In the Middle Ages, with their totalitarian zeal, poets often had a hard time, and the power or person inspiring them was frequently thought to be the devil, whenever the poetic product did not live up to conventional expectations. The poetic process, the power of the imagination, which could overcome the artist in his sleep, the suddenness of incipient production, which bursts through all dams in the personality, was not infrequently explained as the work of the Evil One.

Inspiration, as elucidated by modern psychological research, has become

a cardinal theme, since it has been recognized as part of the creative personality. The creative personality, the psychology of the artist—this has been the center of interest for psychoanalysts and psychologists ever since the resistance to the purely biological conceptions of man, such as have come down to us from Freud's theory of instincts, led to a radical change in the conception of the human situation. Man is no longer the product of Darwinian development or at least not just the product of this struggle for survival. Man is a complex entity that partially yields to the laws of nature and partially fights against them. One can even say that man's resistance to his inclusion in natural laws is an essential facet of his character and that a large number of his actions are determined by this resistance.

A man, even the simplest of men, is an artist and thus is subject to the laws of the psychology of artistic creation, of which an essential aspect is inspiration. Inspiration links the artist, as well as all other men, with the irrational, the unconscious, the imagination, from which everything emanates that can be called artistic creation. The contact with the imagination can occur suddenly, so that people say the muse has kissed the poet; but it can also come about very slowly, so that the creative person is then compelled to return constantly to the originating point of his creativity, which is marked by the unusual quality and newness of the product. Artistic creation, under the pressure of imagination, wrought up by the contact, can thus proceed in a variety of ways.

The imagination, suddenly pouring out into the artist, can express itself as spontaneity, and help him complete his work in an extremely short time; but it can also constitute a danger by leading the artist astray into superficial roads. The fact that the imagination, coming to the artist through sudden inspiration, can be both a friendly and unfriendly power at once often shows itself in the attitude of the accomplished artist to his completed work. He feels aloof from it, he would rather never see it again, he turns his back on it, as though he had borne a child that had caused him too much suffering.

To demonstrate this, one can find examples of and reports about the creative methods of the most diverse artists, corresponding to the variety of inspiration. I said that the suddenness of inspiration contains a violence that makes some artists anxious and angry. This is postcreative resentment, well known in even our greatest poets. Goethe talks about the alien feelings he often had toward his own works. Freud, who traced all human utterances to suppressed sexuality, would have had the possibility of a comparison here if he had understood more about the real creative process and the influence

of inspiration. The "Omne animal post coitum triste" has a clear relation to certain forms of creation.

The muse, as we know, is a whimsical person. Not only is her manner of helping sometimes violent and sometimes too indifferent, so that one can barely understand her voice; she often abandons her friends or her victims, if one may call them that, right in the middle of embracing them. We have many statements by poets and artists about this condition of abandonment or desertion in which nothing more than certain traces remain in the mind and soul of the artist. All he has left is the seeking and restoring, the reconstruction of an idea that he was sure he had, whose parts, however, do not suffice to really begin the process of producing.

Inspiration, formerly reserved for the artist, is now, under the influence of modern psychology, applied to man per se, in that scholars assume that man is not just biologically determined but rather is chiefly distinguished by his ability (the very characteristic of his humanness) to devise things for himself and others. At this point, with such ideas, we have left the area of psychology proper and are moving within the province of modern philosophy. Man, accordingly, is distinguished by his creative faculty; here, in his creative energy, he experiences the development of existence that continuously renews itself. Man, in his human situation, is the renewer as a part and a co-worker of the constant renewal of the universe.

The further this view was accepted, the more the artist—with all his peculiarities, which were emphasized in antiquity and the Middle Ages— became a part of people in general. The daimonion, the inner voice of genius, had to submit to democratization: he no longer spoke as an individual to an individual; he was, so to speak, singing in chorus. The violence of inspiration, the psychic overpowering that genius experiences, the inability to restrain the plethora of visions, became a kind of social encouragement. Everybody's doing it, as the song puts it. In school, children began writing poetry as an assignment, and it turned out that they weren't much worse than the geniuses. At least, it sufficed for domestic use, just as many things—even the highest things—in this age, which swears by the myth of equality, are often retailored for home use. The essentially feminine element of the muse had to be reinterpreted, the irrational vanished, and pleasant camaraderie was stressed.

The huge hosts of amateurs didn't have to wait for inspiration; teachers and practical instructions replaced inspiration. The growing drive to replace inspiration with "hard work" and vision with fact collecting, the influence of the scientific attitude and world view on art and poetry, lowered the

image of the artist in the sense that his uniqueness was no longer appreciated and acknowledged. The artist, as a prominent art critic, Clem Greenberg, once said to me, should be like an artisan, so to speak, with his tool in his hand. Inspiration, the idea, the conception of the entire work of art in preview, such as inspiration produces, was replaced by "problems." The poet and the artist, who no longer wanted to be guided, looked for "problems to solve." The value of art was estimated in accordance with the value of the problems presented in the poem or on the canvas.

The development of inspiration, as shown in the history of art from its incarnation in women such as Beatrice or Frau von Stein to the subjectivism of our age, the inner voice, contains the metamorphosis of mankind and shows the psychological changes under the pressure of cultural environment. The man of our time, for better or worse, carries his muse with him; even those with the best of intentions cannot replace a search for a personal direction and development with external guidance and advice. Today the "each man for himself" is as valid for the artist as it is for everyday and not unusually gifted people.

I have said that our age preaches the myth of equality; one may also say that it preaches the myth of genius in the sense that it expects something special from everybody, but something that is not linked to his own person the way the art work is linked to the artist. Our age expects something *useful* from all people. The muse, as conceived in former times, lived in an intimate relationship with the artist, who waited for her voice, loved her, and feared her. Now that the lady has been pensioned off, the intimacy of the art work or the poem has been replaced by the general expectation of usefulness. Just as no one can tell others about one's intimate life with one's mistress, so the present-day artist cannot really relate anything intimate, since he has lost both his mistress and his intimacy. To continue his work and his existence as an artist, he had to go a different way than his forebears. This fact, namely, the fact that the artist has forfeited his muse and thereby the intimacy of his relationship to inspiration, has produced what is known as modern art. This modern art is a museless art; it rests in its psychological premises on an inwardness and universality of inspiration and spontaneity that everyone has but that the artist experiences to a much higher degree.

("On Inspiration," 1960)

About My Poetry

I began writing poetry at the age of sixteen, while sitting on a dune in Borkum. I've totally forgotten the form and contents of that first poem, but it expressed a feeling of loneliness as well as a critical attitude toward my environment.

These are the basic elements of my poetry: that combination of a sense of being lost and a critical stance, sentiment, and mental acuteness. I also regard this blend as modern and as expressing the standpoint of contemporary man. People in our time, as far as I can see, do not abandon themselves to a feeling of grief, as romantic poets did; we no longer have the possibility of escape in the love of a woman or in nature. We are after some positive gain, a change of our situation; we want a new security for ourselves and for others.

I think the period of romantic poetry lasted until 1914, when suddenly World War I, more convincing than any speech or book, made a new statement about the nature of man. This new statement truthfully reveals that we are all caught in a state of ambivalence in regard to good and evil, beauty and ugliness, poverty and riches. World War I demolished the naïve conception of a progressive kingdom of God on earth. We saw that man was subject to laws preventing him from walking a strait and narrow path to paradise, either down here on earth or anywhere else. The security of inevitable perfection was replaced by the realization of a specific form of imperfection. We felt that man had to learn how to live with his foibles.

The movement known as Neue Sachlichkeit [New Objectivity], which often turned into new ugliness, opposed romanticism. Man, especially the poet and the writer, saw his environment and himself in a state of creative development. This was the time when Kierkegaard's wisdom forced attention to shift from heaven to earth and when Freud introduced the concept of dynamics into psychology. People felt that mankind was creative, and creativity encompassed both evil and good.

I wrote *Phantastische Gebete* as a dadaist, and this volume of poems clarifies the various aspects of modern poetry. First of all, they are "words in freedom," in Marinetti's term: poems that have not only free rhythms but also free associations. They are crazy only if the reader expects a poem to have a plot, tell an anecdote, or contain logical and linear action (the best example being Schiller's "Song of the Bell").

Ever since Bergson made us aware of the creative nature of our era, we have regarded (for the first time in history) simultaneity as creative, a simultaneity encompassing both man as a whole and the totality of milieu. A poem thus becomes something total or universal. The aspect of critical irony, which I mentioned above, is manifest everywhere, of course. It is most evident in T. S. Eliot's *The Waste Land*, whereas in Ezra Pound's poetry, especially the *Cantos*, we mainly feel the simultaneity of action in regard to creative man.

When I wrote *Phantastische Gebete*, I knew nothing about this modern problem of simultaneity, which plays such an important part in physics now. But poetry and art did anticipate the scientific rejection of cause-and-effect logic.

Gottfried Benn, a marvelous poet, said that writing poetry involves work much more than inspiration. This utterance clearly implies the concept of a poem as a creative product. Art as such has remained the same; but the artist's attitude toward his work has fundamentally changed. The poet, feeling the ambivalence of his distance from life, tries to adjust to his environment. He no longer writes for himself alone but definitely for an audience whom he wants to influence and give something to. Poetry is thus something like a psychological fact now, a pragmatic creation, a kind of object-metaphysics.

In *Phantastische Gebete*, as well as in *Schalaben Shalamai Shalamezomai* (which followed hard upon it), the objective is quite tangible within the hymnal form, and we realize that the poems are about man himself, despite frequent mention of the metaphysical and even God. The sense of lostness is very powerful and haunts or rather storms through the poems in the form

of a specific anxiety. Hugo Ball said this in a critique of *Phantastische Gebete*, which he reviewed for the magazine of De Stijl in Holland. He claimed, justifiably, that the shiny surface concealed an "immense terror."

Terror, *Angst*, which plays such a great part in psychiatry, was absorbed by poetry (once it had freed itself of sentimentality), which was then used as confession and prophecy. One of the forerunners of my poetry was the work of Georg Heym, who drowned in Berlin's Wannsee shortly before World War I. Heym had always had a deep effect on me. I have frequently praised him as one of the major German poets in the modern age—and I was well aware of my exaggeration. But more than anyone else in his time or after him, Georg Heym reveals the new attitude of man, and thus what I call the "new adventure"—man's reflection on himself and his powers and strength, expressed in images of anxiety. He was, if I may say so, the most brilliant neurotic in modern German literature.

When I was forced by Hitler to move to New York in 1936, the sense of lostness within me understandably deepened. It became a feeling of uprootedness, a condition of man in our transitional era. It takes man a long time to get used to the realization that no one can help him but himself.

Man for himself and with himself, with no help from above, in full awareness of his lostness and of the strength derived from that lostness, a modern Robinson Crusoe: that is the theme of my *Newyorker Kantaten* [New York Hymns] and my *Antwort der Tiefe* [The Answer from the Depths]. *Die Newyorker Kantaten* are softer and more lyrical, while *Die Antwort der Tiefe* is framed in more rigorous rhythms and implies what is indicated in the title: "Listen to yourself if you want help."

Whereas *Phantastische Gebete* was mainly a bursting of fetters, my latter-day poems introduce a new moderation and earnestness. Man is flung into the world, but he is not lost for all time if he understands the answer from the depths. This answer is the voice of conscience, leading us through the turbulence of this life.

Poems speak in rhythms and symbols. The reader, who may not find very much of the above in my poems, has to try to translate word into spirit. Modern speech is a language of space, and verse is related to an invisible counterpoint. Consequently, we should trust less to words and more to the meaning we capture for ourselves.

("About My Poetry," 1956)

New York

New York

New York ist am Abend wie eine Wiese
Umsponnen vom Glanz vielfacher Wünsche,
Strassen und Stunden verschwinden im Wirrsal
Der Menge. Der Abend ist schwer von Süsse.

Hier und da ist noch ein Reiter verspätet
Im Park, wo die Rufe der Liebenden hallen.
Seen liegen, von Fischen entgrätet
Wie Tote, falsch und verlassen von allen.

Das Karussell, wo die Kinder sich drehten und lachten
Am Tag, ist nun ein Gespenst, dem Schatten entglitten
Und da, wo die Matrosen um Wein und Wette geritten
Warten Figuren in hölzernen Trachten.

Irgendwo in New York schlägt die Uhr der Nacht,
An der Battery vielleicht, wo die Dampfer passieren.
Vater und Mutter haben gewacht
Bei offenen Türen.

Glücklich die Reichen, die in ihren Betten
Vom Sommer träumen, aber auch sie drehen sich
Schlaflos, wenn des Morgens neue Schwüle
Oedes Gleichmass verspricht.

New York

[New York at dusk is like a meadow
Enwebbed with the sheen of so many wishes,
Streets and hours melt in the chaos
Of crowds. The evening is heavy with sweetness.

Now and then a tardy horseman rides
Through the Park, where the calls of lovers echo.
Lakes lie, full of boneless fishes
Like deadmen, false and abandoned by all.

The merry-go-round, where the children whirled and laughed
In daytime, is now a ghost, escaping its shadow,
And where the sailors rode for wine and other stakes
Figures wait in wooden costumes.

Somewhere in New York the clock of night is striking,
At the Battery perhaps, where the steamships pass by.
Father and Mother have kept watch
And the doors are open.

Happy the rich who dream in their beds
About summer, but they too toss and turn
Sleepless, when the morning's new sultriness
Promises dreary monotony.]

("New York," 1954)

Modern Art
and Totalitarian Regimes

The present-day battle over modern art is unique, so far as I can see, in that artists have never before not only assumed different political stances but actually identified their politics with their art.

We all know that the totalitarian countries have been waging emphatic war against so-called formalism. This battle, because of the police systems at their disposal and the total enslavement of the individual in those nations, has led to a complete eradication of what we regard as modern art. The latter includes everything displeasing to the dictators, who, as Hitler's biography reveals, usually combine an unfortunate love of art with total ignorance.

I was saying that dictators are hostile to formalism. What they think it is isn't very clear, and their statements on art attain a certain clarity in one area only: propaganda. It is obvious that the propagandistic element plays a major role in the totalitarian assessment of modern· art. Modern, abstract, problem-ridden, experimental art is useless for propaganda purposes, either in domestic or in foreign politics.

The fact that it is the ignorance of the ruling clique that invents the enmity toward abstract art (an over-all term I would like to apply to modern art) is proved in art history. There have been many nations and civilizations that developed an abstract art, evidently with the consent and understanding of the man in the street. I am thinking of the nations and civilizations of the Near East and the Orient.

It is really not the people who decree the absence of problems, experiment, original ideas, but the dictatorial system, which needs constant propaganda to deaden its own guilt feelings and the fears afflicting the people. Thus, in the hostility of totalitarian states toward abstract art, we see mainly a hostility toward independent thinking by the artist, who is used and must be used by the rulers as a propaganda device against the people.

The dictator as such and, along with him, the minor dictators, in constant dread of toppling from their violently arrogated thrones, have to be glorified by slavish artists as knights in shining armor, demigods, kindly fathers, beneficent thunder from above. This is not just an imitative art, but a sycophantic, slavish stance of the artist, a product of fear and false enthusiasm; and seeking and finding one's own true artistic problems becomes impossible.

Thus, in a dictatorship, formalism signifies everything opposed to the dictator and his glorification and, consequently, is considered to have little to do with popular taste. Actually, this rationalization comes later, when the dictators declare that their taste is identical with that of the people. This obvious lie is then hammered into the heads of the suppressed, violently and with the aid of modern propaganda means, so that eventually even the man in the street believes that independent thinking in art is detrimental to the existence of the state, which he has been falsely led to regard as his own. Never in the history of the world has such a successful network of lies existed on intellectual and artistic terrain, and never in the history of the world have so many submissive intellectuals willingly fallen prey to this network of lies.

Thus, even in those states in which there is no system of violence and in which freedom of speech and thought often goes too far in its tolerance, there are well-known and unknown artists ready to throw themselves into the arms of dictatorship and its propaganda goals. If one asks these artists, one finds the same mental configuration as in the dictator; they have been warped by their own wishes for fame and recognition so greatly that they are compelled to believe that the general population itself is against abstract art. These artists inside and outside totalitarianism have invented the term socialist realism for their goals. They claim to be struggling for socialist realism against a variety of intellectualism known as formalism, which comprises everything running counter to their political and mental goals of violence.

If you take a look at the works of the socialist realists, however, you soon see that the mediocre imitative manner of these pictures and their

photographic fidelity have little to do with art or with any love of the people. The sources of this so-called artistic activity are fear and submissiveness. It is thus lesser art, or rather no art at all—the expression of a certain class of intellectuals who live in the dictatorship, yearn for it, or want to profit from it.

The essence of modern art is the fact that it has developed out of its own problems. Since the advent of the cubists, modern art has tried to concentrate on the essential artistic problems of space, form, and color. The more artistic modern art became, the qualitatively better and more interesting it became, the more unpolitical it became. Yet this is precisely one of the charges made by the totalitarians, namely, that the formalist artist is unpolitical and more concerned with himself and his art than with the people and the state. This is obviously a lie and at best self-delusion, since no artist, indeed not even an abstract artist, can separate himself from his cultural background or the people. Abstract art, too, is aimed at the people and recognition by the people, but artistically and intellectually and not with violence or with the mind of a minor functionary trembling for his head.

It is one thing to work for the people and another to work for a dictatorship, in which the concept of the people is turned to profit. Modern art is for the people and against politics and can thus concentrate on its own problems. And it is no accident that modern art insists on focusing on its own problems by trying to solve questions of form, space, and color rather than questions of partisan domestic or foreign politics.

It was precisely the realization that the artist is an independent human being and not a parrot that influenced the birth of the abstract movement. Thus, modern art involves not only the question of art per se but also the question of the artist's position in society and the freedom of his personality. There is also the problem of artistic and creative activity as a psychological and integrating part of the human personality. The modern artist, the abstract artist, is not simply expressing the painting itself as a problem of space, color, and form; he is also saying something about his own personality and his own privilege as a creative personality. Through his painting and his work, the abstract artist is declaring his independence of the powers that have been trying to urge him into so many different directions for so long.

The rejection of perspective in modern art, the notion of space, the simplicity of the devices, the idea of relativity, the negation of the static and the absolute, must all be seen as artistic expression but also as a symbol of the life-position of the artist and the artistic man.

This is really a struggle for the recognition and freedom of the artistic man against totalitarian encroachment, against his misuse by fear, guilt feelings, and criminal intentions. Therefore, I see the struggle of modern art not only in terms of art as a professional expression but also in regard to the problem of free possibilities of expression. The struggle is for a free possibility of expression, which is the only guarantee of a concern with essential problems and thereby of the quality of every creative act. Thus, we are really confronted not with the antithesis of formalism and socialist realism but with the basic problem of freedom and slavery in the area of expression.

When I and a few friends founded dada in Zurich in 1916, we were unaware of the antithetical fronts of formalism and socialist realism, totalitarianism and free democracy. We were rebelling against a system of illiberality, which wanted to use artistic activity in Germany and in the other belligerent nations for its own purposes. The psychological intentions were not acute yet, and the idea of state propaganda was still dormant and undeveloped. What happened was not more and not less than the creation of an atmosphere in which free artistic activity was impossible. Dada was a revolution that wanted to use any means of aggression to free art from all restraint, and thus dada became a pioneer of modern art.

Dada was a noisy, emotional movement, which had no intention of becoming an art trend. It really created the necessary conditions for artistic activity and demanded an atmosphere that would make it possible for the artist to express himself freely and thereby to live and show his own paradox.

It is precisely this paradox that the totalitarians do not understand because they themselves are so incredibly simple-minded and warped as to try and explain the world in terms of a system made up of formulas of restraint.

This paradox contains the real and nonpolitical conflict of the artist: he is free but needs some form of restraint, which he himself must invent and submit to. The discipline that the modern artist submits to must be a product of his own creative activity rather than an outer restraint, and consists in the limitation of his personality, his artistic means, and his formal intentions. It it thus much, much harder to produce a high-quality cubist painting than to depict the dictator on his high horse.

In the great era starting just before the twenties and ending right after them, dada, as well as other movements (such as futurism and cubism) that focused more directly on artistic problems, dealt with this paradox. All these movements, whether right-wing or left-wing politically, always stated

the same thing: the artist is basically free and any restraint he has to submit to in order to create is an inner and not an outer restraint.

I personally have continued this struggle for the basic freedom of the artist since the founding of dada and have never hesitated to say harsh things about those artists who pledged their allegiance to an outer program because they themselves were unsure, confused, or even malevolent.

Like modern art, dada, despite its radical beginnings, must therefore be understood as a struggle against the dictatorship of opinion and the outer restraint on expression. It is a struggle for the freely creative artistic personality and for the personality as such, which is being jeopardized by totalitarian states and totalitarian men.

It is, in point of fact, the struggle between liberal men and what I call the totalitarian type, the man who feels that personal ideas are dangerous and who has to lean on something in order to exist, who (to use psychiatric terms) has never attained maturity and thus needs a father, a dictator, some power over him, which punishes and raises him up, encourages him to live or destroys him.

And so I would say that we modern artists are really much less formalists and care much more for the people than our enemies on the other side, who parrot the dictators and use their formulas as recipes for creative expression. I have never given up my struggle against the totalitarian elements in the dada movement, mainly the arrogant figure of Monsieur Tzara and his totalitarian friends; and those who truly understand the meaning of modern art and the possibility of its effects will likewise never give in.

("Modern Art and Totalitarian Regimes," 1954)

The Agony
of the Artist

We have to realize that the dada assertion that art is dead is not too far from the truth. I do admit, however, that it is not easy for a layman to find this statement justified. This is tied up with a number of things and reasons, for example, with the fact that, as José Ortega y Gasset explained, the modern member of the masses is characterized mainly by self-satisfaction. His motto is: Everything is fine and is getting better all the time. His religion is progress. The invention of television confirms his unshakable optimism no less than the detonation of H bombs.

The mass man would never dream that the progressive automation of our world could involve an automation of the human being. The eager discussion about automation, which has led a few reflective people to prophesize a gray collective future for humanity, has never even ruffled the composure of the ruling mass man. Quite the contrary: he believes that the more mechanical the world becomes, the more time he will have to lie in public parks and stare at the vacant sky.

The relationship of the ruling mass man to art is tinged with the same optimism. Since he persistently confuses entertainment (in literature) with art, he thinks that mankind has never led such a wonderful life artistically. On the main squares, enormous billboards daily announce new movies fitted to every taste. From pseudo-literary themes to horror movies, in which gorillas drag off girls and Martian soldiers break into the only partially paid-for homes of peaceful citizens—everything can be found. According to the

latest psychological methods, which are examined by a host of professional psychologists and made more practical for commercialism, every temperament can expect satisfaction.

When a petty clerk, whose salary is low but who is frequently told by his firm how indispensable his work is for the general good, enters his apartment, he is greeted by the booming claim to art on his TV. From morning to evening, his TV talks about art, literature, and philosophy, and thus Mr. Jones is quickly brought up to date in every respect, and he simply would not understand how anybody could assert that art is not at a peak or is, as the dadaists said, dead. Art dead? . . . Don't make me laugh.

Mass man proves that without the slightest contact with quality one can not only live an excellent life but also attain a much greater age than our forebears. It is now our task to prove that creative quality is a necessary component of life.

Yet we can only surmise and hope that is true. Thus art, when postulated by us as a necessary creative component of life, can be accepted only as a hypothesis. We may say that art, although seemingly unnecessary for a great number of people in our time, nevertheless remains a creative necessity and an indispensable question of quality for us (a small, perhaps minimal number of people). As modern automaton-man proves, humanity can get along without art.

Thus, the dada protest was based on a false premise, i.e., the assumption that mankind would not be able to survive without the artist. Yet it can get along without art as easily as without religion despite all assertions to the contrary. It may therefore be better to say that in a mass civilization art and religion can be so attenuated and changed and that the mania for taking surrogates as something essential can be so encouraged that what we used to call quality is no longer in demand.

The dada protest in the Cabaret Voltaire arose from the artist's foreboding that he would soon no longer be needed. Thus dada was a kind of shout of alarm and warning. "Art," said the shout, "is moribund, and the artist, sensing his uselessness, is in a state of agony."

"Modern" art is an expression of people to whom the creative signifies the world; artists want to reintroduce art wherever it has been destroyed by an altered world. Dada foresaw all this and thus, mainly through Arp, advocated "abstract" art. Abstract art was a strong desire for a new form as well as a demand for a new feeling of form. It did not want merely to supply the world with art, it wanted to transform man by warning him in symbolic form to turn his back on egalitarianism.

Did it succeed? Did the artist succeed in leaving his agony and finding a new place in society? I may possibly be contradicted by my friends when I say no. I believe that the most brilliant of all revolutions is about to dissolve in thin air because, by being cheerfully accepted by all the world, it has been subordinated to the universal optimism.

The agony of the modern artist is due to his revolution's being integrated in the mass life of our time. The prophetic note of the revolution, which reached its acme in dada and surrealism, has deteriorated into a comfortable grunting. The artists who once stood on moral barricades are now the award winners at biennales and triennales. Abstract art has subordinated itself to progress. The few principles of the revolution that are still understood, for example, automatism, are being used by an army of dilettantes as Sunday afternoon recreation. In a highly industrialized country like America, in which universal conformity is lauded as a sound desire of the people, abstract art has become an occupational therapy for the emotionally threatened. It is a part of the general relaxation program. "Relax with art" is taken as seriously as, say, "Relax by bike riding."

Is art really dead? As a true dadaist, I have to reverse my stance at the end of my comments. Naturally art is not dead, but it needs a new effort at clarification of its principles in an age that is giving itself over to self-destruction with terrifying enthusiasm.

("The Agony of the Artist," 1957)

A Few of the
Artist's Problems

Modern art, especially abstract art, is now so greatly taken for granted as a part of American life that we are inclined to think about the quickness of acceptance. Almost forgotten is the initial response to that first viewing of Marcel Duchamp's *Nude Descending a Staircase*. The Gibson Girl's excitement, aggressive, and sometimes malicious, about this revolutionary event was more telling of the wider climate in which abstract art was born.

The victory of abstraction is so complete that small groups of resistance, confronted with the fact that they are the remnants of a once mighty army, arouse more pity than interest.

It is more than clear that the representational in art (except in literature, where a descriptive realism prevails) is no longer of interest, whether in perspective, form, or color, and that even the human figure and face—most recently in the powerful works of Oskar Kokoschka—are passing into oblivion, crowded out by everything that appears problematical and new.

Thus, Frederick Kiesler managed to gain tardy renown with his "galaxies." His exhibition of abstract compositions at the Janis Gallery astounded the New York spectators, who are truly accustomed to new things, in heaven and on earth. On Fifty-seventh Street, at the entrance to the gallery, I saw several people who wanted to look at the "galaxies." I overheard them talking to one another. A young girl, a typical secretary, elegant, asked what "galaxies" were. No one knew. Then someone said: "It's like Picasso. . . ."

For some people, all abstract and modern art is "like Picasso." Kiesler's "galaxies" are not "like Picasso"; they are nonobjective. They are splotches of color painted on a material that can be sawed and taken apart. A horse—it could just as easily be Odysseus or a tidal wave—that covers an entire wall evidently consists of a belly, a tail, and legs; however, it turns out that our old conception of the connection between the belly, the legs, and the tail was either false or highly superficial.

Kiesler, a small descendant of a great past and of such art movements as cubism and dada, all of which made a deep impression on him, divides and distributes the individual parts of a horse through space. He pushes one leg forward so that you can stroll between the leg and the belly. He turns the tail around so that the sky becomes visible between the tail and the legs. He calls this "correalism." The galaxies, as we know, are constellations and solar systems, and the mystery of the solar systems resides in the fact that they revolve on their axes in infinite space without falling apart. This is Kiesler's "point of argument." His abstract horses, women, tidal waves, cafeterias; his houses, people, situations, projected in harsh colors on wooden slats, are distributed seemingly at random, but we are clearly informed that they do hang together like solar systems in infinity, like galaxies.

New Yorkers are amazed at such interesting sophistry. They are as crazy as children and as infatuated as nighttime guitarists with anything that, as they put it, reveals a "sophisticated mind," a special form of intelligence and sharpness mixed with an awareness of what makes a thing and an author interesting.

Kiesler's special intelligence cannot be questioned, and the "galaxies" are attracting New Yorkers, although the latter may not realize that the "galaxies" are coming thirty years too late and that Kiesler's theory that art and life are identical (an idea first taken up by cubism and then formulated by dada in my book *En avant dada*) is ready for the glue factory.

Kiesler, originally an architect, then a member of the Dutch De Stijl together with Mondrian and Van Doesburg, has always excelled in theoretical skill. He is a bit behind the times now, and his correalism, which has news value in New York, arousing as it does the imagination of reporters and providing them with material, is merely a tardy assault on easel painting, which is allegedly put together but is actually torn apart and destroyed.

Picasso is slowly coming into proper focus. Some may say that he is not as great as has been claimed. His greatest achievement remains his cubism. He instinctively understood the deeper currents of our age and translated

them into pictorial forms, and we have to credit him with working not only with a brush but also with intelligence and—all things considered—with conviction. His renown will fade but not wither, and the tribunal of history will credit him with having been a painter and never an architect, never a mathematician, never a romantic visionary. Picasso knew precisely what painting is, just as a trapeze artist knows what a trapeze is—namely, the projection of an inner or outer object on a two-dimensional plane. Thus, in contrast to what New Yorkers may believe, Picasso was actually always an "objective" painter, never more than semiabstract, and certainly never "nonobjective," nor without an object altogether.

I am saying all this because I disagree with Kiesler's "galaxies." I feel that once and for all an end must be reached to experimenting, and I also feel that if one is utilizing painting as a means of expression, one should stick to the two-dimensional principles. If one wishes to express the inner connection between the parts and the whole, the magnetism of unity, so marvelously reflected in human individuality and its manifold, only seemingly diverse striving, then one must do it as a painter.

Goethe's remark "Work, artist, do not talk!" has a special meaning today. I think that abstract, experimental art has reached a limit that dada showed it a lifetime ago. Life is life, and I know today (something I didn't know as a dadaist) that life has a completely different existential nature from art, which works with symbols of life rather than with life itself. Art, in other words, is the ability of certain individuals to express themselves in life symbols for the benefit of themselves and their society.

The problem of the artist, how he creates, and what he creates, his position in society, his opinions on the stock market, war, a pure-protein diet, the confederation of the Protestant churches, a higher or lower hemline, are of enormous interest to Americans. All these things have probably always interested Americans, even in the days when Lillian Russell and Texas Guinan were spellbinding the men in their audiences and Jenny Lind was singing to art-loving gold miners in an unplastered opera house in Virginia City. Today, however, when every child can say his prayers in accordance with psychological awareness and ministers are caught reciting surrealist poems from their pulpits, today, when all of us are carrying a marshal's staff in our knapsacks (unless it has slipped into our trousers), we are more than ever convinced of the vital importance of the problem of the artist.

In line with this trend, I recently gave a series of talks on "Psychoanalysis and Modern Art" in the ballroom of a huge hotel on Fifty-seventh

Street in New York. The audience simply poured in, and I have never had more gratifying listeners. I was in an excellent mood; during my lectures, I was convinced that there were people present who actually knew what I was talking about. Many were enthusiastic, all were of good will. Everyone wanted to have something to do with art, no matter how or what.

Be that as it may. When I think of the many lectures I have given to half-filled rooms and halls in cities where intellect is endemic, then I am not annoyed at the young girl who asked me whether El Greco was part of the impressionist school. She said she had had an argument about it with her boy friend, who, she said, was "only" an engineer, unfortunately, and thus had recklessly claimed that El Greco was a medieval Spanish painter.

What do you do in such a moment when, impressed by beauty, surprised by enthusiasm, and dismayed by a statement? I ask the reader. Psychoanalysis . . . ? I am past that stage.

("A Few of the Artist's Problems," 1954)

On Leaving America
for Good

When I lived with my family in Berlin before 1933, in the wake of Germany's defeat, we had no idea of the approaching danger of Hitlerism. The Social Democrats who then ruled Germany were good-natured masters of the former Reich, if a bit sloppy. What culture was left flourished: the theaters were filled, the writers wrote, and the musicians played at their best. The Social Democrats really did not depart from capitalism, although they introduced some social reforms. But they never used force. They had, it seemed, no moral backbone, and this atmosphere of *laissez-aller* jibed very well with the general postwar fatigue. It soothed Germans' shame; it helped people to forget the million deaths the kaiser's will had caused. The dead slept in the bullet-torn fields of France and Russia, and the people in Berlin pulled the shroud of what they call *Kultur* over the graves. "Noble be man, helpful and good," Goethe and Schiller had said, and Hegel had declared that the highest human goal was spiritual, the *Geist*. The dismal defeat was really the fault of a decrepit *Geist,* and not the fault of the German people.

That was the way we lived, without *Geist,* accepting *Kultur* as a form of entertainment. We lived on social promises, while the prices rose and the number of poor and desperate people increased by the hour. Then came the hour when the Brownshirts marched through the streets. Their sentimental

and aggressive songs aroused the people. In their precariously neurotic state of mind, they found the Hitlerites interesting, but for the most part never believed them dangerous until they were in power. I was then a doctor, but had been a dadaist and journalist before. I changed my domicile and my address, and it was my good fortune that when Hitler came to power his agencies could not make sure that the dadaist Huelsenbeck and the doctor were the same person. That saved my life.

Hitler, in his psychotic writings, in *Mein Kampf*, had said that dada was one of the most anti-German, destructive and unpatriotic movements. (He was right.) What this meant practically, though, was that any person who had been active in dada could expect to be destroyed in a concentration camp, scientifically—smoothly, so to speak, not brutally.

I certainly did not look forward to that end. Each time that a Gestapo voice came over the telephone, asking whether the doctor Huelsenbeck and the former dadaist Huelsenbeck were the same person, my wife broke into tears. So, after a period of waiting, I went to the American consulate and asked for a permit to enter the States. It took this man (I have happily forgotten his name) about a year to agree to give it to me. His primary reluctance was based on the fact that I had two children and no money. Finally, he yielded, and I left Germany and my family. I thought I would never see them again, but by a sheer miracle they also succeeded in getting out of Germany. We were reunited in New York.

Why have I left America after thirty-four years in New York? I have not left America because I was disappointed in it. I left America after a comfortable life as a doctor and as a psychiatrist (America is the paradise for psychiatrists) because I felt I would never succeed in becoming an American in my heart. This is a complex matter, difficult to express, requiring a delicate precision in saying just what I want to say.

No other country, no other people have been so generous to me as the United States and Americans. In 1936, when the Hitler refugees arrived in New York, there were always helpful people, who gave not only advice but also money. I experienced many sorts of good luck. I was introduced to Karen Horney, and eventually founded with her the Association for the Advancement of Psychoanalysis. Horney was a marvelous woman, highly intelligent, creative, good-natured, and yet practical. What she did—and it really was a revolutionary thing to do—was to introduce the environment (men as well as things)—in other words, the "culture," politics, the way of life into theoretical psychoanalysis, as one of the possible causes of neurosis. Freudianism paled before Horney's activity. Man was looked at as a whole,

and his behavior was a part of his own strength, no longer exclusively dependent on the possibility that Mama had touched the patient's genitals when he was very young. Psychoanalysis, through Horney, became a study of creativity, not only of intellectual findings.

Horney and I became very good friends, and as she was very successful in her own practice, she sent me as many patients as I could take. From one day to another, I fulfilled the American ideal. I became rich (not really). I had a marvelous suite at 88 Central Park West, where old man Brill, one of Freud's first collaborators, had lived, and I could send my children to good schools, even to swanky schools—like the Dalton School and Choate. What a change through the will of God! the old Kaiser Wilhelm used to say. (*Welche Wendung durch Gottes Fügung.*) But I said then, and I still say it today: my good fortune was not caused by supernatural forces. My success came through the spontaneity, the personal freedom, the generosity of Americans, who are the only people in the world able to treat foreigners like real people, similar to themselves. I unfortunately cannot say that about the Swiss, among whom I now live. There is no xenophobia in America, and this is a great thing, a very great thing.

But you see I was not the usual foreigner, seeking his fortune in the land of freedom. I was more—or you may say less. I tried to live anonymously, but I did not succeed.

The specter of dada followed me wherever I went. In the beginning of my American existence—at a time when I was as poor and helpless as anybody can be—a man from the King Features Syndicate came to me and wanted some articles on dada. The *World-Telegram* had given some publicity to my entry into the United States. I was on the way to becoming a dadaist again, but had to be a doctor and pursue my medical activities—because there is nothing that you could less live on, materially speaking, than dada. This conflict between being a dadaist and being a doctor has followed me all my life, and was present at all times in my American existence. I dare say that up to today the Americans have never understood dadaism. They think of it as an art movement, as did Mr. William S. Rubin, a curator of the Museum of Modern Art, when he organized the last great exhibition "Dada, Surrealism, and Their Heritage." The bringing together of dadaism and surrealism was to me perverse, but I could do nothing about it.

Here is one of the reasons that I left the States. I never succeeded in making clear to anyone the true meaning of dada, which fights against a cultural ideology being used as a protective shield for social and political

injustices. Dada fought for the freedom of the creative personality, for the absence of artistic snobbism and lies. This problem is so complicated that the dadaists themselves could never really fully express it. Dada was the beginning of the revolution of the suppressed personality against technology, mass media, and the feeling of being lost in an ocean of business cleverness. Dada is a form of humanism—not the humanism of the German classics, but a fight for the freedom and the rights of the individual.

I could never make this clear to Americans, and so as a doctor I was a success, and as a dadaist (the thing closest to my heart) I was a failure.

The feeling of being a failure as a dadaist followed me through my American existence, and it influenced—happily or unhappily—my medical activity. After some time I could not even stay longer with the Horney group, although I never left them officially. I became interested in existential analysis, the founder of which was Binswanger the Swiss. In New York we founded the New York Ontoanalytical Society and—I dare to say it— they gave me a prize: the Binswanger Award for Outstanding Achievements.

What kind of achievements? I tried to find that out myself. I never wrote a book on psychoanalysis; I never wrote a book on psychiatry, except for one called *Sexualität und Persönlichkeit*, a German publication. I really was in a state of malaise. I tried to state that and to make clear that it resulted from the conflict between being a dadaist and being a doctor. It more and more came to my mind that at the end of my life I had to be a dadaist again. And to be a dadaist, I had to go to a country where the creative personality had been and still now was a problem.

I think I have to make this very clear. First, I want to repeat that I have no resentment against America. I consider my leaving the States as a failure on my part to adapt myself to the situation in America—a failure that, owing to the fact that I am a dadaist and will stay a dadaist, became especially painful.

But as good as it sounds, I think I will still have to make the whole thing clear by explaining why I left America for good. I have already said that many outside circumstances played a role: my age, the fact that I wanted to retire and to write again, the fact that I wanted to go back to the place, the country, the situation where my dadaist problem had arisen. To be clearer, I hope: there is no dada conflict in America, while there is still such a thing in Europe, or there was at least until recently.

But is this really so? Isn't the world everywhere the same? Influenced by proud scientists, who are too stupid to understand that the differences are

not less important than ubiquitous sameness? Don't I find the same nationalistic, depersonalizing, computerizing pride of scientists and pseudoscientists in Europe as in America? What a joy for these people that we went to the moon! But what will they say when it is found out that the dirt scratched from the moon is the same dirt that we find here on earth, and that we spent our billions more for the dreams of Mr. Wernher von Braun than for our own personal realities?

It is a fact that at heart I feel unhappy when I have to function well. And I more and more become aware of the fact that functioning well is the sickness of the American civilization—just about to kill the remaining stock of personal freedom and spontaneity. During my last years in the States, in spite of all my love for American ideals and for American reality, I became sick of my growing success and orderliness. I was in danger of becoming one of those handshaking "How are you" and "How do you do" types that I hate so much. I wanted to be a hippie again, a dadaist hippie in my own style with short hair and with a good fitting suit—but a hippie anyway. My desire to be disorderly, chaotic and malfunctioning, although constantly thwarted by the AMA and my colleagues, became overwhelming. I wanted to go back to some kind of chaos: not a chaos that kills, but a chaos that is the first step to creativity. I more and more hated the physician-businessman type who uses all the tests and all the tricks, but is not able to give the patient something substantial that gets him well. I hated the over-all money-making attitude of the average physician, and I then even hated being a physician.

Here, gentlemen, is my conflict. Being unable to solve it entirely, I try to solve it by changing scenes. It is a mistake. I know it, but this mistake may have curative qualities. I see it from here in Switzerland, where I now live, very clearly: America is a tragic land, and the Americans are a tragic people. Their grandiose try to found a free society has failed, and now they are in an unsolvable conflict. The war in Vietnam, the Negro problem, poverty, and the bankruptcy of the cities—while the arms manufacturers thrive on their income. Gentlemen, America is bankrupt. But I don't claim to be in a much better situation. I want to be a hippie, a doctor and a money-making clever man at the same time. These are unsolvable propositions.

I sometimes try to help myself by looking at the famous mountain panorama, at the forests, and at the lake. But I think I am a realist, not a romantic. I will have to make it clearer and clearer to myself why I left the States, or else one day I shall rush to the station, buy a ticket, and go back

to New York. I shall salute the Statue of Liberty with a melancholic smile, but I think I will then understand that liberty really never existed anywhere, and that the American attempt to bring it about (although it has failed) has been one of the most sincere attempts.

("On Leaving America for Good," 1969)

Bibliography

A. Publications by Richard Huelsenbeck

Phantastische Gebete. Zurich: Collection Dada, 1916. With 7 abstract woodcuts by Hans Arp. 2d enlarged ed., with drawings by George Grosz: Abteilung Dada. Berlin: Malik-Verlag, 1920.

Schalaben Schalamai Schalamezomai. Zurich: Collection Dada, 1916. With 4 drawings by Hans Arp.

Verwandlungen. Munich: Roland-Verlag Dr. Albert Mundt, 1918. A novella.

Azteken oder die Knallbude. Berlin: Reuss & Pollack, 1918. A militaristic novella.

Dadaistisches Manifest. Berlin, 1918. First dada manifesto in German. Read by Huelsenbeck at the great Berlin dada soiree in April 1918 and published as a pamphlet; co-signed by Tzara, Franz Jung, George Grosz, Marcel Janco, Gerhard Preiss, and Raoul Hausmann. Reprinted in *Dada Almanach*, Berlin: Erich Reiss Verlag, 1920. English translation in *The Dada Painters and Poets*, edited by Robert Motherwell, pp. 242–46. New York: Wittenborn, Schultz, 1951.

Dada siegt! Eine Bilanz und Geschichte des Dadaismus. Abteilung Dada. Berlin: Malik-Verlag, 1920. Cover design by George Grosz.

En avant dada. Eine Geschichte des Dadaismus. Hanover: Paul Steegemann Verlag, 1920. English translation in *The Dada Painters and Poets*, edited by Robert Motherwell, pp. 21–47. New York: Wittenborn, Schultz, 1951.

Dada Almanach. Edited by Richard Huelsenbeck for the Central Committee of the German Dada Movement. Berlin: Erich Reiss Verlag, 1920. Illustrated. Facsimile ed.: New York: Something Else Press, 1966. First book-length dada anthology, with contributions by Huelsenbeck, Tzara, Hans Baumann, Walter Mehring, Picabia, Ribemont-Dessaignes, Hugo Ball, Baader, Soupault, Arp, Hausmann, Huidobro, Dermée, and others. Contains Huelsenbeck's "Erste

Dadarede in Deutschland" [First Dada Talk in Germany] (February 1918), pp. 104–108, and his *Dadaistisches Manifest* (April 1918), in the article "Was wollte der Expressionismus?" [What Did Expressionism Want?], pp. 35–41.

Deutschland muss untergehen! Abteilung Dada. Berlin: Malik-Verlag, 1920. Illustrated by George Grosz. Memoirs of an old dada revolutionary.

Doktor Billig am Ende. Munich: Kurt Wolff Verlag, 1921. With 8 drawings by George Grosz. A novel.

Die freie Strasse. Berlin: Verlag die Freie Strasse, 1921. Essays and manifestoes.

Das Geld unter die Leute. Produced in the Danzig Civic Theater, 1924. A comedy.

Afrika in Sicht. Ein Reisebericht über fremde Länder und abenteuerliche Menschen. Dresden: Jess-Verlag, 1928. With a photomontage by John Heartfield. "A travelogue about strange lands and adventurous people."

Der Sprung nach Osten. Bericht einer Frachtdampferfahrt nach Japan, China und Indien. Dresden: Jess-Verlag, 1928. With a photomontage by John Heartfield. "Report of a voyage on a freighter to Japan, China, and India."

China frisst Menschen. Zurich and Leipzig: Orell Füssli, 1930. A novel.

Schweinfurth, ein deutscher Afrikaforscher. Berlin: Ullstein Verlag, 1932. A biographic sketch.

Der Traum vom grossen Glück. Berlin: S. Fischer Verlag, 1932. A novel.

Warum lacht Frau Balsam. Written in collaboration with Günther Weisenborn. Berlin: S. Fischer Verlag, 1932. A comedy.

"Ruhrkrieg." In *Dreissig neue Erzähler des neuen Deutschland* [Thirty New Storytellers of the New Germany], edited by Wieland Herzfelde, pp. 681–708. Berlin: Malik-Verlag, 1932. A story.

"Bitte der Parteilosen an das neue Jahr." *Die Literarische Welt*, 8, no. 2, 1932.

"Der Kampf um China." *Das Tagebuch*, 13, 1932.

"Die Neger von Scottsborough." *Das Tagebuch*, 13, 1932.

"Von der Völkerkunde über Deutschland zum Wert der Dichtung" [Ethnology in Germany and the Value of Poetry]. *Die Literarische Welt*, 9, no. 9, 1933.

"Die Gemeinschaft der geistig Schaffenden Deutschlands" [The Community of Creative German Intellectuals]. *Die Literarische Welt*, 9, no. 11–12, 1933.

Dada Manifesto 1949. Separate pamphlet of a text written for *The Dada Painters and Poets.* New York: Wittenborn, Schultz, 1951.

Die Newyorker Kantaten. Preface by Michel Seuphor. Paris: Berggruen, 1952. With 6 drawings by Hans Arp. Poems.

Die Antwort der Tiefe. Wiesbaden: Limes Verlag, 1954. With 7 "collages aux dessins" by Hans Arp. Poems. For translation of the poem "New York," see pp. 170–71.

"Erinnerungen" [Recollections]. In *Limes-Lesebuch*, pp. 53–64. Wiesbaden: Limes Verlag, 1955.

Mit Witz, Licht und Grütze. Auf den Spuren des Dadaismus. Wiesbaden: Limes Verlag, 1957. Translated by Joachim Neugroschel in *Memoirs of a Dada Drummer.* Edited and with an introduction by Hans J. Kleinschmidt. The Documents of 20th-Century Art. New York: The Viking Press, 1974.

Phantastische Gebete. Sammlung Horizont. Zurich: Die Arche, 1960. A reissue of: *Phantastische Gebete*, 1916; *Dada-Gedichte*, 1916; *Die Kuckjohnaden*, 1959; and "Erinnerungen an George Grosz" [Remembering George Grosz], *Neue*

Zürcher Zeitung, July 14, 1959. With illustrations by Arp and Grosz. For partial translation of the essay on Grosz, see pp. 116–22.

Dada—Eine literarische Dokumentation. Edited by Richard Huelsenbeck. Reinbek bei Hamburg: Rowohlt Verlag, 1964. Bibliography by Bernard Karpel. Contains "manifestoes, pamphlets, and protests" by Huelsenbeck, Huidobro, Breton, Hausmann, Picabia, Van Doesburg, Tzara, Mehring, Eluard, Duchamp, Man Ray, Emmy Hennings-Ball, Richter, Péret, Gabrielle Buffet-Picabia, and Ribemont-Dessaignes; "prose" by Arp, Franz Jung, Schwitters, Cravan, Breton, Cocteau, Baader, Baargeld, among others; "poetry" by Aragon, Mesens, Schwitters, Tzara, D'Arezzo, Soupault, Evola, Pansaers, Crevel, Serner, Ivan Goll, Max Ernst, and others; and "portraits, self-portraits, anti-portraits," by Erik Satie, Jean Cassou, Wieland Herzfelde, Michel Seuphor, Hannah Höch, and others. Included in this collection (pp. 59–64) is Huelsenbeck's manifesto "Der Neue Mensch," originally published in *Neue Jugend*, no. 1, on May 23, 1917. See pp. xxx–xxxii of the Introduction of this volume for a partial translation of this piece.

B. General Studies of Dada with Special Reference to Huelsenbeck

Arp, Jean. *Arp on Arp: Poems, Essays, Memories.* Edited by Marcel Jean. The Documents of 20th-Century Art. New York: The Viking Press, 1972. See pp. 266–267.

Ball, Hugo. *Flight Out of Time.* Edited by John Elderfield. The Documents of 20th-Century Art. New York: The Viking Press, 1974.

Coutts-Smith, Kenneth. *Dada.* London and New York: Studio Vista/Dutton, 1970.

Elderfield, John. "Dissenting ideologies and the German Revolution." *Studio International*, no. 927 (November 1970), pp. 180–87.

Forster, Leonard. *Poetry of Significant Nonsense.* Cambridge: Cambridge University Press, 1962. Also in: *Revue de l'Association pour l'Etude du Mouvement Dada* (Paris) no. 1, October 1965, pp. 22–32.

Greenberg, Allan C. "Artists and the Weimar Republic: Dada and the Bauhaus, 1917–1925." Ph.D. dissertation. University of Illinois, 1967. Excellent bibliography.

Grossman, Manuel L. *Dada: Paradox, Mystification, and Ambiguity in European Literature.* New York: Pegasus, 1971. Bibliography.

Hausmann, Raoul. *Am. Anfang war Dada.* Steinbach/Giessen: Anabas-Verlag Günter Kämpf, 1972.

Hugnet, Georges. *L'Aventure Dada (1916–1922).* Introduction by Tristan Tzara. Paris: Galerie de L'Institut, 1957.

Lippard, Lucy R., ed. *Dadas on Art.* Englewood Cliffs, N.J.: Prentice-Hall, 1971.

Motherwell, Robert, ed. *The Dada Painters and Poets: An Anthology.* With a critical bibliography by Bernard Karpel. New York: Wittenborn, Schultz, 1951. To be revised and reissued in The Documents of 20th-Century Art series. New York: The Viking Press, 1975.

Muche, Georg. *Blickpunkt: Sturm, Dada, Bauhaus, Gegenwart.* Munich: Langen-Müller, 1961.

Richter, Hans. *Dada: Art and Anti-Art.* New York-Toronto: McGraw-Hill, 1965.

Rubin, William S. *Dada and Surrealist Art*. New York: Harry N. Abrams, [1969]. Also: *Dada, Surrealism, and Their Heritage*. New York: The Museum of Modern Art, 1968. Extensive documentation and bibliography.

Sanouillet, Michel. *Dada à Paris*. Paris: Jean-Jacques Pauvert Editeur, 1965.

Schifferli, Peter, ed. *Dada: Die Geburt des Dada. Dichtung und Chronik der Gründer*. In collaboration with Hans Arp, Richard Huelsenbeck, and Tristan Tzara. With photographs and documents. Biographies and bibliography. Sammlung Horizont. Zurich: Verlag der Arche, 1957.

Schifferli, Peter, ed. *Als Dada begann: Bildchronik und Erinnerungen der Gründer*. In collaboration with Hans Arp, Richard Huelsenbeck, and Tristan Tzara. Zurich: Sanssouci Verlag, 1961.

Schifferli, Peter, ed. *Das war Dada. Dichtungen und Dokumente*. Munich: Deutscher Taschenbuch-Verlag, 1963.

Schmidt, Diether, ed. *Manifeste Manifeste 1905–1933*. Schriften deutscher Künstler des zwanzigsten Jahrhunderts, Band I. Dresden: VEB Verlag der Kunst, 1964.

Seitz, William C. *The Art of Assemblage*. New York: The Museum of Modern Art, 1961.

Thomas, Karin. *Bis Heute: Stilgeschichte der bildenden Kunst im 20. Jahrhundert*. Cologne: Verlag M. DuMont Schauberg, 1971.

Tomkins, Calvin. *The Bride and the Bachelors: Five Masters of the Avant-Garde*. Viking Compass Edition. New York: The Viking Press, 1968.

Verkauf, Willy, ed. *Dada. Monograph of a Movement*. Co-editors: Marcel Janco and Hans Bolliger. Teufen: Arthur Niggli, 1957. Trilingual. Illustrated. Contains Huelsenbeck's essay "Dada and Existentialism," reprinted on pp. 142–48 of this volume. Useful "Dada Chronology" and "Dada Dictionary" by Bolliger and Verkauf, and "Dada Bibliography" by Verkauf.

Index